THE GHIBLIOTHEQUE
ANIME
MOVIE GUIDE

Published in 2022 by Welbeck

An Imprint of Welbeck Non-Fiction Limited,
part of Welbeck Publishing Group.
Based in London and Sydney.
www.welbeckpublishing.com

Text © 2022 Little Dot Studios Limited, written by Michael
Leader & Jake Cunningham
Design © 2022 Welbeck Non-fiction Limited
Cover Illustration © Marie Bergeron

A CIP catalogue record for this book is available from the
British Library

ISBN 978 1 80279 288 1

Editors: Ross Hamilton, Conor Kilgallon
Design: Russell Knowles, Emma Wicks
Production: Rachel Burgess

Printed in China

10 9 8 7 6 5 4 3 2 1

THE GHIBLIOTHEQUE
ANIME
MOVIE GUIDE

MICHAEL LEADER & JAKE CUNNINGHAM
FROM THE LITTLE DOT STUDIOS PODCAST

WELBECK

CONTENTS

● INTRODUCTION 6

● PANDA AND THE MAGIC SERPENT 10
● THE LITTLE NORSE PRINCE 14
● BELLADONNA OF SADNESS 20
● LUPIN III: THE CASTLE OF CAGLIOSTRO 26
● NIGHT ON THE GALACTIC RAILROAD 32
● ROYAL SPACE FORCE:
 THE WINGS OF HONNÊAMISE 38
● AKIRA 44
● ROUJIN Z 52
● NINJA SCROLL 58
● GHOST IN THE SHELL 64
● JIN-ROH: THE WOLF BRIGADE 72
● METROPOLIS 78
● MILLENNIUM ACTRESS 84
● COWBOY BEBOP: THE MOVIE 90
● INTERSTELLA 5555 96

● THE ANIMATRIX 100
● MIND GAME 104
● TEKKONKINKREET 108
● EVANGELION:
 1.0 YOU ARE (NOT) ALONE 114
● REDLINE 120
● GIOVANNI'S ISLAND 126
● MISS HOKUSAI 132
● YOUR NAME 138
● A SILENT VOICE 146
● IN THIS CORNER OF THE WORLD 152
● MODEST HEROES 158
● CHILDREN OF THE SEA 164
● PROMARE 170
● ON-GAKU: OUR SOUND 176
● BELLE 182

● INDEX 188
● FURTHER READING 190
● CREDITS 192

Opposite: New voices. Naoko Yamada's *A Silent Voice* lights the way to a promising future for the field of Japanese animation.

INTRODUCTION

Welcome back, friends, to the Ghibliotheque, our cozy corner where we talk about some of the world's greatest animation and the people who make it. We started as a podcast back in 2018 with a simple goal: for Michael to turn Jake into a hardened superfan of Studio Ghibli, one film at a time. Spoiler alert: he succeeded – and we have scores of podcast episodes and even a whole book to prove it. But where next?

For many film fans around the globe, Studio Ghibli is their first taste of the wonders that await them in the world of Japanese animation. Maybe you're just like Chihiro in *Spirited Away*, whisked down a darkened tunnel and led into a mysterious world of gods and monsters. We all have our gateways, and Ghibli has fit the bill for generations. Now, we've thoroughly covered the films of Studio Ghibli (did we mention we wrote a book?), so for our second excursion we're going further down the rabbit hole.

There is so much more still to discover, so here it is, our Anime Movie Guide, covering 30 notable films from the last 60 years of Japanese animation. Each chapter features a hefty slice of contextual background from Michael, followed by Jake's critical commentary, capped off with further viewing recommendations if any of the films inspire deeper dives.

Curating this selection of 30 films has been tough. This is by no means comprehensive, and we wouldn't dare claim that this is the essential canon of anime films (for more exhaustive, encyclopaedic approaches, see Further Reading, page xx.) What we have compiled is a broad selection that highlights many of the exciting genres, filmmakers, trends and themes that you can find when dipping your toe into Japanese animation.

Taken as a whole, these selections do tell a sort of story about the anime industry, featuring a cast of characters who frequently cross paths from chapter to chapter. It's a story of creative ambition locking horns with strict, shoestring budgets; of visionary (overwhelmingly male) dreamers slogging away in what is ultimately a rather badly paid career; of the conflict between realism and something more visually expressionistic and, by extension, that between digital animation and traditional, hand-drawn artwork. Also, and this is something that must be recognized, as we're two British blokes tackling one of Japan's greatest cultural exports, it's a story about the relationship between anime and its global audiences, specifically those in English-speaking countries.

In the UK and the US, public perception of anime has been greatly influenced by distribution, and what has been made available at certain times to certain key audiences, such as the wave of ultra-violent

Opposite: If you love the films of Studio Ghibli, try Studio Ponoc's Hayao Miyazaki tribute, *Mary and the Witch's Flower.*

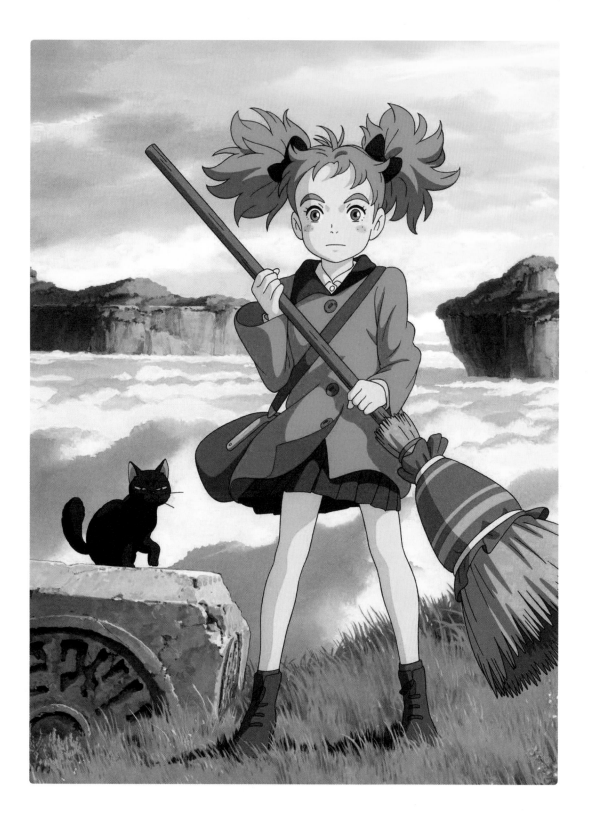

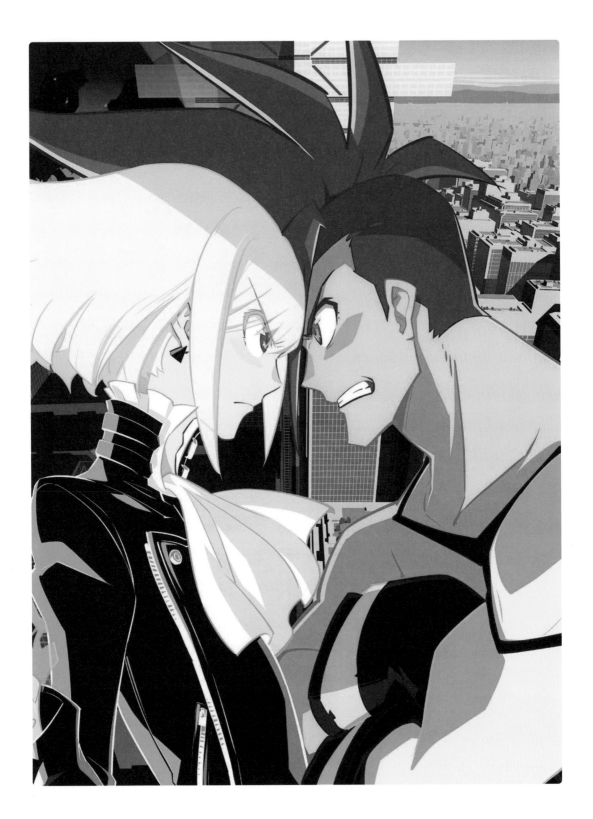

Opposite: Head to head. The anime industry is a world of contrasts and conflicts, like the clashing heroes of *Promare*.

genre films released on home video in the wake of *Akira*. There is also the pervasive prejudice that Japan's output is all hyperactive, empty calorie, kids' stuff. As an art form and a medium, animation can cover as diverse a range of stories, styles, tones and genres as live action, and anime is the industry where this rings most true. However, we have only ever been presented with a keyhole-sized view of that industry: many of anime's greatest hits and landmark works are still unavailable to purchase officially in the English-speaking world. That said, it does feel like things are getting better – and we'd like to trumpet the sterling work of labels such as Anime Limited, GKids and Discotek for bringing important anime past and present to screens both big and small, picking up the baton from companies such as Manga Entertainment and StudioCanal, who kickstarted many a fan's journey.

We're both firm believers that list-making should be a fun and silly endeavour, and we're guilty of making some quirky and idiosyncratic choices. For example, we decided that only one film per filmmaker was allowed, something particularly painful when we came to all-killer, no-filler filmmakers such as Satoshi Kon. And, since we'd literally written the book about them, no Studio Ghibli productions were permitted. (But don't worry, we still found a way to include both Hayao Miyazaki and Isao Takahata in the mix.)

We also wanted to honour a very particular area of anime: original feature films crafted for the big screen. Admittedly, this isn't necessarily the largest part of the industry in terms of output, audience and revenue – that would be anime television and their mega franchises such as *Naruto*, *One Piece* and *Dragon Ball*. But in the interest of honouring our roots as film fans, we have focused on features. And to keep our gateway vibe going, these are recommendations that can be enjoyed without doing any homework. They're available, accessible and digestible in one feature-length sitting. This has meant sidelining some notable features that are spin-offs from long-running series, such as the record-breaking blockbuster smash hit *Demon Slayer: Mugen Train*, the highest-grossing Japanese film of all time. But, frankly, part of the fun with lists is that they have glaring omissions that make you want to heckle the book as you read.

Whether you're mildly curious or wildly furious, we hope you find something you dig in this book. From *Akira* to *Your Name*, the horizons of Japanese animation are broad and bounded only by the limits of the imagination – and they are open for you to explore. Welcome!

PANDA AND THE MAGIC SERPENT
OR THE WHITE SNAKE ENCHANTRESS

白蛇伝

THE DISNEY OF THE EAST

Drawing inspiration from a Chinese folk tale, *Panda and the Magic Serpent* (also known as *The White Snake Enchantress*) tells the story of a young man, Xu Xian, who falls in love with Bai Niang, a white snake that has magically transformed into a human girl.

1958

DIRECTOR: TAIJI YABUSHITA

78 MINS

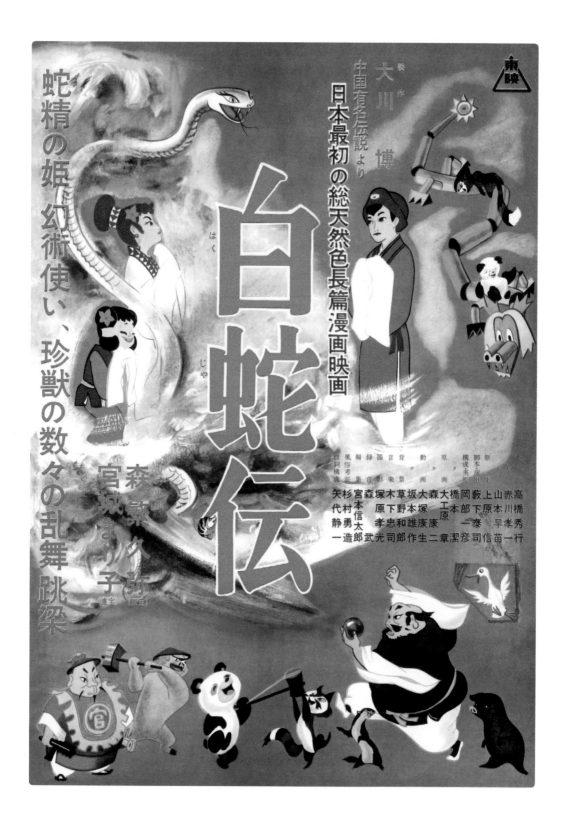

It might not be the first feature-length animation produced in Japan – that honour goes to the 1945 wartime propaganda film *Momotaro: Sacred Sailors* – but *Panda and the Magic Serpent* was Japan's first feature-length colour animation, and the first that aspired to compete with the enormously popular animated fantasies crafted by Disney.

The film was the dream of Hiroshi Okawa, an industrious entrepreneur with previous form working as an executive for the Tokyu Corporation in a variety of roles, from developing their retail portfolio to being managing director of a baseball team. Okawa ended up head of Toei, the corporation's film studio and cinema chain subsidiary, and he had his eye on a family demographic that was well-served by Disney. Putting an Asian spin on the fairy-tale format that had flowered since *Snow White and the Seven Dwarfs*, the studio's first feature-length project would be an adaptation of a Chinese folk tale, the *Legend of the White Snake*.

To crew up such an ambitious project, Toei bought out the animation studio Nichido, renamed it Toei Doga, and recruited and trained a new generation of young animators, many of whom would shape Japanese animation over the course of the following half century. They included Yasuo Ôtsuka (*The Little Norse Prince* and *Lupin III: Castle of Cagliostro*), Gisaburô Sugii (*Night on the Galactic Railroad*), and, according to some sources, Rintaro (*Galaxy Express 999* and *Metropolis*), debuting as an in-between animator at age 17.

Panda and the Magic Serpent's team of animators also included several key female artists, all pioneers in a male-dominated field, such as Reiko Okuyama and Kazuko Nakamura, as well as Akemi Ôta, who worked steadily at Toei on projects ranging from *The Little Norse Prince* to *Puss in Boots*, before retiring from animation to raise a family after she married one of her colleagues, one Hayao Miyazaki.

When *Panda and the Magic Serpent* was released in 1958, Hayao Miyazaki was still in high school, studying for his college entrance exams and dreaming of becoming a manga artist in the *gekiga* vein – an adult-orientated style of storytelling that espoused a more disillusioned view of the world. But seeing *Panda and the Magic Serpent* in, as he recalls, 'a third-run theatre in a seedy part of town' had a powerful impact on the young man:

'I fell in love with the heroine of this animated film. I was moved to the depths of my soul and – with snow starting to fall on the street – staggered home... I spent the entire evening hunched over the heated *kotatsu* table, weeping.'

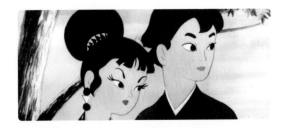

FURTHER VIEWING ────────

Following *Panda and the Magic Serpent*, Toei Doga (later renamed Toei Animation) has endured as one of the Japanese animation industry's leading studios, thanks to series and franchises such as *Mazinger Z* and *Galaxy Express 999*, *Dragon Ball* and *Sailor Moon*, and *Digimon* and *One Piece*. Much of their output has shaped what international audiences expect from anime, which makes it even more fascinating to dig into their early attempts to crack the Disney code in magical family adventures such as 1959's *Magic Boy* and 1960's *Journey to the West* (aka *Alakazam the Great*), which share elements of *Panda and the Magic Serpent*'s style and much of its crew. All three were dubbed and released in the United States in 1961, making them the very first feature-length anime films to cross the Pacific – a journey many features have made in the decades since.

Miyazaki would later attempt to downplay this fevered response as naive, and for years would tussle with the film, teasing out its flaws as he developed his own creative vision. But one thing was for certain: 'It made me realize that... in actuality I really was in love with the pure, earnest world of the film.'

Miyazaki wasn't the only one inspired by *Panda and the Magic Serpent*. In fact, much of the Japanese animation industry was set in motion here, from the ambition to create feature-length, colour films to the incubation of home-grown talent, to the tough working conditions and low pay that later saw Toei animators form a union to fight for a better deal – a conflict still raging today. Alongside *Astro Boy* (aka *Mighty Atom*), Osamu Tezuka's hit anime that captured imaginations both at home and abroad, *Panda and the Magic Serpent* forms what Jonathan Clements and Helen McCarthy describe in their *Anime Encyclopedia* as the 'twin big bangs' of the modern anime business.

PANDA AND THE MAGIC SERPENT – REVIEW

With *Panda and the Magic Serpent*, Toei Doga studios wanted to create their own version of the work produced by the Disney powerhouse, but they failed. There might be the odd musically inclined animal but this unique work could never be misconstrued as one of Walt's offerings – its liminal spaces, mythical aura and roaming visual flair is wholly its own.

Adapted from a centuries-old story, that of a young boy who falls in love with a magical princess who was once a snake, the film itself is excavated and unrolled in front of us. Minimalist landscapes are formed of simple shapes in otherwise empty frames, off-white clouds blend with the background and form over buildings like pages and details of an ancient picture book, sun-bleached over years of telling. On top of this antique canvas, the film's colours shine like they've had a polish, just the gleaming blue sphere of an eye seems like a precious stone.

The conquering love, ancient treasures, prison sentences and exile in the narrative feel like familiar fairy tale territory, and the influence of the House of Mouse can be seen in a few characters and sequences. Animals dance through the film, choreographed to their own synchronized natural rhythms, and while some harmonize with the world like they do in *Snow White*, there are others that act more like the stray gangs of *Lady and the Tramp*. One sequence of comically escalating weapons of violence even has shades of that other great animator of animals: Looney Tunes.

It's on the sidelines of the narrative, however, that the film is at its most special. In-between moments of firework displays, ribbon dances and tidal waves twirl and crash in and out of the story, and viewers are spun into uncanny dream spaces in a meandering celebration of life and animation. A showcase of street performers, each with their own bright, mercurial skill, is another gorgeous sideshow and one that reflects the film itself – a festival of episodic, artistically dextrous talent.

One can see traces of Hayao Miyazaki's work in the philosophy and style of the film, too, the 'pure, earnest' uncomplicated and compassionate emotion carries into *My Neighbour Totoro* and *Ponyo*. The hypnotic wriggle of a white dragon whipping across a sky would appear in the Oscar winner *Spirited Away*. Even the villain of this piece is of a piece, with Miyazaki's own ambiguous baddies. Fahai, a monk who initially forces the young lovers apart, is then integral in bringing them together again. Although not quite inhabiting the same murky grey areas as Lady Eboshi from *Princess Mononoke*, or The Witch of the Waste from *Howl's Moving Castle*, their family tree can possibly be traced back to Fahai.

From its influences to its influence, *Panda and the Magic Serpent* is a fascinating and beautiful key to so much of anime's history. It might not have a huge amount of bite but its alluring, artistic charms are hard to resist.

Opposite: Featuring romance, adventure and magical talking creatures, *Panda and the Magic Serpent* hoped to replicate Disney's successes in animation.

Below: *Panda and the Magic Serpent* has also been released under the titles *The Great White Snake* and *The White Snake Enchantress*.

THE LITTLE NORSE PRINCE

太陽の王子 ホルスの大冒険

THE BEGINNING OF A GREAT ADVENTURE

A young man called Horus is on a quest to reforge the Sword of the Sun, and thereby become Prince of the Sun. Along the way, he must travel to his father's ancestral village, face the Frost King Grunwald and befriend a mysterious girl called Hilda.

1968

DIRECTOR: ISAO TAKAHATA

82 MINS

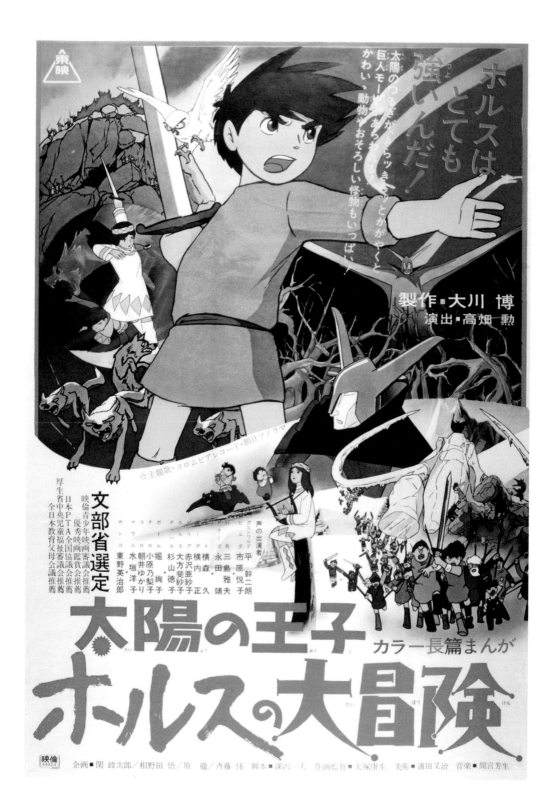

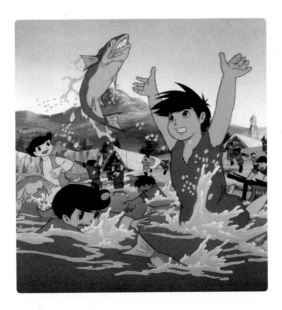

Above: Catch of the day. Even in their first film together, Isao Takahata and Hayao Miyazaki explore the links between humanity and nature.

Opposite: Lyre lyre. Hilda is the first of many compelling female characters seen in films by Takahata and Miyazaki.

Any guide to anime needs to salute the work of Studio Ghibli – and the life and work of the studio's two lead filmmakers, Hayao Miyazaki and Isao Takahata, But their work at Ghibli is only part of their story. Before Ghibli's formation in 1985, and the breakthrough feature *Nausicaä of the Valley of the Wind* the year before, both Miyazaki and Takahata were already established figures in the anime industry, and had many influential series and films under their belts. Their first feature collaboration was released almost two decades earlier: 1968's *The Little Norse Prince* (also known as *The Great Adventure of Horus, Prince of the Sun*), Takahata's first film as director.

Born in 1935, Takahata graduated from Tokyo University in 1959 with a degree in French literature. Although not a naturally gifted artist, as a student he became obsessed with Paul Grimault's *The Shepherdess and the Chimney Sweep* (which would later be re-released as *The King and the Mockingbird*), and decided to pursue a career in animation. He landed a job at Toei Doga, the pioneering Japanese animation studio that had just released Japan's first feature-length theatrical animation, *Panda and the Magic Serpent*, and was positioned as 'the Disney of the East'.

Takahata joined Toei as an assistant director and worked his way up to series director on *Wolf Boy Ken*, in the process forming a long-lasting relationship with one of Toei's rising-star animators, Yasuo Ōtsuka. It was Ōtsuka who, in 1968, was leading on a new feature-length animation project for Toei and brought Takahata on board to direct. Miyazaki, a friend of Takahata's since they had met at a union committee meeting, volunteered to join as a key animator. The production itself was somewhat hierarchy-free, allowing animators and artists to chip in with character designs, story ideas and other contributions during planning meetings. This was the perfect climate for an ambitious junior staffer like Miyazaki to make his mark. He would sneak sketches and drawings into Takahata's and Ōtsuka's offices – and before he knew it, he was designing whole scenes. In an interview years later Miyazaki described it as something of a crash course in animation production:

'I actually learned how to do that work during the process of making the film... it wasn't a case of implementing what I already knew; I was feeling my way as I worked on the project. So when *The Little Norse Prince* was done, it was easy for me to do anything.'

The project that would become *The Little Norse Prince* was adapted from a puppet play called *Sun Above Chikisani*, which in turn was inspired by a myth from the oral tradition of the Ainu people, an indigenous community from the Hokkaido region of Japan. The setting was changed to medieval Scandinavia on request of the execs at Toei. Takahata, Ōtsuka, Miyazaki and their collaborators (including future Ghibli colour designer Michiyo Yasuda) had lofty ambitions for their film – innovating in the art of animation and depicting new depths of emotion while offering strong commentary on the world around them, including the ongoing Vietnam War.

However, the production was plagued with problems: mounting budgets and missed deadlines would follow. In the end, Takahata was so far behind that he reportedly had to cut half an hour from the film's planned runtime, and certain scenes were left unfinished due to time constraints. When the film received a very limited theatrical release in 1968, it had been in production for almost three years. Meanwhile, Miyazaki had married fellow Toei artist Akemi Ōta, and she had given birth to their first child, Gorō. Takahata, on the other hand, was 32, and had delivered his first flop.

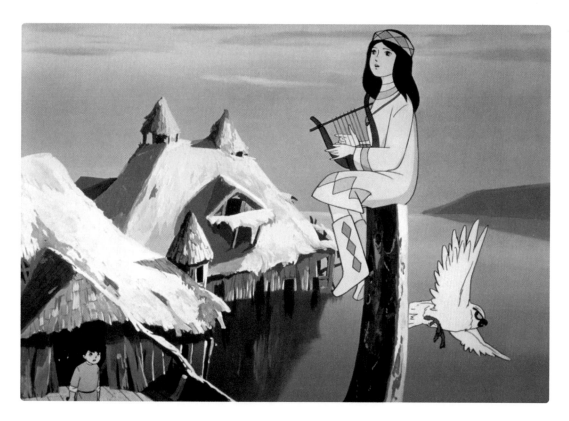

Nevertheless, *The Little Norse Prince* would endure as an early landmark in the history of Japanese animation, even more so as its crew members went on to change the industry. Its reputation was so strong that, in the late 1970s, when the fledgling magazine *Animage*, led by its young editor Toshio Suzuki, developed a recurring feature dedicated to classic anime films, *The Little Norse Prince* was the first to be picked for potential inclusion. Suzuki reportedly rang up Takahata, who refused to be interviewed for the magazine, but

amazingly suggested 'there is Hayao Miyazaki... he is sitting with me right now... if you want, I'll put him on the line'.

Suzuki says Takahata spent an hour saying no, while Miyazaki spent half an hour demanding more pages or he'd refuse to contribute, meaning that the article was never published – but the fruits of this first conversation between the three men would flower years later, when Takahata, Miyazaki and Suzuki guided Studio Ghibli to historic success after historic success.

FURTHER VIEWING

As the first collaboration between Takahata and Miyazaki, *The Little Norse Prince* serves as the starting point for two intertwined careers that, eventually, led to the formation of Studio Ghibli in 1985. But there is over a decade of Takahata's work worth exploring in between, from the cute family animation of *Panda! Go Panda!* and the feature films

Chie the Brat and *Gauche the Cellist* to his popular series adapted from European literature that was produced under the World Masterpiece Theatre banner. These were *Heidi, Girl of the Alps*, *3000 Leagues in Search of Mother* and *Anne of Green Gables*. Alas, much of this work remains unreleased in English-language territories.

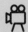

In 1988, when a double bill of *My Neighbour Totoro* and *Grave of the Fireflies* was released in Japanese cinemas, the works of two titans of animation – then working at the legendary animation house Studio Ghibli – could be seen together on screen. The fantastical, magical, adventuring spirit of Hayao Miyazaki and the expressionist, anthropological lens of Isao Takahata were paired in what is retrospectively an undeniably strange duo of films. But if you look back 20 years, to 1968 and *The Little Norse Prince*, you'll discover a single work that bares the soul of both.

Opening in the middle of a propulsive and violent battle between a young boy, Horus, and a pack of wolves, Takahata's feature debut begins much like Miyazaki's opus *Princess Mononoke*, in which the young warrior hero Ashitaka violently combats a feral boar god. As Miyazaki was a key creative force on *The Little Norse Prince* this comes as no surprise, and throughout the film similarly well-staged action sequences showcase a fruitful and thrilling animation partnership. A particularly striking sequence involves Horus, the little Norse prince himself, in a watery duel with a giant pike that's been terrorising local villagers. With clear screen geography, recognisable stakes and flinch-inducing moments of violence, it's an elegantly crafted set piece, so good that the rest of the film struggles to live up to it.

As is often the case with a Takahata film, eventually the money ran out, so later action – including a wolf attack and Horus's village getting overrun by rats – are staged as frustrating, cost-effective stills in a slideshow, without the refined fluidity seen just moments before. Although disappointingly jarring when placed alongside the battles seen previously, we do curiously see the recurring Studio Ghibli conflict between admiration for facilitators of war and a formal rejection of conflict.

It's not just in the action that the seeds of Studio Ghibli's work can be seen. We see the magic that can be found in harmonising the natural world, the fantastical and the human, and they are ever-present here (and are key to *Mononoke*, *Spirited Away*, *Whisper of the Heart* and many other Ghibli films). The gentle act of removing a splinter from a giant rock creature is simple and relatable and, in being so, becomes transporting and real. Furthermore, as is most recognisable in Takahata's *Only Yesterday* and *The Tale of the Princess Kaguya*, there is a shining admiration and passion for nature and agriculture.

One of a number of surprisingly moving musical moments arrives when a sea of fresh fish swims into the

Left: Due to budgets and time, action scenes in the film play out as sequences of images, rather than fluid animation.

Opposite: King fisher. Studio Ghibli co-founder Hayao Miyazaki cut his teeth on the thrilling action sequences of *The Little Norse Prince*.

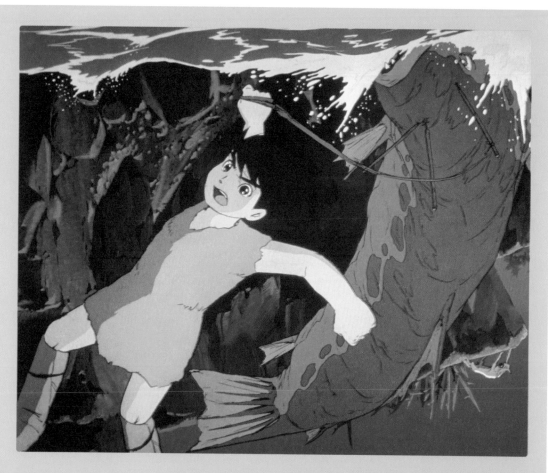

village: the tune isn't memorable, but the choreographed utopian harvest is captivating. In his later works (including a rare live-action excursion into the workings of a canal system) Takahata shows his fascination and regard for the processes and details of essential social infrastructure. The same can be seen here, where gathering food isn't a procedure – it's a dance. Behind the scenes, as well as being part of a labour union with Miyazaki, Takahata's *The Little Norse Prince* was a uniquely collegiate production, and his socialist and professional beliefs are evident in this beautiful moment of collaborative work. Less subtly, a later sequence deploys a hammeringly Soviet dream of infinite curled biceps and mallets across a bright sunny sky.

Beyond the radiant fields, sparkling streams and round faces of the village, an imposing gothicism creeps into the character design and setting of the hissable villain

Grunwald, a towering, sharply angled Disney-esque figure, and a type that wasn't seen again in Takahata's more impressionistic Ghibli work. Instead, he let the obvious antagonists and binary moral values dissolve, while heightening further his almost documentary-like viewpoint of working people and their tools and rhythms.

Narratively, *The Little Norse Prince* isn't the most satisfying watch; Horus's adventures can feel a little episodic, and a shift in character focus leads to a slightly meandering second act. However, it radiates warmth in its moments of commune, whether that's between humans, or with nature or magical being alike. Undeniably delightful, if a little rough around the edges, *The Little Norse Prince* is a fascinating, formative work from one of animations greatest directors.

BELLADONNA
OF SADNESS

哀しみのベラドンナ

ANIME GOES ART HOUSE

Adapted from Jules Michelet's 1862 book *La Sorcière*, *Belladonna of Sadness* tells the erotically charged story of a young woman living in rural medieval France who is sexually assaulted by a nobleman on her wedding day. Seeking revenge and the power to overcome adversity, she turns to witchcraft and makes a pact with the Devil himself.

1973

DIRECTOR: EIICHI YAMAMOTO

87 MINS

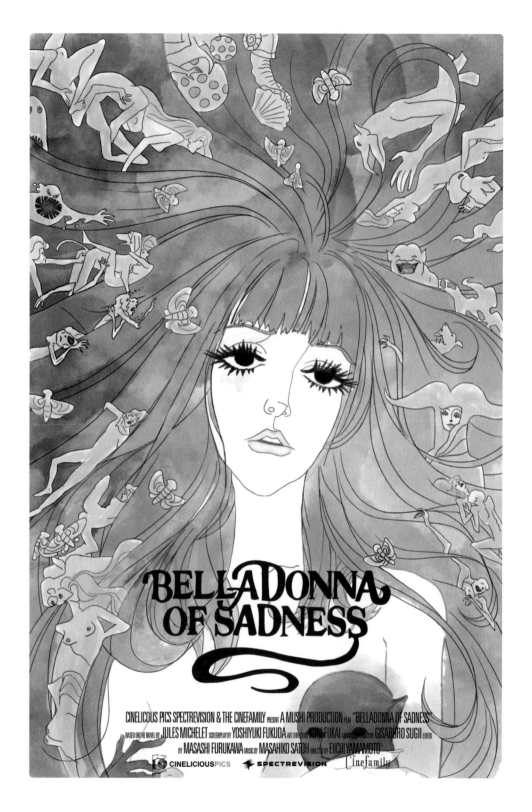

Osamu Tezuka, popularly known as the 'God of Manga', was also a key figure in the popularization of Japanese animation, forming the Mushi Production studio in 1961 and producing several breakthrough anime series for television, including 1963's *Astro Boy* (known in Japan as *Mighty Atom*). While those series enthralled younger audiences, by the end of the 1960s, the studio experimented with a series of innovative, erotic, unabashedly adult-themed films under the Animerama banner, with Tezuka collaborating with director Eiichi Yamamoto.

The third of these, *Belladonna of Sadness*, was directed by Yamamoto alone, after Tezuka stepped back from production as Mushi Production headed towards bankruptcy, resulting in a more serious, art house-style film. Born in 1940, Yamamoto learned the fundamentals of animation by studying Disney films frame by frame, but *Belladonna of Sadness* challenges our definitions of animation – going beyond the cost-saving 'limited animation' style prevalent in the anime of the time to deploy often fully static, beautifully painted frames that the camera would track over, sometimes merely suggesting movement and incident.

The 'inanimate' animation of the film made it more cost-effective, and Yamamoto formed a small creative team that could work at a more methodical pace, including screenwriter Yoshiyuki Fukuda (who was told 'it's porn, but make it a pure love story'), art director Kuni Fukai, and composer Masahiko Satoh. Legendary actor Tatsuya Nakadai, notable for roles in films ranging from *Hara-Kiri* and *Kwaidan* to *Yojimbo* and *The Sword of Doom*,

provided the voice of the lustful and at times literally phallic Devil, remarking to Yamamoto, 'I've been an actor for a long time, but I never thought I'd play a penis!'

The ambition was to position the film in the slipstream of George Dunning's psychedelic Beatles animation *Yellow Submarine*, which had been a cult hit. However, *Belladonna* was a flop on release in Japan, and remained an avant-garde curio with an air of controversy. It played internationally at the Berlin Film Festival in 1973, in competition with films from international greats like Stig Björkman, Claude Chabrol and Satyajit Ray – and premiered alongside Steven Spielberg's *Duel*. Curiously, the psychedelic jazz-rock soundtrack proved to be as enduring as the film, released in Italy alongside similarly freaky scores for 1970s European thrillers by Ennio Morricone and Claudio Simonetti's Goblin, and later reissued by crate-digger tastemakers Finders Keepers.

Never quite a 'lost' film, *Belladonna*'s reputation was widely reappraised after a loving restoration by the New York-based distributors Cinelicious, in 2015, with a global re-release following. Speaking in interviews bundled with the Blu-ray release of the restoration, Yamamoto remained proud of the film, relating a maxim that Tezuka shared with his young staff at Mushi Production: 'An artist should make experimental work... and produce commercial work every once in a while to balance it out. If you make only commercial work, you're not an artist.'

Below: Space to reflect. The huge vistas of *Belladonna of Sadness* are as expressive as its portraits. .

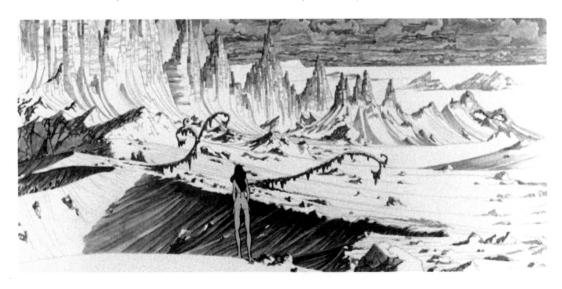

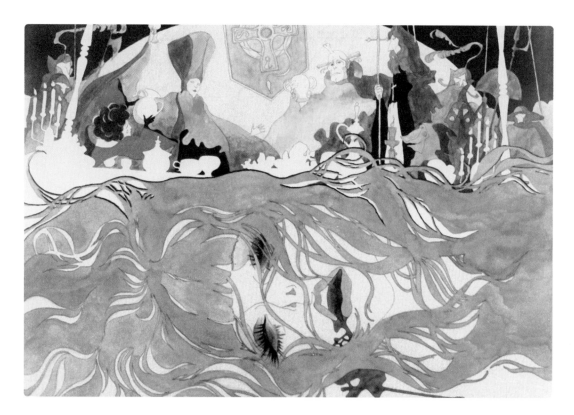

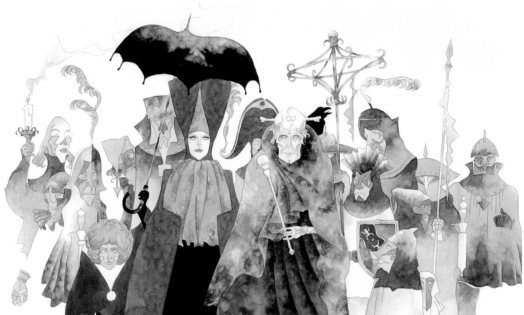

Top: With its graphic and erotic sequences, *Belladonna of Sadness* challenges any prejudiced assumptions that animation is just for kids.

Above: A parade of creativity and innovation, *Belladonna of Sadness* looks like no other anime out there.

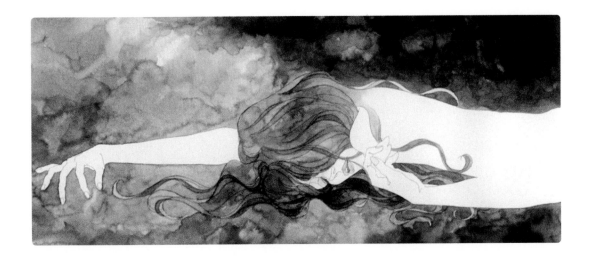

FURTHER VIEWING 👁

As is perhaps to be expected with a rare bird such as *Belladonna of Sadness*, there aren't many films in the anime canon quite like it. *A Thousand and One Nights* and *Cleopatra*, the two previous entries in Mushi Production's Animerama series, are similarly vivid X-rated features. But *Belladonna*'s art house sensibility brings it closer to its European contemporaries, both animated and live action. Pair it with the likes of *Yellow Submarine* or René Laloux's visionary sci-fi *Fantastic Voyage* for a psychedelic midnight-movie head trip, or with the lurid delights of Ken Russell's *The Devils*, the *fantastique* erotic horror of Jean Rollin, or the Italian *giallo* thrillers of Dario Argento if you fancy something more subversive.

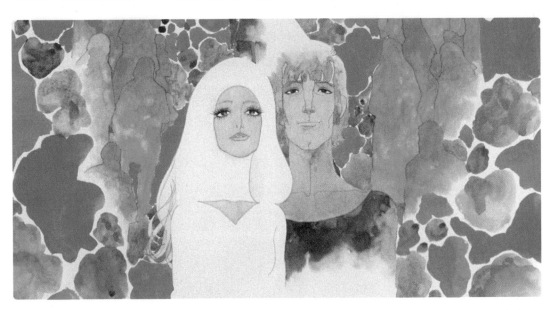

Top: With its cloudy water colour environments, even the backgrounds of *Belladonna of Sadness* are a spectacle.

Above: Bad romance. While it starts with a marriage, Belladonna finds radical power in subverting the accepted norms of society.

BELLADONNA OF SADNESS – REVIEW

Almost fifty years after its release, *Belladonna of Sadness* has a reputation as an explosion of psychedelia, controversy and erotic fantasy, but you wouldn't know at the beginning. It all starts with a line. A thin line on a naked white screen. Then, by simply panning to the side, this black line becomes animated – and unfurling behind it comes an Eden-like visage of softly watercoloured flora, at the centre of which is the wide-eyed, pastel-haired heroine Jeanne. With its warm hues and lush brass accompaniment, it's a serene seduction into what becomes a thrilling odyssey of sex, death, magic and the French Revolution.

Jeanne begins the film with an idyllic pairing with her lowly partner Jean, but their consummation is violently interrupted by the local Baron and his gang, who sexually assault her in an unsettling realized sequence. And rather than console her, Jean reacts violently towards Jeanne instead. In her grief, Jeanne is visited by the wispy, disembodied devilish spirit of a phallus, who offers her power. Leveraging this new found strength, Jeanne escalates her social and financial position in society, creates a cure for the bubonic plague, conducts lavish al fresco orgies and is eventually burnt at the stake for her actions.

With so much stimulation in the narrative, one might expect the animation to be equally frenzied, but *Belladonna of Sadness*, for all its extremities, is surprisingly delicate in its form. The generously deployed scrolling style of animation, featuring pans and scans across kaleidoscopic fairy-tale vistas, invites us to slowly study the richly painted artwork and to meditate with it. Combined with the hypnotic voice-over work, these tragic tapestries become completely enveloping.

Slipped between these panoramas, however, are moments of animated fluidity and style-hopping montage, whose salacious thrills in subject are matched by their confidently mutating look. Jeanne's penis-shaped companion gleefully flows between states of solidity and colour, screen-filling metamorphic cloud of desire in all its forms. Up

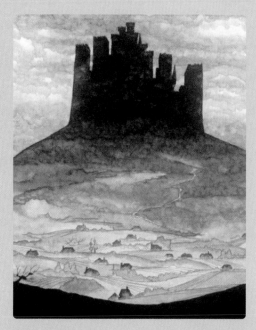

Above: Every tale of witches and warlords requires a dark and gloomy castle, and *Belladonna of Sadness* is no exception.

against the harsh, angular Baron and his people, Jeanne's long curling hair and curved figure are constantly reshaping and conjoining with vulvic and phallic imagery from the natural world. Through her reaffirmed sexual confidence and generosity, Jeanne harmonizes with her environment, her synchronicity at odds with her dagger-shaped doubters.

Sadly, Jeanne's story comes to a fiery end but not without an 'I am Spartacus' moment with the surrounding villagers, perhaps suggesting a sinister possession of the crowd but more likely the metaphorical impact of her liberating actions. A coda, linking Jeanne's actions to the French Revolution, feels like a leap – and one that breaks the contained hypnosis of the central story – but it's a daring thrust of ambition in a film full of them. Although it ends in tragedy, Jeanne, and *Belladonna of Sadness*, feel like a miracle.

LUPIN III: THE CASTLE OF CAGLIOSTRO

ルパン三世 カリオストロの城

MIYAZAKI THE FIRST

Gentleman super-thief Lupin III pulls off a daring heist, only to find
out that the money he has stolen is fake. Tracking down the source of
the counterfeit cash, he travels to the country of Cagliostro to face the
dastardly Count, and rescue the kidnapped Princess Clarisse.

1979

DIRECTOR: HAYAO MIYAZAKI

100 MINS

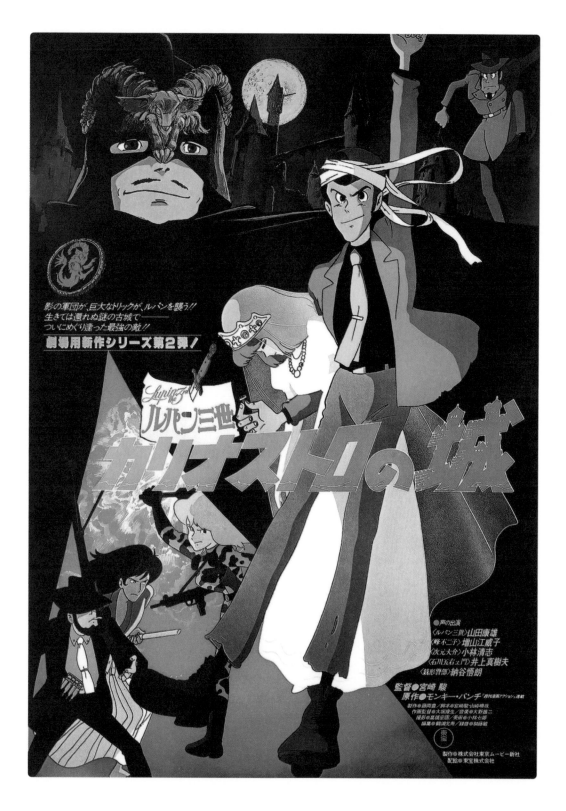

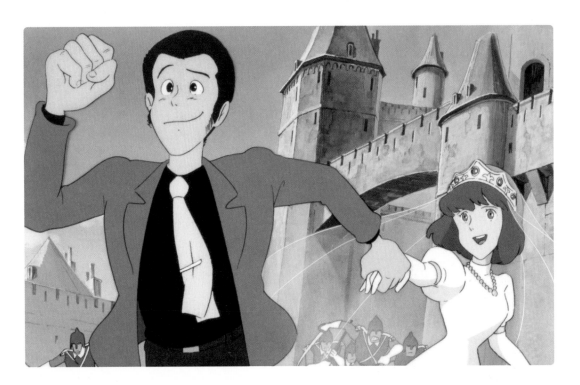

Long before *Spirited Away*, *Princess Mononoke* and *My Neighbour Totoro*, and long before the ubiquitous merchandise, record-breaking box office receipts and globally recognized reputation of Studio Ghibli, Hayao Miyazaki was a teenager moved to tears by a movie.

Already an aspiring manga artist, Miyazaki's life was changed by a viewing of Japan's first feature-length colour animation, Toei Doga's *Panda and the Magic Serpent*, in his final year of high school, which put him on a new course into the world of animation. A staff job at Toei followed, as the young Miyazaki worked his way up the pecking order, starting as in-between artist on *Wolf Boy Ken* and *Gulliver's Travels Beyond the Moon*, then key animator and storyboard designer on *The Wonderful World of Puss 'n Boots* and *Moomin*. Then followed a whole raft of roles on *The Little Norse Prince* (see previous chapter) with long-term collaborator Isao Takahata.

Miyazaki and Takahata would reunite and continue working together through the 1970s, often with Takahata as director and Miyazaki doing key animation, storyboards and other design work, on projects ranging from *Panda! Go Panda!* to *Heidi, Girl of the Alps*. But there was one uncredited instance where they worked as co-directors, when they were handed the reins mid-season

to a troubled 1971 adaptation of the popular manga, *Lupin III*, by the artist known as Monkey Punch.

The *Lupin III* series is a Japanese institution, successful on the page, on television and on the big screen, but this first attempt at bringing it to the small screen had teething problems when the original director, Masaaki Ōsumi, was fired after refusing to change the tone of the series to give it a broader appeal. Miyazaki and Takahata stepped in, bringing a more upbeat, 'happy-go-lucky' tone to the series and lead character. The resulting episodes weren't spectacularly successful but paid dividends several years later, when a new Lupin feature film was in development. The animation director for the project, Yasuo Ōtsuka – Miyazaki and Takahata's old colleague from Toei Doga, who was also animation director on *The Little Norse Prince* and later became a key member of the production team behind *Lupin III* – suggested that Miyazaki direct.

Miyazaki, on a hot streak after wrapping the inspired TV series *Future Boy Conan*, reportedly threw himself into the production, handling much of the scripting, storyboarding, character designs and key animation. In contrast to Takahata's first feature, *Lupin III: The Castle of Cagliostro*'s production was smooth sailing, taking seven-and-a-half months from start to finish, with around four or five months of active, hands-on production.

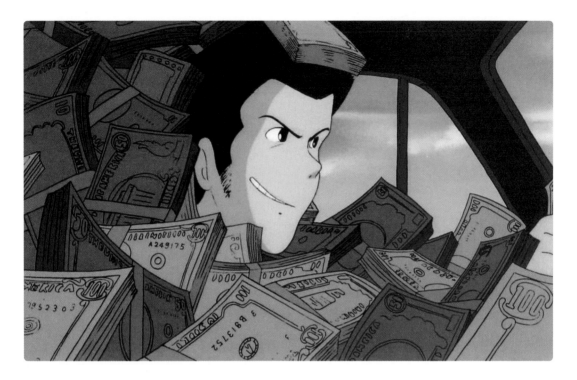

THE SPIELBERG MYTH

The Castle of Cagliostro is the subject of one of the anime community's most peculiar and long-standing urban myths. In various places – online, in print and even on the cover of official home video releases – there are references to the film being a favourite of Hollywood legend Steven Spielberg, some going as far as to attribute a quote to Spielberg saying that *Cagliostro* is 'one of the greatest adventure movies of all time'.

This has given rise to theories that Spielberg drew inspiration from *Cagliostro* for his Hollywood capers *Raiders of the Lost Ark* and *The Adventures of Tintin*, theories that have been unshakable despite there being no verifiable sources available to back up the claims. One indisputable connection, however, can be found in the Spielberg-produced kids adventure *The Goonies*, where we see an arcade cabinet for the *Lupin III*-related video game *Cliff Hanger*, which features animation adapted from *Cagliostro*.

Opposite: In contrast to the original manga, Hayao Miyazaki's approach to *Lupin III* cast him as a more charming, happy-go-lucky type.

Above: Stretching across manga, TV and film, the *Lupin III* franchise has been a money-spinner for decades.

Below: Surveying the landscape from a nearby rooftop, master thief *Lupin III* plots his next move.

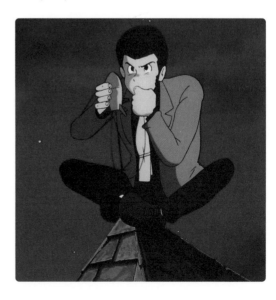

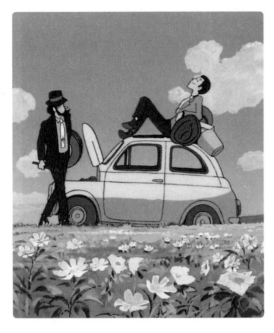

Above: The aftermath of one of cinema's greatest car chases, featuring the car owned by animator Yasuo Ōtsuka, the Fiat 500.

Below right: Pixar's recent gem *Luca* found inspiration in the early works of Hayao Miyazaki, including *The Castle of Cagliostro*.

When the film was released in cinemas in December 1979, Miyazaki was 38, six years older than Takahata when *The Little Norse Prince* flopped in cinemas. *Cagliostro*, too, was initially seen as a disappointment, at least in terms of box office returns. However, it received the Ōfuji Noburō Award from the Mainichi Film Awards for its technical innovation, and would later become a regular in lists and round-ups of the greatest anime of all time. Its reputation would only grow as fans in Japan and elsewhere discovered the film – on the big screen, on its regular screenings on Japanese television, or via fan communities, conventions and tape-trading networks.

Looking back, Miyazaki regarded *The Castle of Cagliostro* as the end of one era of his career, describing it as 'like a clearance sale of all I had done on Lupin and in my Toei days. I don't think I added anything new... I realized I should never do this again. Neither did I want to.'

Miyazaki called 1980, the year following *Cagliostro*'s release, 'my year of being mired in gloom', but what wonders were around the corner over the next decade: *Nausicaä of the Valley of the Wind*, *Castle in the Sky*, *My Neighbour Totoro*, *Kiki's Delivery Service* and, in the middle of them all, the founding of Studio Ghibli.

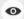

FURTHER VIEWING

The Castle of Cagliostro's influence on animation in Japan and abroad is vast: for many filmmakers of a certain age it was a pivotal viewing experience. Without it, we likely wouldn't have the filmographies of Mamoru Hosoda or Masaaki Yuasa, to name but two. A visit from a delegation of staff from production company TMS, including Miyazaki, to Disney in the early 1980s is credited as greatly influencing the younger generation of staffers who would eventually transform Western animation, including Pixar's John Lasseter. Look out for potential homages and nods to *Cagliostro* in John Musker and Ron Clements' *The Great Mouse Detective*, *The Simpsons Movie* and the 'Clock King' episode of *Batman: The Animated Series*.

More recently, director Enrico Casarosa drew a direct line of influence between the character design and animation of his Pixar feature *Luca* and early Miyazaki projects like *The Castle of Cagliostro* and the epic post-apocalyptic adventure series, *Future Boy Conan*, two projects that showcase a quality missing from his later films: 'When you look at *The Castle of Cagliostro* and the running over the castle rooftops,' Casarosa told us, 'there's a joy in the animation, and the playfulness, that I miss a little bit in the later work.'

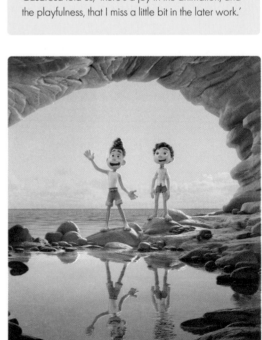

LUPIN III: THE CASTLE OF CAGLIOSTRO – REVIEW

This caper might open with a frenetic car chase, but it's when master thief Lupin's (and his partner in crime, Jigen's) vehicle breaks down that it really gets going, because that's when it's clear you're in a Hayao Miyazaki film. Throwing buckets of counterfeit cash out of the sunroof certainly makes for an entrance, but as he does throughout his films, Miyazaki always finds a balance between the thrills of adventure and the quiet miracles found in between them. When Lupin rests on top of the broken car, he takes a breath (something viewers might need after the opening, too) and soaks up the details of nature, from a bird flying overhead to the way the shadow of a cloud moves across a field. The shades of blue for the sky and green for the fields feel unmistakably Miyazaki, rich and inviting, waiting to be rolled in and basked under. These are the same dreamy fields that Kiki would lie on in *Kiki's Delivery Service*, Naoko would paint on in *The Wind Rises*, and Sophie and Howl would stroll through in *Howl's Moving Castle*. *Lupin III: The Castle of Cagliostro* arrived long before Hayao Miyazaki made his Studio Ghibli classics, but his roots are all here.

Once Lupin and Jigen get their car up and running again, they're immediately driven into yet another chase, which sees them defying cliff faces – and gravity. The screeching brakes and hairpin turns steal the foreground, but with all the action rattling through a very classical European setting and with a charming cad confidently steering the way – it feels like a reference point for an Indiana Jones stunt, which rumour has it, it could have been. As seen in *The Little Norse Prince*, his collaboration with fellow Ghibli founder Isao Takahata, Miyazaki has a real skill for clear, momentum-building, expertly staged action.

While this film never reaches the philosophical depth of Miyazaki's later works, it soars during its set pieces, the exemplary cliff-side car chase being one of many heart-racing moments. Lupin, who combines the charm of Danny Ocean with the tech wizardry of *Mission: Impossible*'s Ethan Hunt, is a more cartoonish creation than the more grounded figures

that Miyazaki would later create, his body constantly contorting form for maximum entertainment value. One scene sees the gangly gentleman thief turn into rubber, swimming, sliding and slipping nefarious clutches, while pinned between the pedals of a watermill, in a Chaplin-style farcical and thrilling chase. A race along some rooftops sees him take on the pacy, prancing feline side of his cat-burglar status, and would later inspire the zipping character movement in Pixar's *Luca*.

Later, a bout inside a clock tower makes for a grand finale, the cogs of the giant machine spinning in all directions, filling the screen like an Escher painting. Yet Lupin and his rival – the dastardly counterfeiting titular Count – are never lost, their dizzying surroundings heightening the excitement, but their combat remaining grippingly clear.

The story that contains Lupin stretches to fit such an elastic character, with a plot involving a wedding, Interpol, two ancient rings and a hidden treasure feeling fairly thinly sketched. Surprisingly for Miyazaki, who would go on to create so many characters that exist in compelling moral grey areas (The Witch of the Waste in *Howl's Moving Castle*, Yubaba in *Spirited Away* and everyone in *Princess Mononoke*), there is a clear binary choice between good and evil here. The loveable Lupin and his gang of rogues, including the undeveloped samurai Goemon and his former flame Fujiko, are simple heroes and the Count a hissable villain.

The result is a film that is highly entertaining, but not as rich and rewarding as later works from the great director. Considering its more throwaway plot, *Lupin III: The Castle of Cagliostro* seems like Miyazaki operating in a more experiential mode. The focus here is on the propulsive, liquid power of animation, which throws viewers through the story, with the occasional pause to remember the joy of instant noodles on a cold night, before hurtling into another sensational set piece. As a debut for Miyazaki, it shows a craftsman confidently in control of his tools, revelling in his form, laying the seeds for a studio that would go on to steal millions of hearts.

NIGHT ON THE GALACTIC RAILROAD

銀河鉄道の夜

STARLIGHT EXPRESS

Adapted from the children's novella by Kenji Miyazawa, *Night on the Galactic Railroad* follows two young kittens as they leave behind their daily hardships and embark on a magical, metaphysical journey through the cosmos.

1985
DIRECTOR: GISABURŌ SUGII
113 MINS

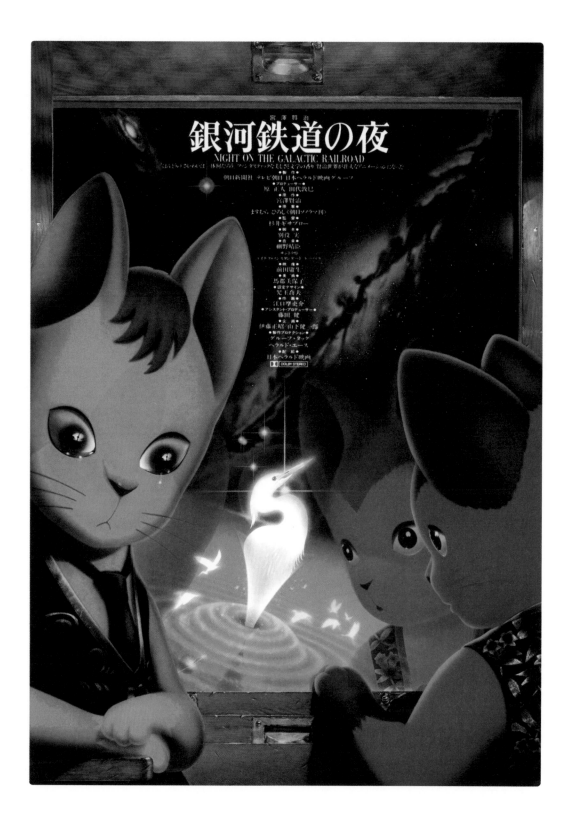

Gisaburō Sugii was born in 1940 and his career lines up perfectly with the maturation of Japanese animation as a popular industry. As a kid, he was inspired by the films of Max Fleischer and Disney features such as *Bambi*, and initially thought that the only route into animation would involve emigrating to the United States. But not long after he finished high school, he saw an advertisement in the newspaper for new artists to join Toei Animation, the studio gearing up to be Japan's answer to Disney. In an interview with *Animerica*, he recalled that there was reportedly a 30:1 chance of passing the entrance exam, but Sugii succeeded, and started working on Toei's first major feature, *Panda and the Magic Serpent*. He was also involved in the productions that followed, including those released in the United States as *Magic Boy* and *Alakazam the Great*. Later he directed episodes of the landmark TV series adaptation of Osamu Tezuka's *Astro Boy*, before following Tezuka into more overtly artistic and adult-themed territory with the likes of *A*

Thousand and One Nights, *Cleopatra* and *Belladonna of Sadness*.

His 1985 feature *Night on the Galactic Railroad* mixes elements from those earlier projects while charting new territory. Like Disney and the early Toei features, Sugii focused his feature on a core cast of anthropomorphized animals, yet the film's curious style and pacing recall the more artistic, literary aspirations of a feature like *Belladonna of Sadness*. Kenji Miyazawa's source novella, with its often enigmatic, philosophical tone, still stands apart from the pack even three decades after release. In stark contrast to Sugii – whose career is a case of right place, right time – Miyazawa was never embraced during his lifetime, and his reputation in the annals of Japanese literature only grew after his death at the age of 37 in 1933, *Night on the Galactic Railroad* later becoming regarded as a classic of children's literature. To bring the work to the big screen, Sugii assembled a team that included key creative

Above: *Night on the Galactic Railroad's* relaxed and thoughtful pace sets it apart from mainstream anime features.

players from outside anime: absurdist playwright Minoru Betsuyaku wrote the screenplay, and Japanese pop music legend Haruomi Hosono, the co-founder of Yellow Magic Orchestra, contributed the score.

Released in Japanese cinemas in the summer of 1985, *Night on the Galactic Railroad* was honoured with the Ōfuji Noburō Prize at the Mainichi Film Awards. Years later, Sugii would remember the production fondly, as one of the rare cases where everything just clicked, telling *Animerica*: 'this was a work where, through multiple lucky breaks, the intentions of all the staff – from the music writer to the screenwriter and all of the animators – converged. This was the one work I've done where the staff's mind became one for the film.'

FURTHER VIEWING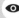

Night on the Galactic Railroad's influence can be felt throughout Japanese animation, most notably in Mizuho Nishikubo's homage-filled feature *Giovanni's Island*. Many other films have been adapted from Miyazawa's fiction, including Isao Takahata's *Gauche the Cellist*, and the Studio Ghibli curio *The Night of the Taneyamagahara*, the sole directorial credit of the legendary art director and background artist Kazuo Oga. Gisaburō Sugii himself would continue in *Galactic Railroad's* stately, artistic vein with his 1987 feature *The Tale of Genji*, before turning all expectations on their head in the 1990s with his biggest hit: the beat 'em up, action flick *Street Fighter II: The Animated Movie*.

In anime, trains are a lot more than the place you get to listen to podcasts while on your commute. In Hayao Miyazaki's Oscar-winning *Spirited Away* (2001), a railway, floating on an amber sea, offers tranquillity and resolution. In *Mirai* (2018), directed by Mamoru Hosoda, a train links a young boy to the vast network of his family tree. And for Hideaki Anno, in *Neon Genesis Evangelion* (1995), a train carriage becomes a vehicle to reflect isolation and public anxiety. In Gisaburō Sugii's *Night on the Galactic Railroad*, though, a train scene isn't just a brief encounter, it's the whole journey.

A metaphysical voyage into realms of death, friendship and sacrifice, but built by fuzzily charming characters and a calming, spacious art style, Sugii's film is both anxiety-inducing and meditative. It follows a young school outcast Giovanni – a boy in the book but a cat in the film – who cares for his ill mother while his father is away, and who boards a dreamy voyage on the Galactic Railroad, accompanied by his ally Campanella. Along the way they pick up passengers and swoop into space, swerve around stars, encounter fossil excavations, enigmatic bird catchers and victims of a *Titanic*-like disaster, all journeying towards their own final destination.

Surprisingly for the vibrancy of the story, the design of the film is quite restrained, keeping the focus on the emotions of the characters, without unnecessarily ornamenting them. Giovanni's isolation is different to the urban, claustrophobic entrapment we see in anime like *Ghost in the Shell* or *A Silent Voice*: it is presented as an unusually warm emptiness, both tempting and frightening. The soft colouring, flat, wide textures and stark contrasts of fields, rooftops and streetlights recall the landscapes of Giorgio de Chirico who so inspired the surrealists, where simple, light, open expanses are both alluring and uncanny. There is a unique sense of space to the film which lies beyond its visuals and involves its speed and sound, offering gaps to let Giovanni, and viewers, ruminate on the experience.

One standout scene sees Giovanni working as a typesetter, the measured, precise nature of his job

followed with patience and intrigue by the animation. It has a peaceful rhythm to it, the slow editing piecing together the sense and order found in the work, a temporal moderation that extends through the film. Told in brief chapters, the markers of which also serve as moments of reflection, *Night on the Galactic Railroad* feels like the drowsy, fractured nature of a long train ride, where jolting stops and anodyne voyeurism mesh. Haruomi Hosono's score runs along similar tracks, its sparkling synths dotting the story with minimal, ghostly reverberations, but it occasionally heightens the grandeur and menace of scenarios too. A curiously joyous scene featuring a man capturing birds by the hand and stuffing them into a bag is a symphony of triumphant motion and grand sonic romance, which thanks to the score, and like much of the film, becomes retrospectively more unnerving than it first seems.

Giovanni himself is one of the least emotive parts of the film. He is very much a passenger to the story, rarely showing any emotion, the strongest perhaps when his mouth slightly opens – the same face he pulls for shock and wonder. It's a brilliant piece of character design. *Night on the Galactic Railroad* is a poetic and elusive film, with meanings left open to each viewer to interpret, reflected in the passive, enigmatic face of the hero. This is a place to project and receive a spectrum of untethered emotions, constructed in a welcoming, but unsettling landscape. If you're in the mood for an introspective trip, it's just the ticket.

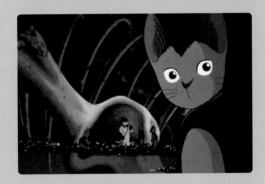

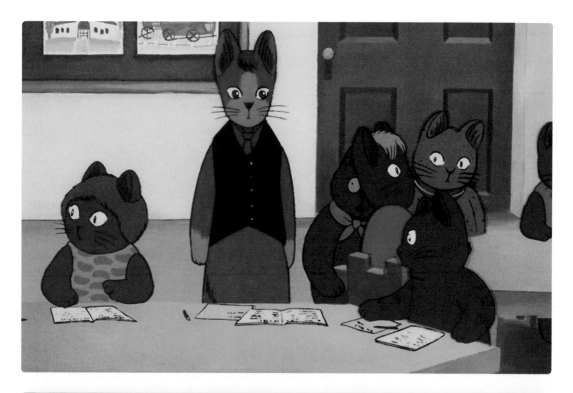

Opposite: Led a-stray. Giovanni's adventure leads him to a variety of strange encounters, including a visit to a giant fossil.

Top and above: Gisaburō Sugii's most radical change in adapting *Night on the Galactic Railroad* was to make his protagonists look like cats.

ROYAL SPACE FORCE: THE WINGS OF HONNÊAMISE

王立宇宙軍~オネアミスの翼

THE RIGHT STUFF

In a retro-futuristic alternate world divided between the Kingdom of Honnêamise and The Republic, a young man joins the Royal Space Force, a small team that is about to undertake the ambitious project to send the first human into space.

1987

DIRECTOR: HIROYUKI YAMAGA

119 MINS

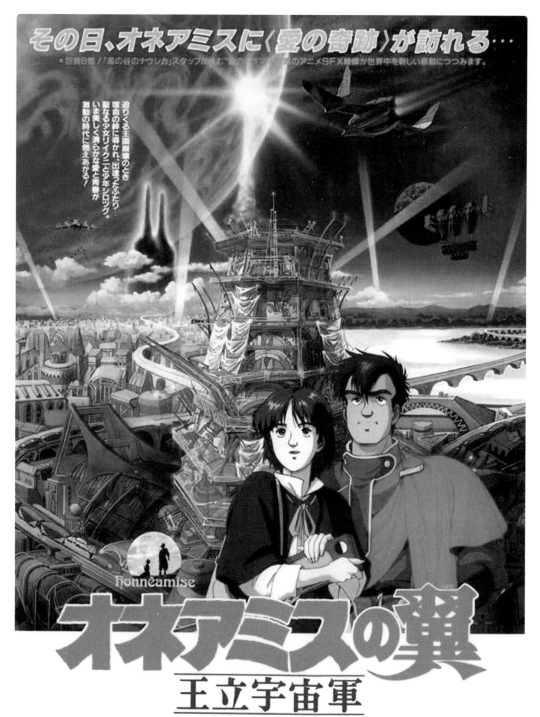

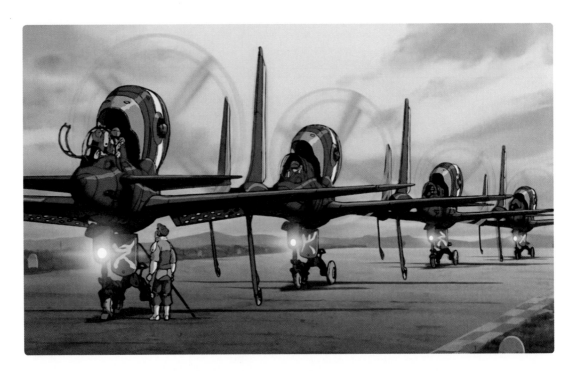

Of all the anime wunderkinds covered in this book, the team behind this 1987 feature sit at the top of the heap. Director Hiroyuki Yamaga was only in his mid-20s when he was entrusted with the project by erstwhile toymakers Bandai, along with a ballooning budget that proved impossible to recoup. However, Yamaga and his compatriots at the studio Gainax – including animation director Hideaki Anno, character designer Yoshiyuki Sadamoto and producer Toshio Okada – weren't interested in making money, they were true anime fans.

The roots of *Royal Space Force* lead back to a pair of short films created for the Nihon SF Taikai science fiction convention (nicknamed DAICON) by a group of fan animators who had come together while studying at the Osaka University of Arts. These short films, now popularly known as the *DAICON III* and *IV Opening Animations*, were dazzling celebrations of fandom, lovingly crafted and featuring a heady collage of references to films and franchises ranging from *Star Wars* and *Space Battleship Yamato* to *Godzilla* and *Star Trek*. Buoyed by the response to these shorts, both from fans and from within the industry, Yamaga and Okada were given the opportunity to pitch a project to the toy manufacturer Bandai, which at that time was making inroads into anime production.

Their proposal, later developed into a pilot film, was to push the art form forward to cater for a new generation,

heralding a new era of realism in animation that rejected fanciful fantasy in favour of detailed, grounded and believable fictional worlds. Like real fans, they fleshed out *Royal Space Force* lore first: the initial proposal contained more sci-fi world building than distractions such as characters and plot. Yamaga and his team had grand ambitions, and the director remembers that the first point of order was 'utterly breaking the concept of anime within the staff's heads'.

The Icarus-like production story of *Royal Space Force* makes for a great read, and the critic Jonathan Clements has illuminated several of the more outlandish twists and turns in his book *Anime: A History*. Like much of Japanese society in that era, anime was experiencing something of a bubble economy, as investors had their heads turned by a potential new source of income. The rush of interest, helped in no small part by the booming home video market and the success of feature films like *Nausicaä*

Above: Wings at the speed of sound. *Royal Space Force* offers an alternate, sci-fi vision of the space race.

Opposite top: First man. Shirotsugh Lhadatt is far from a heroic protagonist, subverting the typical astronaut narrative.

Opposite bottom: The devil's in the details. The young team behind Royal Space Force prioritized realistic detail over everything else – even budget.

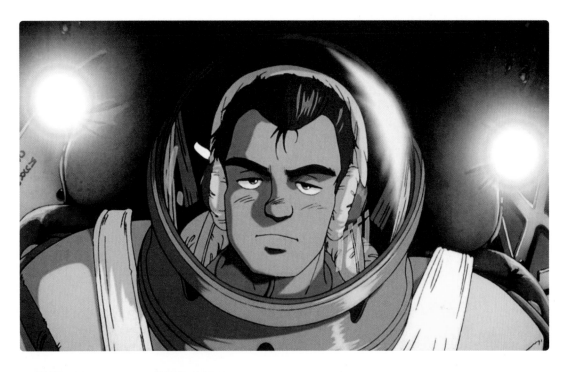

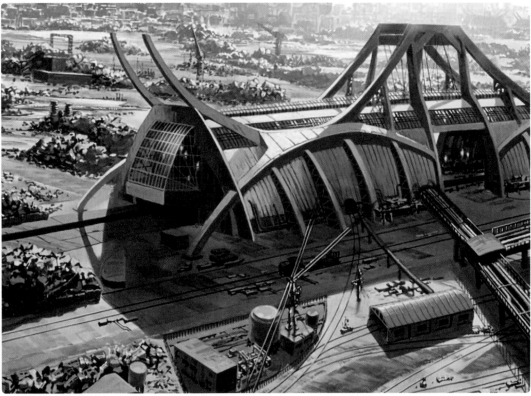

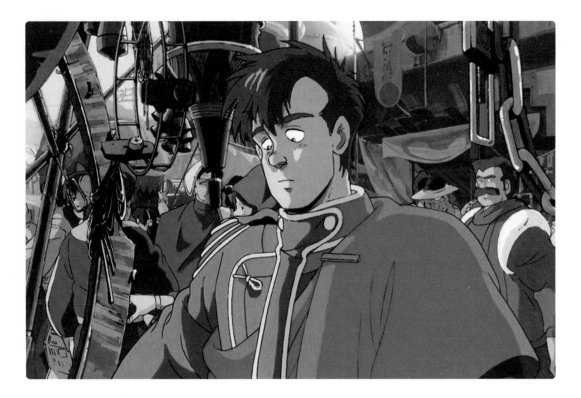

of the Valley of the Wind, no doubt contributed to how *Royal Space Force* turned from a low-budget, 20 million yen, straight-to-video fan project into a feature film with insurmountable production and marketing costs of 800 million yen – and, crucially, very little merchandise tie-in potential for backers Bandai. Clements recounts how the studios behind the release sought to minimize risk at the last minute by pushing the film closer to established successes, giving the film a new subtitle, *The Wings of Honnêamise*, and a poster campaign that suggested the film was riddled with monstrous alien invaders.

Royal Space Force did not set the box office alight in Japan, even after a hype-building pre-release premiere at the legendary Mann's Chinese Theatre in Hollywood. However, it eventually earned its budget back through video sales. And while the experience nearly bankrupted Gainax and broke its staff, they soon rallied together, finding success with series such as *Neon Genesis Evangelion*. The film now stands as a watershed moment in anime, when a new, untested generation were inexplicably given the freedom and budget to realize their vision. Or, to quote Yamaga, reflecting on the production from the safety of 2007, 'it was like we all were swinging swords with our eyes blindfolded.'

Above: The creative team's design ambitions even went as far as covering the unique styles of Honnêamise fashion.

Opposite: Eyebrow raising. *Royal Space Force's* collection of complex characters sport some distinctive names, such as chief engineer Gnomm.

FURTHER VIEWING

Following the release of *Royal Space Force*, Gainax built a reputation as one of anime's great studios. Their biggest money-spinner was *Neon Genesis Evangelion*, Hideaki Anno's complex and convoluted mega-franchise, but that's just the tip of the iceberg, from the cyberpunk adventure *Appleseed* to the fan-service-filled 'Top Gun in space' romp *Gunbuster*. The proto-Gainax fan animations created for *Daicon III* and *IV* still pack a punch over 40 years on, while 1991's *Otaku no Video*, a fictionalized retelling of the studio's early beginnings, is a fun exercise in affectionate self-parody, charting the struggle of the humble super-fan in a world that simply doesn't care.

REVIEW – ROYAL SPACE FORCE

Within each frame of *Royal Space Force* is the spirit of enterprising young men pushing a form into new creative frontiers previously unexplored, and doing so with wild confidence and unbridled imagination. Spending two hours in the film's setting of the Kingdom of Honnêamise doesn't feel like getting a postcard: it's a brief but entirely sweeping migration to a new planet as richly detailed as our own. You'll come back, but you're never the same.

Unlike most space films before or since, there's far less nationalist pride, military backslapping or colonial conquering. Having failed his exams, lead character (but certainly not hero) Shirotsugh Lhadatt shows he has the wrong stuff, and in Honnêamise that means he's relegated to the Space Force – a ramshackle governmental footnote, whose name was already a joke long before Donald Trump. After declaring that he'll become the first ever astronaut, Lhadatt spins through the familiar centrifuges, media circuses and computer tests of cinema missions past, but the film holds an intriguing question mark over him and his actions throughout.

Early in the film Lhadatt meets Riquinni, a meek female preacher, and becomes infatuated. It's she who suggests that space travel could unite their warring planet, an epiphany that sends Lhadatt on his journey from slacker to spaceman, and one that binds him to faith and Riquinni. Similarly to Robert Zemeckis's *Contact* (1997), Royal Space Force navigates science and faith on a starry canvas, offering debate and intrigue for the converted of either side. Questioning the traditional astro-hero narrative, Lhadatt's divine pursuit incites warmongering, assassination, expenditure and media focus (as well as some convoluted battle planning), at a time when the homeless sleep outside Space Force, on its steps. In a moment of disillusionment he sexually assaults Riquinni, before re-emerging as an interstellar figurehead – a moment that certainly highlights his grey morality but, as was far too common in anime at the time, does so via an act that only rewards the perpetrator.

The world that Lhadatt inhabits has a far stronger

gravitational pull than the man himself, though. Coloured in rich autumnal shades with deep shadows, recalling Soviet space race propaganda, Honnêamise is so vividly captured it's hard not to pause the film just to scan every millimetre. Distinctly round televisions and cameras, metal matchstick currency, extravagantly collared tailoring and beautiful neon lettering in a bespoke language, all layer up the generously constructed world. Scratchy archive footage, news broadcasts and holy books colour in the society and its culture, until the setting becomes a more intriguing hook than the narrative itself.

Complementing the film throughout is Ryuichi Sakamoto's enchanting score, which glides through styles and emotion with elegance and surprise. Traversing regal ceremonial bombast and the lilting introspection that comes from staring too long at the night sky. Baroque choruses mesh with harpsichords and quivering synths, giving this fictional tale a feeling of classical weight and sci-fi intrigue.

Watching Royal Space Force feels like seeing a historical document that's slipped through from a parallel universe; and one that became a giant leap for anime.

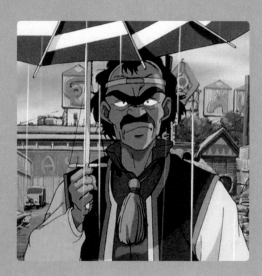

AKIRA

アキラ

ANIME... IS ABOUT TO EXPLODE

In the post-apocalyptic future of 2019, two teenagers adrift in the streets of Neo-Tokyo become embroiled in a top-secret government project to give humans destructive telekinetic powers. When Tetsuo is captured and subjected to experiments by the military, it is up to his friend Kaneda to rescue him – and uncover the truth about the mysterious 'Akira'.

1988

DIRECTOR: KATSUHIRO OTOMO

124 MINS

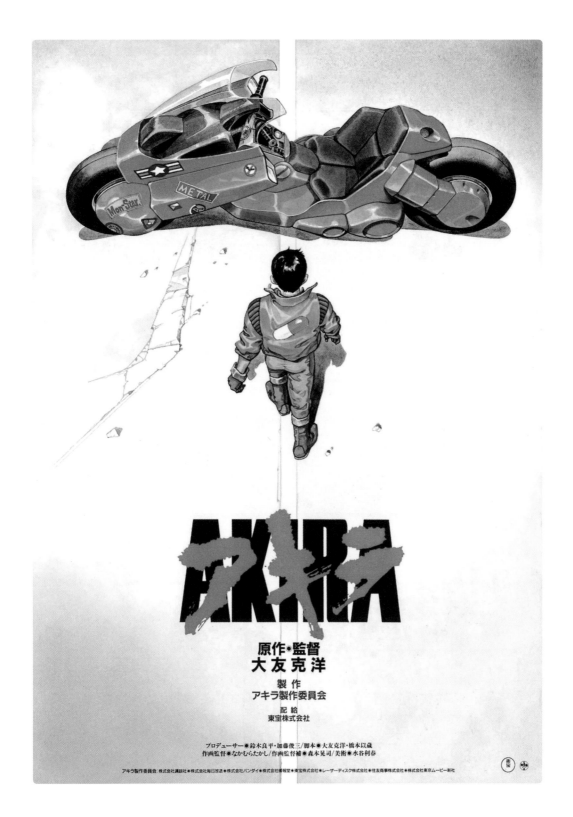

原作・監督
大友克洋

製　作
アキラ製作委員会

配　給
東宝株式会社

プロデューサー◉鈴木良平・加藤俊三／脚本◉大友克洋・橋本以蔵
作画監督◉なかむらたかし／作画監督補◉森本晃司／美術◉水谷利春

アキラ製作委員会：株式会社講談社●株式会社毎日放送●株式会社バンダイ●株式会社博報堂●東宝株式会社●レーザーディスク株式会社●住友商事株式会社●株式会社東京ムービー新社

If you know the word 'anime', it's highly likely that you've heard of *Akira*. Alongside the likes of *Ghost in the Shell* and *Spirited Away*, it is one of the few anime features that approaches household-name status – at least in movie-geek households – and for anime fans of a certain generation, it was their gateway into a vibrant world.

Akira has a towering reputation, not just in anime, but in the art of animation, the genre of post-apocalyptic science fiction, and the history of global film distribution. It's easy to forget now, with access to anime easier than ever thanks to specialist distributors and streamers, just how much of an impact *Akira* had on the perception of Japanese animation in the English-speaking world.

In 1994, a half-hour BBC documentary special, *Manga!*, sought to examine the 'boom' in anime in the UK following *Akira*'s release at the end of previous decade. Host Jonathan Ross made sure to highlight one filmmaker who was working in a different mould, one who was, in his words, 'surprisingly little-known outside of Japan'. That was Hayao Miyazaki, but the star interview on the programme was *Akira* creator, artist and director Katsuhiro Otomo.

Born in 1954, Katsuhiro Otomo grew up in Miyagi Prefecture in north-east Japan. As a teenager, he moved

to Tokyo to pursue a career in manga and was inspired by the bustling metropolis and the millions of people and potential stories that now surrounded him. In his manga work, Otomo developed a distinctive and impactful art style inspired by French master Jean 'Moebius' Giraud – with realistic character designs and intricately detailed, almost draughtsman-like settings and backgrounds.

His rise to prominence is seen as a generation-defining watershed moment in manga circles – especially once he picked up the Nihon SF Taisho Award for his paranormal sci-fi series, *Domu*, in 1983, the first manga to do so. His next long-form series, *Akira*, also drew from communities and subcultures he observed in Tokyo, and he explained to the BBC that he saw 'the ambience, student demonstrations, bikers, political movements, gangsters [and] homeless youth'.

Akira ran from 1982 to 1990 in *Young Magazine*, eventually spanning over 2,000 pages, but partway

Below: Katsuhiro Otomo was inspired by the gangs of disaffected youth he saw roaming the streets of 1980s Tokyo.

Opposite: The face that sold a million tapes: this iconic artwork graced the first UK home video release of *Akira*.

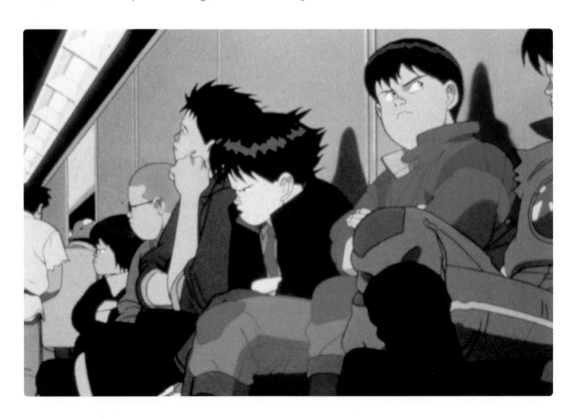

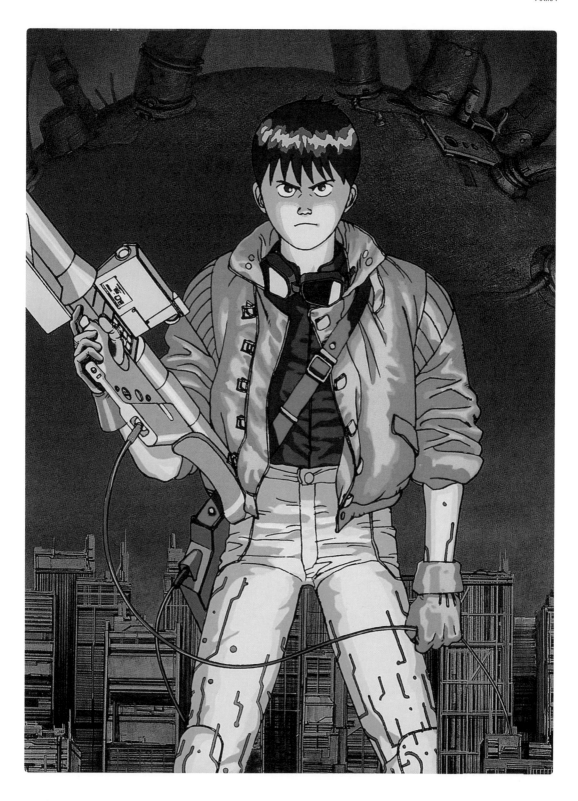

FURTHER VIEWING ⦿

Unlike many of the filmmakers discussed in this book, Katsuhiro Otomo effectively retreated from directing feature animation after the release of *Akira* in 1988. Instead, he directed the live-action comedy-horror *World Apartment Horror*, which is perhaps best known today for those he collaborated with, both at the start of what would become illustrious careers: co-screenwriter Keiko Nobumoto (*Cowboy Bebop*), working from a story by Satoshi Kon.

For well over a decade, Otomo's involvement in anime was primarily as screenwriter (*Roujin Z*, *Metropolis*), a 'supervisor' (*Spriggan*), or, as with the uneven but sometimes brilliant anthology film *Memories*, a mix of co-director, screenwriter and head honcho. Ironically, the undisputed highlight of *Memories* is the segment that bears the least of his influence: the beguiling *Magnetic Rose*, written and designed by Kon and directed by Kōji Morimoto.

The reason for this relative silence became clear in 2004 with the release of Otomo's steampunk adventure *Steamboy*, a high-budget, much-hyped feature 10 years in the making. Neither a hit nor a cult favourite, *Steamboy* is still intriguing, if only for Otomo's exotic, sci-fi-tinged anime vision of Industrial Revolution-era London and Manchester.

Above: Drenched in neon, Otomo's near-future dystopian city, Neo-Tokyo, is just as iconic as those seen in *Blade Runner* and *Metropolis*.

through the series publication, the offer arose to adapt it into a film. The 'Akira Committee' was formed as several companies (including toymakers Bandai, distributor Toho and Kodansha, Otomo's publisher) banded together to back the film, which would become the most expensive anime of all time (until Hayao Miyazaki's *Kiki's Delivery Service* overtook it). A clutch of studios collaborated with production company Tokyo Movie Shinsha on the animation itself, under Otomo's supervision and direction.

Otomo had already worked on a number of anime projects, including the anthology films *Robot Carnival* and *Neo Tokyo*, but this was his first time directing a feature film and he wanted to make it count. An incredible number of drawings – reportedly over 150,000 cels (sheets of celluloid that are drawn on in the production of animation) – were created to provide an eye-popping fluidity of animation, with extra effort invested into syncing mouth movements of characters with dialogue pre-recorded by the cast. Then, the finished artwork was photographed on 70mm film to best capture all the detail of Otomo's intricately hand-drawn, post-apocalyptic megalopolis of Neo-Tokyo. With these and other experiments and innovations in colour, sound, photography and computer animation, it's no surprise that the budget was so high; some animators took to adding their own graffiti to Otomo's art-strewn slums – protesting Otomo's obsession with detail.

Released in July 1988, *Akira* was a modest success at the Japanese box office, failing to land in the top 10 highest-grossing releases of the year. However, like another landmark anime release of 1988 – Miyazaki's *My Neighbour Totoro* – *Akira* would endure, both at home and abroad. What was cutting-edge and

extravagant in 1988 has remained remarkably future-proof, with every re-release on new home video formats from DVD and Blu-ray to 4K dazzling viewers anew (although, as fans of the cult TV show *Spaced* would tell you, it's worth seeing on the big screen – especially in IMAX).

The impact of *Akira* could – and, indeed, has – filled a book in its own right. Generations of writers, comic artists, animators, filmmakers and video game designers have grown up in its shadow of influence, while many of the artists who helped Otomo achieve his vision went on to long careers in animation, such as Hiroyuki Morita (director of *The Cat Returns*), Kōji Morimoto (*The Animatrix, Mind Game*), Toshiyuki Inoue (animation director of *Millennium Actress*) and Makiko Futaki, the veteran artist who became one of Hayao Miyazaki's most trusted key animators.

Internationally, *Akira* broke through on a scale never before seen. In the USA, it played on the midnight movie circuit and on college campuses. As it opened in New York cinemas in October 1990, *New York Times* critic Janet Maslin praised the film as 'a phenomenal work of animation with all the hallmarks of an instant cult classic'. An art-house release in the UK in January 1991 by the Institute of Contemporary Arts was followed by an unprecedentedly successful home video release by a subsidiary of Island Records, soon shifting 70,000 copies. Sensing a sea change, Island's Andy Frain founded a new label that would specialize in Japanese animation – named somewhat confusingly after Japanese comics rather than film – Manga Entertainment, with the ambition of bringing more films over from Japan to build on *Akira's* crossover success.

AKIRA BIKE

Reputedly inspired by both the light cycles of *Tron* and the Harley Davidson of *Easy Rider*, Kaneda's futuristic motorbike has surpassed all competition to become *the* quintessential on-screen dream vehicle. It's no surprise, then, that it crops up in the overstuffed movie-geek Easter Egg hunt of *Ready Player One*, racing alongside Speed Racer's Mach 5, the 1966 Batmobile and the Delorean from *Back to the Future*. Meanwhile, a moment in the film where Kaneda skids the bike to a standstill seems to have become a

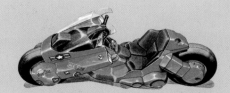

popular shot to homage among younger generations of animators. Look out for possible contenders in *The Lego Ninjago Movie, Steven Universe: The Movie, Keep Your Hands Off Eizouken!, Star Wars: Clone Wars, Batman: The Animated Series*, and even Aardman's British kids' TV staple, *Morph*.

If there's one film in this book to see in a cinema, make it *Akira*. Once you do, you'll be going back to visit dystopian Neo-Tokyo on the big screen every time you can. *Akira* is anime at its biggest, loudest and most powerful. On first viewing, Katsuhiro Otomo's grungy neon future of architectural excess, violent biker gangs and razing psychokinesis is an overwhelming experience. No matter how many times you watch it it's still going to be that, but with each viewing a new automotive miracle, glowing window pane or balletic background character movement will reveal itself. Neo-Tokyo's cybernetic carnage hooks you, but the waves of detail and intricate craft are what will keep you returning to the rubble.

The central story of Tetsuo and Kaneda – orphaned boyhood allies, failed and exploited by their government and, respectively, turned into an omnipotent humanoid weapon and humanity's defence – is a tyre-screeching, whiplash-inducing rush. Their exhilarating ride from bratty bikers to rivals on a cataclysmic front line is relentless, speeding through several volumes of the manga to get to its spectacular finale.

Despite the mayhem, the world that contains them is so exquisitely crafted that their extreme experiences don't feel alien – they're totally at home within the film's all-encompassing, nightmarish urban vision. Neo-Tokyo is an imposing, brooding, breathing force that rumbles beneath every moment of *Akira*. Part city, part fortress, its enormous walls and endlessly overlapping skyscrapers almost brick up the outside world and ask if its inhabitants are at home or in prison.

The sky-blocking towers reflect the economic boom and excess of the 1980s, and endless pipes wriggle above ground in Neo-Tokyo, latticing the city, its dirty and ugly veins now varicose. Akira himself, an atomically psychic being who levelled the original Tokyo in a mushroom cloud of destruction, is buried far below the building site of a new Olympic stadium, the scars and lessons of the past buried and forgotten beneath a superficial symbol of international affluence.

Injecting life, light and rebellion come Kaneda and his gang of two-wheeled terrors, who tear around their concrete environment with vigour and chaos, almost willing crashes to happen in the hope of destroying a small part of the city. The headlights of their bikes leave trails of light, as if their world can't keep up with them. The fluidity of the animation as the bikers careen around is astonishing, tarmac disappearing beneath their tyres, they dance between cars, play elegantly smooth but frighteningly

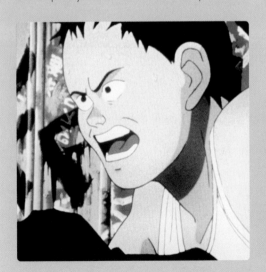

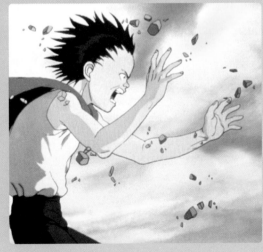

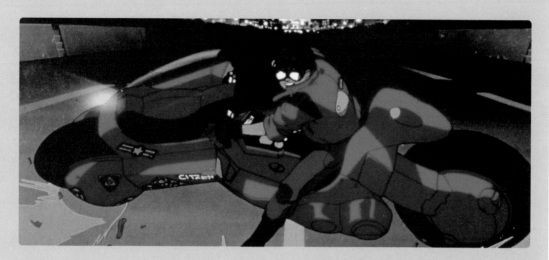

violent polo with rival gangs' faces and smash through panes of restaurant glass, offering swanky diners some sharp seasoning. Each drifting corner, teeth-shattering wallop and skin-slicing shard is felt.

Through the painstakingly smooth animation, Otomo and his team create a stomach-lurching, white-knuckle Neo-Tokyo tour that gives Kaneda and Co's heightened, futuristic experience impressive tactility. After connecting audiences to the landscape through recognizable sensations of speed and pain, when the film has to stretch familiar anatomy – such as when Tetsuo mutates into a giant, biomechanical, explosive tumour – the detailed animation, sleekly binding metal and muscle, manages to make the fantastical physical and this turbocharged dystopia palpably real.

Accompanying the blitz of neon, concrete and fumes is the film's score, which pounds along with an unrelenting drive and gives the heaving city a pulse. Created by Geinoh Yamashirogumi, a musical collective founded by artist and scientist Tsutomu Ōhashi, the score is an intense mixture of sci-fi synths entwined with precise, repeating traditional Asian percussion and breathy choral voices. As well as further enhancing the swelling corporeal nature of

Neo-Tokyo, the contrasting sounds, and the eras they come from, give the film a surprising, almost biblical, patina, signalling that although set in the future, this techno parable is timeless.

In bypassing a huge amount of the manga's plot, *Akira* can at times feel rushed, but the breakneck pacing feels aligned to the way the characters live their lives. Tetsuo, Kaneda and their friends are constantly mobile, never seen at home, and they're most comfortable when aggressively patrolling the streets, rebelling against a government that doomed them. Their roaring belligerence is contrasted with a group of unnervingly serene but supremely psychically powered beings (who have the bodies of children but skeletal eyes and sagging blue skin) who are the only youths seen in domesticity, but even that home is revealed to be a disquieting holding cell. Whether through destruction or stasis, Neo-Tokyo is a place where the homely innocence of youth simply cannot exist.

While Tetsuo's metamorphosis makes for a gruelling and gripping finale, the villain here is the system that formed him, where power-hungry politicians revolve in a circle of violence, abandoning, weaponizing and destroying the very people they should be supporting. While thematic richness and even more detailing of Neo-Tokyo can be found in Otomo's manga, the film *Akira* makes for a beautiful, charged and fiercely concentrated hit, crashing through your screen and leaving you begging for another lap.

Opposite: Not all heroes wear capes, sometimes villains like Tetsuo (if you can really call him a villain) do so too.

Above: Easy rider. Kaneda skids to a halt in what is one of *Akira's* most effective and widely referenced shots.

ROUJIN Z

老人Z

AGE AGAINST THE MACHINE

An enhanced robotic hospital bed dubbed the Z-001 is set to revolutionize healthcare with all-purpose support tailored to the needs of the patient. An 87-year-old man is used as the machine's first test subject – with unexpected, and destructive, results.

1991
DIRECTOR: HIROYUKI KITAKUBO
84 MINS

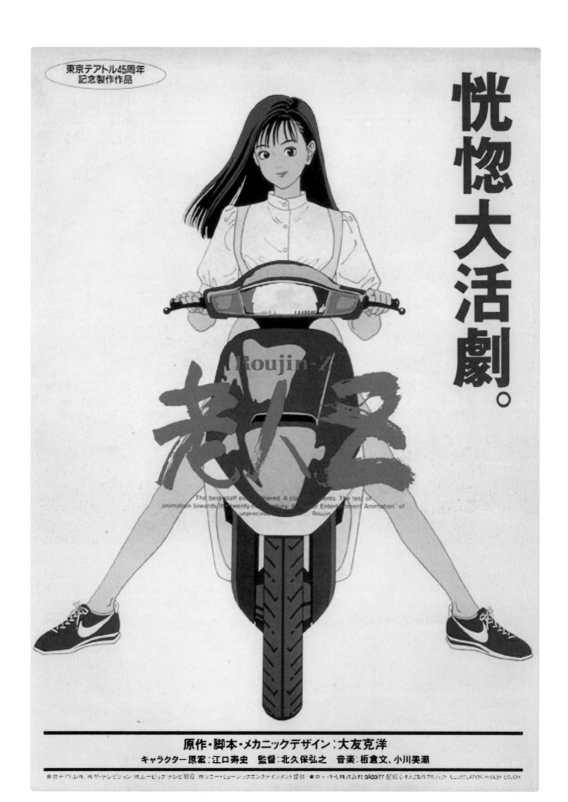

'From the director of the cult classic *Akira*' screams the 1994 English-language Manga UK VHS release of *Roujin Z*. While certainly accurate, the billing, and its accompanying cover graphic of a frail old man enveloped in a gigantic robotic machine, does little to prepare viewers for what is an unlikely follow-up to Katsuhiro Otomo's 1988 cyberpunk epic. For one, Otomo did not direct *Roujin Z*, instead providing screenplay and mech designs, preferring to sink his energies into directing the live-action project *World Apartment Horror*. Additionally, the film sees a swing away from the spectacular teen-rebellion future shock of *Akira*, in favour of a more thoughtful social satire on how a high-tech society like Japan will address an inevitable near-future problem of older-age demographics outnumbering the young.

With Otomo away in the live-action realm, the job of directing *Roujin Z* fell to Hiroyuki Kitakubo. The veteran animator had made inroads into the industry while still a teenager, proving himself as a key animator on *Urusei Yatsura: Only You*, directed by Mamoru Oshii, and as co-director on the sci-fi anime *Black Magic M-66*, stepping in when the production went over budget and creator Masamune Shirow (*Ghost in the Shell*) was edged out. Kitakubo later directed a segment in the *Robot Carnival* anthology film, alongside one by Otomo, with whom he'd work as key animator on *Akira*.

By contrast, *Roujin Z*'s art director, Satoshi Kon, was far less established. He was at that time a seasoned manga artist, but this was his first foray into anime, no doubt as part of his ongoing relationship with Otomo. It may seem

fanciful to pore over the backgrounds of the film to spot the creative fingerprints of Kon, a filmmaker who would later be lauded for his all-encompassing vision. However, critic Andrew Osmond highlights the grounded, 'lived-in' quality of the locations of *Roujin Z*, noting the aesthetic that Kon would develop in films like *Perfect Blue*, which were rooted in real-world settings before departing into more surreal, dreamlike territory.

Roujin Z was released in Japan in 1991, and would be released in English-speaking territories by Manga Entertainment in 1994, offering an intriguing counterpoint to both *Akira* before it and the incoming *Ghost in the Shell*. Appearing both on screens and on shelves in the United States from 1995, it became one of the more visible anime features of the era. It was also one of the

better-reviewed films, too, with popular critic Roger Ebert spotlighting the release on his TV show *Siskel & Ebert & the Movies* in 1996, and writing in the *Chicago Sun-Times* 'a film like *Roujin-Z* shows how animation can liberate filmmakers to deal with themes that would be impossible in a conventional movie.' And yet, even in the world of animation, *Roujin Z* still remains a rare gem.

Opposite: Frontline worker. Social satire *Roujin Z* sees an unassuming nurse thrown onto a dangerous technological battleground.

Above: Put your hands together. *Roujin Z*'s ensemble is full of unique and memorable background characters.

FURTHER VIEWING

While there's nothing quite like *Roujin Z* in the annals of anime, the film stands at the centre of a web of genre trends and career trajectories. Katsuhiro Otomo returns to certain themes from his groundbreaking feature *Akira*, specifically the nefarious practice of experimentation on innocent human subjects, and the film anticipates Mamoru Oshii's exploration of the interface between technology and humanity in the *Ghost in the Shell* franchise. Meanwhile, Satoshi

Kon's credit marks his first contributions to the medium he would revolutionize over the ensuing decade, culminating in *Paprika* – another tale of sci-fi gadgetry tapping into characters' deepest desires and dreams, albeit in a much more surreal style. *Roujin Z* director Hiroyuki Kitakubo later helmed the action-horror short *Blood: The Last Vampire*, which became a cult favourite in the English-speaking world during the years when *Buffy the Vampire Slayer* ruled genre television.

ROUJIN Z – REVIEW

Palliative care isn't normally a subject that will excite cinemagoers, but with *Roujin Z*, not only will you care about care, your pulse will be racing so much you'll need a beta blocker. What begins as an intimate, gentle portrait of a nurse and her patient, transforms into a city-razing bout between a weaponized deathbed and the forces of government artillery. *Amour* this is not.

Trapped amid the carnage, strapped into the machine, is Kijuro Takazawa, an 87-year-old man, cared for only by compassionate nurse Haruko. Kidnapped from his home by the sinister Ministry of Public Welfare, the docile Kijuro is aggressively tucked into the latest in-home care technology: the Z-001, a hospital bed that bathes, exercises and cooks for its patient, without the need for a nurse. Presented with all the stage lighting, white surfaces and cockiness of an Apple product launch, the Z-001 is an automated future for the elderly, one that keeps them out of public view.

After connecting to a computer, the Z-001 becomes imbued with the soul of Takazawa's dead wife. The download also installs exciting new updates, which include transforming into a giant robot and (with the help of Haruko and her nursing colleagues) breaking out of hospital. The Z-0001 now drifts around city roads like KITT with a catheter, and a government weapon is sent to destroy it, but no military power matches the might of bickering old people.

Assisting the fight are a group of geriatric computer hackers, thwarting the armed forces and helping our heroes. Patients in Haruko's hospital, these men are clever, complex, rude and surprisingly virile. They're actually people, not passengers to the narrative. The same goes for Takazawa and his reanimated wife: despite being half senile, half robot, their relationship has the strength and character to defeat anything. There are no romantic borders between physical and virtual, flesh or mechanical. The film's thick, black outlines and hard contrasts initially highlight the sagging skin and deep shadows on skeletal figures, but come the finale, the same colouring shades in the threat and power that comes with old age.

Alongside all of the mechanical chaos is Haruko and her colleagues, whose dedication to care work is unfaltering, from cleaning up wet beds to orchestrating prison escapes: theirs is a dedication with the power of any mecha. The Z-001's significant but destructive automatic abilities underlines how essential human care workers are – a point no audiences should need reminding of post-COVID, and something *Roujin Z* has hardwired.

Opposite: Totally wired. *Roujin Z*'s geriatic protagonist finds himself the subject of a futuristic government experiment.

Below: Appetite for destruction. While *Roujin Z* has its quieter, personal moments, it still delivers detailed mecha-style devastation.

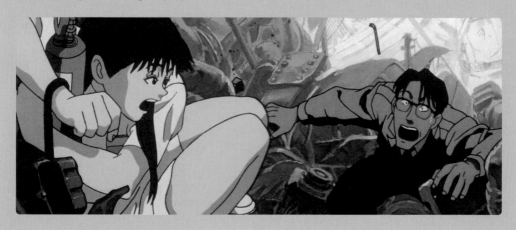

NINJA SCROLL

獣兵衛忍風帖

A TIME OF DANGER, INTRIGUE AND DECEPTION

In feudal Japan, a wandering ninja becomes embroiled in a mounting war between hostile clans, and must face eight demonic foes, each with monstrous supernatural powers, to prevent an old foe from seizing power.

1993

DIRECTOR: YOSHIAKI KAWAJIRI

99 MINS

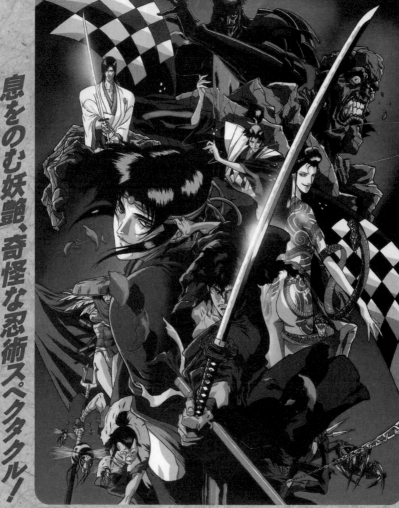

「妖獣都市」の鬼才・川尻善昭が描くノンストップ・アクション!

息をのむ妖艶、奇怪な忍術スペクタクル!

孤高のアウトロー忍者を待ち受ける壮絶なバトル!

じゅうべえにんぷうちょう

獣兵衛忍風帖

東京国際映画祭協賛企画
ゆうばり国際冒険・ファンタスティック映画祭'93　ゆうばり市民賞受賞作品

原作・脚本・監督・キャラクター原案:川尻善昭

キャラクターデザイン・作画監督:寺田 克也／美術監督:小倉宏昌／撮影監督:山口 仁／音響監督:本田保則／音楽:和田 薫／サントラ盤:東芝EMI・TMファクトリー／主題歌:「誰もが過ぎてゆくバラードを聴いている」山梨勝平(東芝EMI・TMファクトリー)

製作協力:マッドハウス／製作:アニメイトフィルム

「声の出演」山寺宏一／篠原恵美／青野武／郷里大輔／関 俊彦／森山周一郎 ほか

配給:東京テアトル　配給協力:日本ビクター　製作:日本ビクター・東宝・ムービック

Ⓒ1991 川尻善昭・マッドハウス・日本ビクター・東宝・ムービック

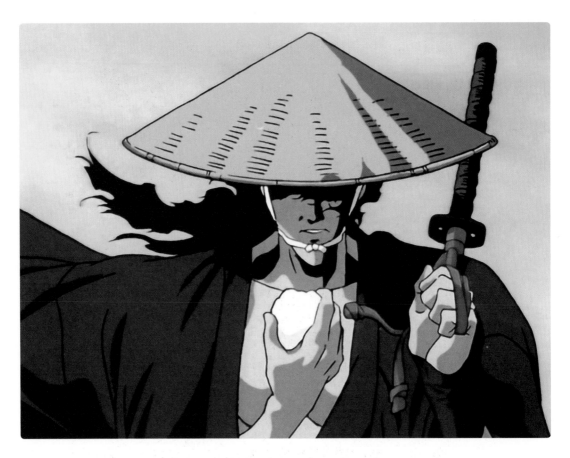

A perennial favourite on home video in the UK, *Ninja Scroll* was one of the breakout hits of the wave of releases that followed in the wake of the release of *Akira*, as the newly formed company Manga Entertainment sought more stylish genre thrills to dazzle English-speaking audiences. Many of these were produced by the studio Madhouse, and a fair few were directed by one of their co-founders, the influential animator Yoshiaki Kawajiri, including *Cyber City Oedo 808*, *A Wind Called Amnesia* and the violent, controversial *Wicked City*.

Born in 1950, Kawajiri dreamed of becoming a manga artist, and initially entered the growing Japanese animation industry as a way of earning a living and sharpening his skills as an illustrator, but the decision led to a lifelong career in anime. He graduated from university just in time to catch the tail end of the life of Osamu Tezuka's Mushi Production, contributing in-between animation to *Cleopatra*, the second half of Tezuka and Eiichi Yamamoto's *Animerama* double bill, and working his way up to key animator for the influential boxing series

Tomorrow's Joe. In 1972, as Mushi Production neared bankruptcy, Kawajiri jumped ship with colleagues Rintaro, Masao Maruyama and Osamu Dezaki to form Madhouse, a studio that would have an incalculable impact on the anime industry over the subsequent decades.

Kawajiri worked consistently as an animator, on Madhouse projects such as war drama *Barefoot Gen* and even on the odd freelance gig, including contributing to Hayao Miyazaki's series *Future Boy Conan*. In the mid-1980s, he turned his hand to directing, and points to 1987's *Wicked City*, a fantasy horror adapted from the work of writer Hideyuki Kikuchi, as his creative breakthrough, the point where he found his feet as a uniquely visceral visual storyteller. He would later return to Kikuchi's work with the 1999 film *Vampire Hunter D: Bloodlust*, but first he wanted to create something original.

Ninja Scroll married the dark and violent tones of *Wicked City* with Kawajiri's love of the novels of writer Futaro Yamada, whose writing encompassed detective

fiction, mysteries and supernatural ninja adventures. The result was a spectacular tale of intrigue, a showcase for hand-drawn animation that was rich in detail and full of distinctive and grotesque characters. Like *Wicked City* before it, *Ninja Scroll* featured scenes of sexual violence that were cut by the British Board of Film Classification in order to achieve its highest rating of 18: something that only further added to Manga Entertainment's branding of anime as forbidden fruit. Reinstated for later anniversary releases, these scenes feel in keeping with the grim, unseemly, exaggerated world of *Ninja Scroll* – but even its makers, on a retrospective director's commentary track, wondered if they were entirely necessary.

Opposite: Fistful of rice. *Ninja Scroll's* Jubei joins the many ranks of lone, outnumbered anti-heroes fighting for survival.

Below: *Ninja Scroll's* ultra-violent sequences made the film a strictly adults-only affair, and resulted in cuts from the BBFC.

FURTHER VIEWING

The international success of *Ninja Scroll* put Kawajiri high on the list of collaborators sought by the Wachowskis when they were developing what became *The Animatrix*. Kawajiri wrote and directed the short *Program* for that anthology series, and wrote the episode *World Record* for one of his protégés, Takeshi Koike, to direct. This implied passing of the baton continued with Koike's feature debut, *Redline*, another dazzling and hyper-stylized Madhouse production, for which Kawajiri contributed key animation. Even today, Kawajiri's fingerprints can be found on spectacular, action-packed anime series, with storyboard credits on episodes of popular shows ranging from *Attack on Titan* to *Demon Slayer: Kimetsu no Yaiba*.

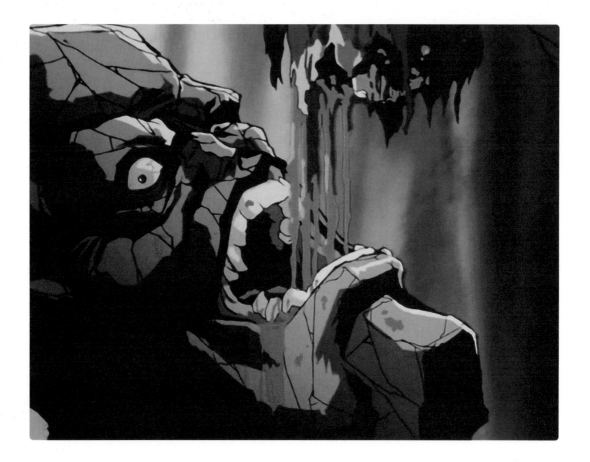

NINJA SCROLL – REVIEW

In the opening minutes of *Ninja Scroll*, there are grisly murders, a violent thunderstorm and an unforgiving, gruesome plague. After that, it gets dark. It's the story of Jubei, a ninja who slices his way through eight ludicrous and uniquely skilled enemies, aided by Kagero, a woman with deadly poison in her veins and a blade to match. With brilliantly inventive character designs, and thrilling staging, the film is a compelling and violent ninja tale, but for all its sharp action it doesn't always hit the target.

The story is both simple and complicated. The most exciting parts of the film are the bouts between Jubei,

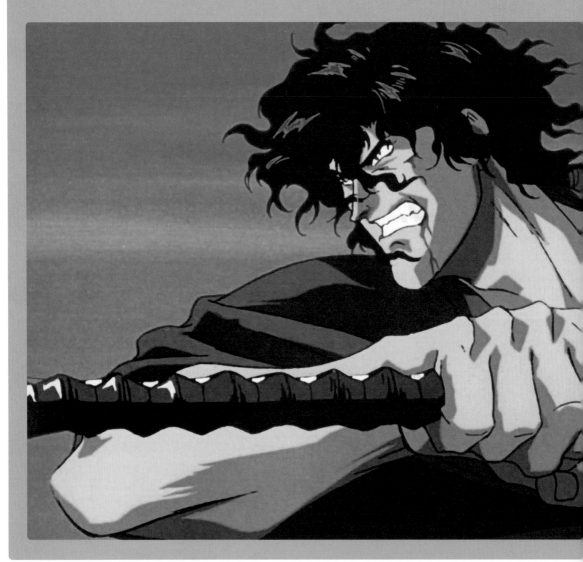

Kagero and the stream of superpowered adversaries in front of them. In between comes some information about warring factions, apparent justification for poisoning entire towns and a lot of chat about revenge. It's like playing a video game: all the challenges are laid out at the start, with a teasingly revealed final boss at the end, and in between levels come some expository cutscenes that might hold your attention.

Steeped in shadow and dripping in (and at one point even raining) blood, the vivid animation is characterized by its high contrasts and explosive violence. The heroic ninjas have handsome, elegant forms, with cheekbones and chins as subtle as their swords, but in contrast, we see emerging from the gulfs of black that fill the screen a rogues' gallery of horrific inventions. One enemy is gouged down the back, only for their body to be creepily revealed as a snakeskin shell; another, with a wasp hive for a hunchback, drowns, turning a river red while being stung from the inside out. Always escalating, the final fight, conducted in a sinking ship that's on fire and filled with sloshing molten gold, sees bodies sliced up like meat at the deli.

Unfortunately, between the strobe flashes of swords, there is some undeniably cruel and sexist treatment of the film's leading female character. Kagero's journey is heroic and arguably empowering, as she climbs from a subordinate role testing poisons to becoming a powerful warrior. However, she's subjected to extreme, unnecessary acts of protracted sexual violence, explicitly detailed on screen. There's sparing recognition of the trauma these events can create, and they ultimately build up Kagero as a character able to serve Jubei, rather than herself.

With its stylistic influence and cultural impact, *Ninja Scroll*'s legacy is still felt today. It earned its place in the history books, but some of it deserves to stay in the past.

Left: Flying off the handle. Jubei's speed and accuracy with his blade lead to some ferociously staged battle sequences.

Above: For all its style and impact, *Ninja Scroll's* grim scenes of sexualized violence should perhaps be put to the sword.

GHOST IN THE SHELL

攻殻機動隊

ANIME 2.0

Major Motoko Kusanagi, a cyborg officer of the counter-cyberterrorist squad Public Security Section 9, is assigned to track down a mysterious hacker called the Puppet Master, who has been 'ghost hacking' the cybernetic brains of citizens in 2029 Tokyo.

1995

DIRECTOR: MAMORU OSHII

82 MINS

世界同時公開決定
この秋、このアニメが
映画を進化させる!!

People love machines in 2029 A.D.
"Who are you? Who slips into my robot body and whispers to my ghost?"

GHOST IN THE SHELL
攻殻機動隊

原作:士郎正宗(講談社『週刊ヤングマガジン』掲載)

監督:押井 守

製作:宮原照夫 渡辺繁 ANDY FRAIN

脚本:伊藤和典 絵コンテ:押井守 演出:西久保利彦 キャラクターデザイン 作画監督:沖浦啓之 作画監督:黄瀬和哉 音楽:川井憲次
アニメーション制作:プロダクションI.G 音楽制作:BMGビクター
製作:講談社 バンダイビジュアル MANGA ENTERTAINMENT 配給:松竹
© 1995 士郎正宗 講談社・バンダイビジュアル・MANGA ENTERTAINMENT

Following the international cult success of *Akira*, the newly formed anime specialist label Manga Entertainment began to drip feed audiences in English-speaking countries with more giddy and grimy genre thrills from Japan, from *Fist of the North Star* to the controversial 'tentacle porn' of *Urotsukidōji: Legend of the Overfiend*. Nothing hit quite like Katsuhiro Otomo's animated epic, though, so label boss Andy Frain decided to invest in a new, spectacular sci-fi project, one that promised to push the medium into the new millennium with cutting-edge technique and speculative, post-human cyberpunk themes: *Ghost in the Shell*.

Adapted from the manga series by Masamune Shirow (*Dominion*, *Appleseed*), *Ghost in the Shell*, fittingly, started its run in *Young Magazine* in 1990, just as the epic *Akira* manga was wrapping up. Shirow gave his blessing to the project, allowing as loose an adaptation as the creative vision required – which was fortunate, since the director of the project was a veteran of the industry who had proved that he had creative vision in spades: Mamoru Oshii.

Oshii was born in 1951 in Tokyo, the son of a private detective who was also an avid cinemagoer. As a kid, Oshii devoured science-fiction novels by English-language authors such as Robert Heinlein, JG Ballard and Theodore Sturgeon, and became obsessed with the work of European filmmakers including Michelangelo Antonioni, Federico Fellini, Jean-Pierre Melville, Ingmar Bergman, Andrei Tarkovsky and Jean-Luc Godard. 'I have always watched and enjoyed European films since I was young,' he told *Midnight Eye*. 'I was always intrigued by the classic styles and old designs of the architecture and atmospheres of Eastern Europe because they are serene, beautiful and nostalgic.' Oshii's love of live-action art cinema later seeped into his animation, as well as the

Above: When *Ghost in the Shell* was released in the UK, this iconic artwork graced its poster and subsequent VHS release.

Opposite: Welcome to the future. *Ghost in the Shell*'s opening scenes make up one of anime's most revered sequences.

FURTHER VIEWING 👁

If you're in the mood for more of *Ghost in the Shell's* brand of philosophical cyberpunk, you are in luck. The 1995 movie spawned a franchise, including the sprawling *Stand Alone Complex* series of TV shows, novels, specials, video games and even a feature film – *Solid State Society*. Director Mamoru Oshii was not involved in *Stand Alone Complex*, but he returned to the *Ghost in the Shell* universe for the standalone sequel, *Innocence*. This was a visually striking, complex and challenging film that premiered at the Cannes Film Festival in 2004. Outside of *Ghost in the Shell*, Oshii has amassed an impressive body of work in both animation and live action, as both director and writer (see: *Jin-Roh*). Of his animated features, *Urusei Yatsura 2: Beautiful Dreamer*, *Angel's Egg* and *Patlabor 2: The Movie* remain the cornerstones of his reputation as a filmmaker who could equally dazzle and divide audiences.

many live-action projects he squeezed in, between his anime gigs.

He graduated from Tokyo Gakugei University with a degree in arts education but found himself attracted to the world of animation, joining Tatsunoko Productions as a storyboard artist in the mid-1970s before moving to Studio Pierrot in 1980. There, Oshii rose through the ranks and had his first taste of mainstream success as a director with the anime adaptation of Rumiko Takahashi's popular manga *Urusei Yatsura*. Oshii also directed two feature-length spin-offs, *Only You* and *Beautiful Dreamer*, which he used as a playground for his developing voice and vision. In particular, *Beautiful Dreamer* traded in much of the series' trademark romantic comedy hijinks in favour of a convoluted time-loop plot and digressions into exploring more philosophical themes. Eventually embraced by some directors (such as *Cowboy Bebop* creator Shinichirō Watanabe) as a horizon-expanding classic, the stylistic shift angered many hardcore fans of the series.

Developing a reputation as something of an iconoclast, Oshii later cooked up an idea for a feature film in the *Lupin III* franchise – the first since Hayao Miyazaki's *Lupin III: The Castle of Cagliostro* – but his concept was deemed so outlandish by the producers that the project was junked. Instead, he went independent and created the beguiling (or simply bewildering) art-house anime *Angel's Egg* in collaboration with artist Yoshitaka Amano, whose designs later set the tone for the long-running *Final Fantasy* video game series. Also around this time, Oshii was in talks with Hayao Miyazaki and Isao Takahata to direct a

project at their newly founded Studio Ghibli, but we can only dream about what this potential collaboration could have produced as the partnership between these three strong personalities fell apart in the early planning stages.

But *Patlabor* – the influential TV series, OVA (original video animation) specials and feature films from 1989 onwards – was a major turning point in Oshii's career, where he combined his aspirations to explore philosophical, historical and political themes in a familiar genre framework, in this case 'mecha' giant robots, with successful results. It's off the back of the success of 1993's *Patlabor 2: The Movie* that Oshii was offered the reins of *Ghost in the Shell* by the suits at Bandai Visual.

Like *Akira* before it, *Ghost in the Shell* was partly promoted based on its generous budget, positioned as a no-expense-spared, boundary-pushing production that combined hand-drawn animation with new technology – perfectly suiting the film's futuristic outlook. Traditional techniques were blended with 3DCG processes (created by a crew including animation supervisor and character designer Hiroyuki Okiura) to achieve what Oshii envisioned as a detailed, photorealistic depiction of the future, complete with the ability to showcase visual effects, cinematography and camerawork previously only possible in live action. The nonlinear digital editing platform Avid was also used, pushing *Ghost in the Shell*'s production away from the analogue and towards the digital.

Manga Entertainment had supplied roughly 30 per cent of the budget, and were hoping for a hit. Following a world premiere at the Tokyo International Film Festival in October 1995, and a domestic release soon after, *Ghost in the Shell* premiered at the London Film Festival in November, with a general release in December. The Manga Entertainment English-language dub of the film featured a piece of music over its end credits by Passengers, a side project between U2 and producer Brian Eno, who were signed to Manga Entertainment's sister company, Island Records. Now a pop-history footnote – and a holdover from a time when such shoehorned tie-ins were crucial parts of the promo game – this curio still remains in dubbed releases of the film today.

Ghost in the Shell didn't perform well in Japan, failing to chart in a year where the domestic box office was topped by Ghibli's *Whisper of the Heart*, but it proved to have a long tail worldwide, selling over a million copies in the USA alone when released on home video. It also had a profound influence on many filmmakers and animators,

including those behind Hollywood's biggest blockbusters.

Tech-noir exponent James Cameron provided a rather hyperbolic testimonial for the film's marketing material, calling it 'a stunning work of speculative fiction, the first truly adult animation film to reach a level of literary and visual excellence', while Dreamworks, the studio co-founded by Steven Spielberg, snapped up the remake rights – with some fans theorising that *Ghost in the Shell* may have influenced the director's shift into darker sci-fi territory at the turn of the new millennium with *A.I. Artificial Intelligence* and *Minority Report*. However, chief of all the blockbusting *Ghost in the Shell* fans were the Wachowski siblings, who used the film when developing and pitching their own innovative cyberpunk epic, *The Matrix*. The story goes that they showed *Ghost in the Shell* to producer Joel Silver and shared their ambition: 'We want to do that for real.'

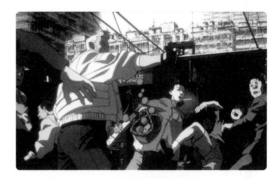

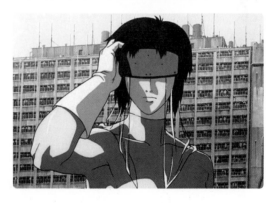

Opposite: Scarred Jo. 2017's *Ghost in the Shell* is the highest-profile Hollywood anime remake to date – and arguably the most contentious.

Above top: The market chase sequence in *Ghost in the Shell* is one of many scenes that inspired the Wachowskis' *The Matrix*.

Above bottom: The future is now. Despite being released in the 1990s, the tech of *Ghost in the Shell* feels extremely modern.

GHOST IN THE SHELL – REVIEW

Watching *Ghost in the Shell*, it's hard not to think of its legacy, beyond the film itself. From its many sequels and spin-offs to the stylistic and narrative impact it had on western filmmakers that arguably reshaped an industry, *Ghost in the Shell*'s coding has been copied far beyond its original source. It's almost become a myth, adapted first from manga, then retold, expanded and remade again. But viewed in isolation, you can see why. For all its cultural impact and attempted clones, *Ghost in the Shell* remains unequalled.

In a spry 82 minutes, Mamoru Oshii's film tackles a huge amount creatively and thematically, its visual inventiveness constantly updating and its philosophical explorations burrowing in the mind long after the credits roll. It's fun to play 'Matrix Bingo' – which starts with a gimme, as a rain of green code descends down the screen – but while the Wachowski's film was at its best in its more explosive moments, despite

its enormous butterfly effect on modern action cinema, *Ghost in the Shell* is a contrastingly quiet film.

Following Motoko Kusanagi, an artificially constructed but mentally human law enforcer, during an investigation into the identity and whereabouts of super hacker the Puppet Master, *Ghost in the Shell* is as much about investigating the self as it is the case in hand. For every awesome leap backwards from a tall building while turning invisible there's an introspective river diving session to uncover the depths of the soul, and it's this balance that makes the film so rich, exciting and inviting to revisit. Dialogue about different sections of law enforcement, governmental espionage and the souls of humanity remaining in cybernetic bodies is almost impenetrable but just graspable enough to propel viewers through the story, and have them return in the hope of understanding more.

For some audiences, however, trying to unravel the lore of a sci-fi world is not as enjoyable as simply exploring that world; and the stand-out sequence from the film offers

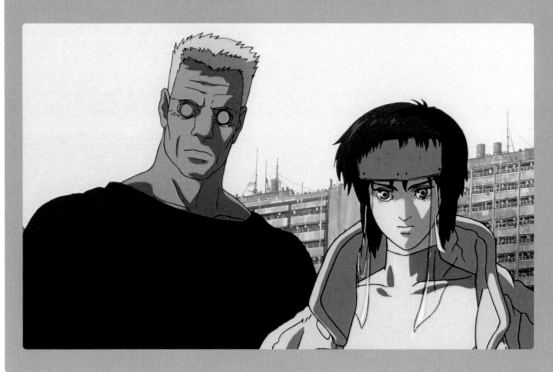

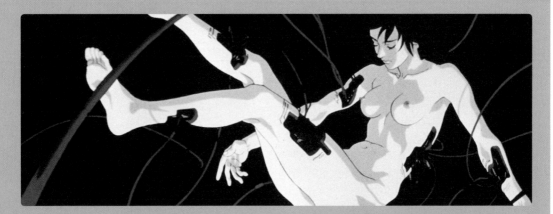

that, with the ultimate futurist postcard. Taking up a nice chunk of what is a fairly short runtime, a third of the way through the film Oshii takes viewers on a tour around the film's grungy urban setting. Observational and voyeuristic, the sequence heightens the sense of paranoia that pervades the film, lingering shots of neon advertisements and tangled cables scorch and strangle the air above the anonymous crowds below. Display mannequins are cut against umbrella-carrying pedestrians, shop windows and puddles of lashing rain, refracting any sense of identity. The sequence interrogates the individuality of humanity while showing off the animator's evocative artistic prowess.

Inside the city's oppressive buildings, alone with herself or her colleagues, Motoko's introspection continues. At home, her wide apartment window rests in the middle of the frame, a glowing screen within our screen, the natural light of the sun tinged with a digital blue glow. It's the same glow that's in Motoko's eyes and the computer screens that surround her, constantly reminding her of her cyber-self like cold, pixelated mirrors. Rather than follow her at all times, she wanders on and off screen, evoking her mazy, mental dislocation. Here, the film keeps her at arm's length and, in other moments, such as when we witness the disquieting tactility of her metallic, yet fleshy, construction, she's uncomfortably, intimately close. The full portrait of Motoko is never clear, because it's never clear for her either.

Accompanying her journey towards the Puppet Master is a superb soundscape and score that flickers with analogue and digital delights. The rattle of bullets

is echoed in the clacking of keyboard keys and, as code tumbles down screens, we're reminded that the battleground of the new century is virtual as well as material, and a smack on the 'enter' key can be as eruptive as a machine gun. Kenji Kawai's classical Japanese choral score initially seems idiosyncratic, but with each appearance its eerie, minimalist construction feels more primal and anxious. Reportedly based on a traditional wedding song, it may initially seem like an odd counterpoint to the film's existential probing, but as Motoko and the Puppet Master get closer its origins make more and more sense, too.

For all its examinations of artificiality and technology, there's a very physical strain of body horror that runs through the film, further blurring the lines between human and computer. Come the end, as we feel synthetic tendons excruciatingly, exquisitely burst, it's hard not to wince. This moment, set in front of a decayed mural of a family tree, installs in the mind. Prophetic at the time, now more like reality, the film sees the genetic ghosts of humanity degrade; and in the foreground, life as a virtual and material hybrid in the painful throes of evolution. Stunningly evocative in its fantastical world-building, remarkably tactile in its execution, *Ghost in the Shell* shows how the most ambitious anime can be wildly transportive but still undeniably present.

Opposite: Cyborg patrol. Major Matoko Kusanagi and the hulking Sergeant Batou of Public Security Section 9.

Above: With its cables that look like veins, *Ghost in the Shell* makes the connection between humans and technology disconcertingly physical.

JIN-ROH: THE WOLF BRIGADE

人狼

A WOLF IN SOLDIER'S CLOTHING

In an alternate history where Japan is ruled by an oppressive totalitarian regime, Kazuki Fuse is an officer in a counterterrorism squad known as the Kerberos Panzer Corps. Following an encounter with a young insurgent, Fuse's worldview is shaken, leading him to pick his way through a web of conspiracies at the heart of the government.

1999
DIRECTOR: HIROYUKI OKIURA
102 MINS

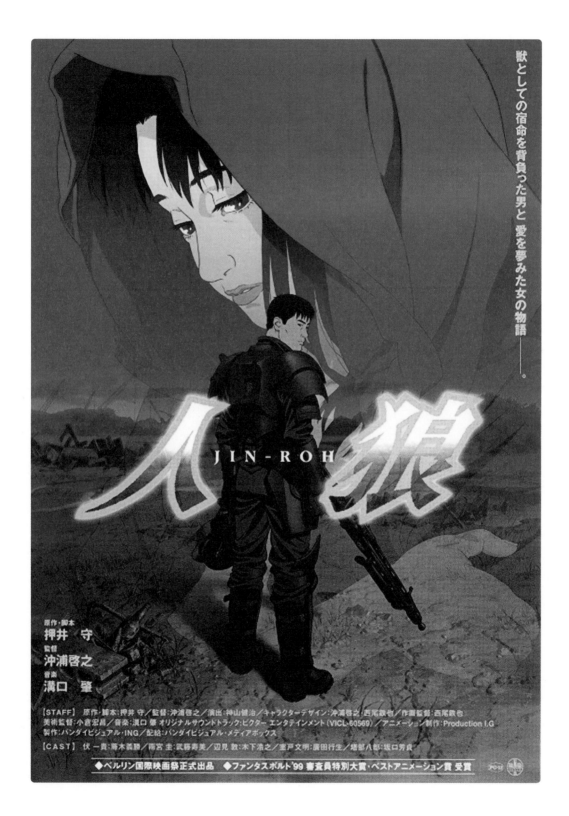

獣としての宿命を背負った男と　愛を夢みた女の物語――。

JIN-ROH

人狼

原作・脚本
押井 守
監督
沖浦啓之
音楽
溝口 肇

【STAFF】原作・脚本:押井 守/監督:沖浦啓之/演出:神山健治/キャラクターデザイン:沖浦啓之・西尾鉄也/作画監督:西尾鉄也
美術監督:小倉宏昌/音楽:溝口 肇 オリジナルサウンドトラック:ビクター エンタテインメント(VICL-60569)/アニメーション 制作:Production I.G
製作:バンダイビジュアル・ING/配給:バンダイビジュアル・メディアボックス
【CAST】伏 一貴:藤木義勝/雨宮 圭:武藤寿美/辺見 敦:木下浩之/室戸文明:廣田行生/塩部八郎:坂口芳貞

◆ベルリン国際映画祭正式出品◆ファンタスポルト'99 審査員特別大賞・ベストアニメーション賞 受賞

After *Ghost in the Shell*, director Mamoru Oshii took something of a back seat, electing to foster young talent and develop projects for emerging filmmakers. In 1998, he set up a study group, called Oshii Jyuku (Team Oshii), and, in response to a call from Production I.G. studio head Mitsuhisa Ishikawa, encouraged its participants to pitch their own original ideas for potential projects. This workshop bore fruit in 2000 with the release of two projects that Oshi coaxed into existence: *Blood: The Last Vampire* and *Jin-Roh*.

The *Jin-Roh* project had been simmering away for some time. Before Oshii embarked on directing *Ghost in the Shell*, it was first proposed as a potential animated series drawing from his *Kerberos Saga* series of manga and live-action films, with its shared universe of an alternate, post-war Japan occupied by Nazi Germany. Following *Ghost in the Shell*, however, it was suggested by Bandai Visual and Production I.G. that the project be used as a platform for new talent, with Oshii providing the screenplay.

Step forward first-time director Hiroyuki Okiura. Born in Osaka Prefecture in 1966, Okiura left school at 16 and dived head first into the world of animation, later making his mark as a key animator on several classic features, including *Akira*, *Roujin Z* and *Memories* (all from the mind of Katsuhiro Otomo, whose groundbreaking manga work was what first inspired Okiura to turn his hand to art). He also developed a close, if at times spiky, working relationship with Mamoru Oshii on *Patlabor: The Movie* and its sequel, and served as character designer, layout artist and animation supervisor for *Ghost in the Shell*.

Below: Red eyes. Jin-Roh is a nightmarish flight into a violent and morally murky dystopian world.

Opposite top: Short fuse. The mysterious, violent lead of Jin-Roh finds himself lost in a world of political intrigue.

Opposite bottom: Howl at the moon. Jin-Roh's military lexicon and fairy tale themes are full of lupine references.

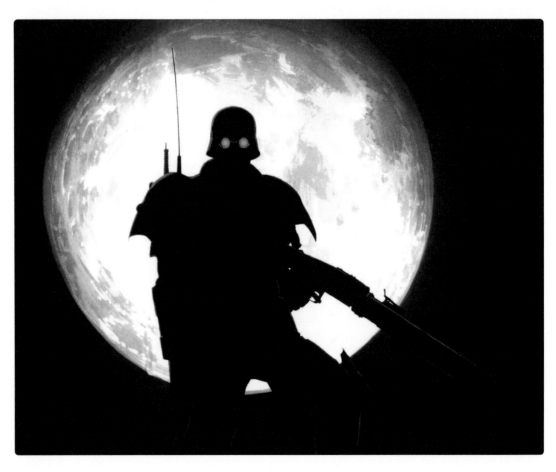

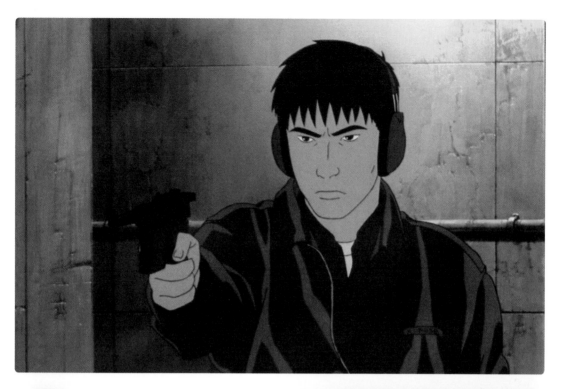

Much like *Ghost in the Shell*, *Jin-Roh* would be a loose and radical adaptation of its source material. Okiura was unabashed about making demands of his former boss, requesting that the script focus on an original love story, set within the totalitarian regime and social unrest of the Kerberos universe. The result was a grounded animated drama that has the rain-slicked melancholy of a film noir and the textures of a dystopian political thriller, with themes of oppressive regimes, romantic dreams of rebellion, and ultimately futile hopes of escape. Befitting its more serious tone, *Jin-Roh* received its world premiere at the Berlin International Film Festival in 1999, and was then released in France not long after, before appearing in Japanese cinemas in June 2000.

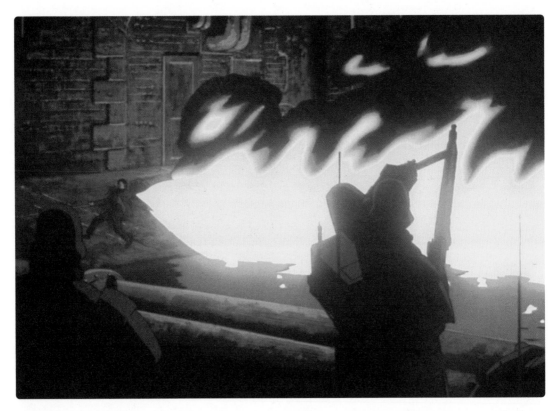

Above: Eternal flame. Jin-Roh draws from a rich political history of public protest and militaristic oppression.

Opposite: Jin-Roh's alternate-history setting is a vision of post-war Japan under occupation by Nazi Germany.

FURTHER VIEWING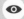

Jin-Roh: The Wolf Brigade is just one entry in Mamoru Oshii's sprawling *Kerberos Saga* multimedia franchise, which features everything from novels and manga to feature films and radio dramas. Sadly, it is mostly inaccessible to English language audiences, although the live-action films *The Red Spectacles* and *StrayDog: Kerberos Panzer Cops* have received limited home-video releases. Elsewhere in anime, *Jin-Roh*'s serious tone and genre texture point to Oshii's earlier work in *Patlabor* and *Ghost in the Shell*, as well as that perennial favourite, Katsuhiro Otomo's *Akira*. If you're in the mood for something more heartfelt, though, try director Hiroyuki Okiura's subsequent feature, *A Letter to Momo*, a gently moving Miyazaki-esque story of a young girl struggling with the loss of her father, helped by three local goblins.

JIN-ROH – REVIEW

Throughout *Jin-Roh: The Wolf Brigade* there are recurring images of the tracks and wires of a tram system. Riding the tram, clearly at a distance from the normality of the commute and out of rhythm with the sway of the handles and the flipping of newspaper pages, is the pensive, elite soldier Fuse. Strapped into the armour of a counterterrorist unit, he has just watched a young girl blow herself up in front of him. Caught between military obligations, guilt and romance, *Jin-Roh* follows Fuse as he navigates the crossing wires of espionage, asking whether the track he's on can ever be changed.

Opening with a slideshow of washed-out stills and an authoritative voiceover, this is an alternate history where the Axis won, leading to the formation of Fuse's urban military unit. Cowled in black helmets, bulky armour and masks with haunting red eyes, as well as an unlimited supply of huge guns and bullets (the film even has a Weapon Design credit, which goes to Kazuchika Kise), they're a terrifying vision of social protection. Fuse himself is an ambiguous, slippery character, his stony face suggesting both unprocessed pain and ruthlessness. Flipping between his domestic and professional appearances, the film asks viewers to consider whether the red-eyed, armoured veil is really a mask at all.

Like *Ghost in the Shell*, the vividly animated, explosive set pieces aren't the primary draw for the film. *Jin-Roh* is as invested in atmosphere as it is in action. It has a hazy, overcast and rainy setting, with an eerie soft glow that emanates from the characters' faces, both warming and ghostly. When Fuse meets Kei Amemiya, a red-cloaked woman claiming to be the sister of the young suicide bomber, it seems like a chance for light in a world that's suffocating from a perpetual fog of war; but in *Jin-Roh* every person could also be a performance. Just as Fuse could be the sensitive, battle-scarred soldier, he could also be a blood-hungry wolf. And while Kei could be the crimson femme fatale, she could also be his red riding hood.

Again, like *Ghost in the Shell*, there is some bureaucratic conversation that's not the most engaging, and some big reveals that are so underplayed they don't register on first viewing. But it's this understated, almost brutal lack of emotion that makes the film's environment so strong. It's weighty and compelling, existing both visually and psychologically in the grey, occasionally offering the hope of twists on a track of doomed inevitability. It's got political thrills and beautifully rendered action, but be warned: the grim *Jin-Roh* is certainly no fairy tale.

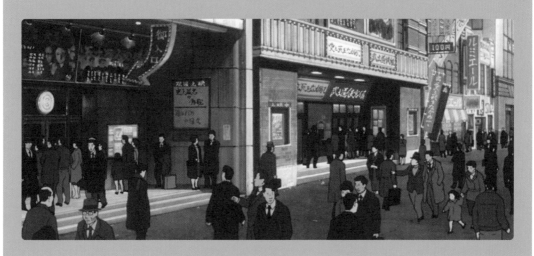

METROPOLIS

メトロポリス

TO CUT A LANG STORY SHORT
Adapted from Osamu Tezuka's manga – which itself was loosely
inspired by Fritz Lang's landmark 1927 sci-fi – this futuristic adventure
follows a private investigator and his nephew as they plumb the
dystopian depths of the multilayered city of Metropolis.

2001

DIRECTOR: RINTARO

113 MINS

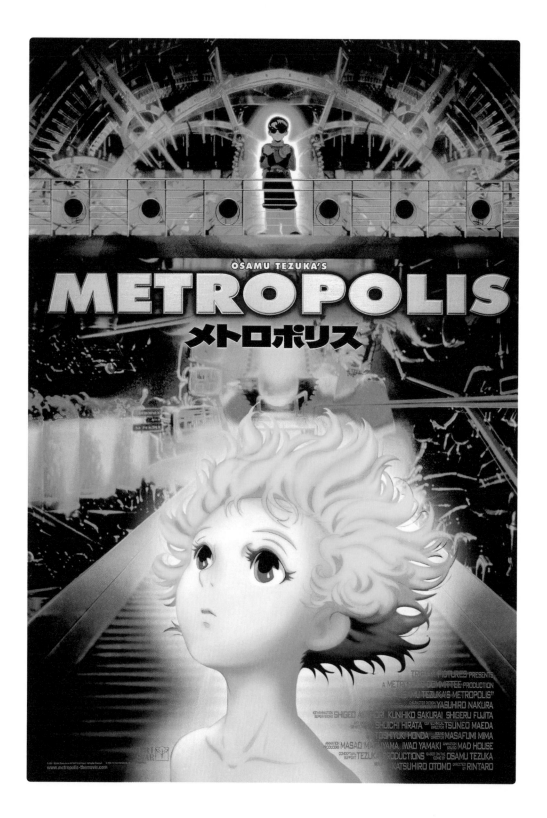

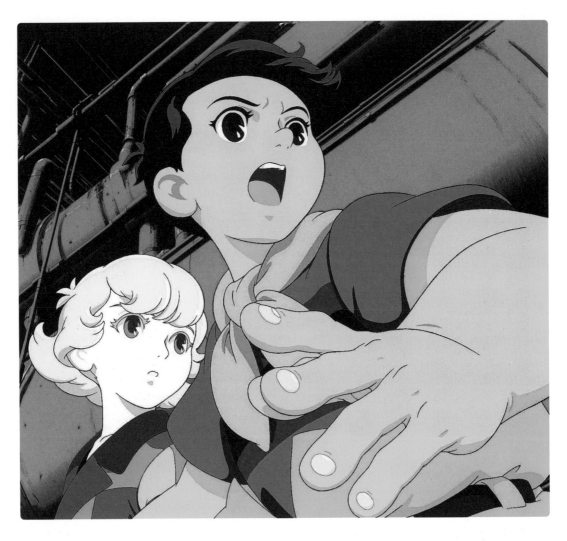

The influence of Fritz Lang's visionary 1927 silent masterpiece *Metropolis* looms large over sci-fi cinema. And yet, when pioneering artist Osamu Tezuka came to create his manga series of the same name two decades later, he had reportedly seen only a single still from the film, using that image to flesh out an original story of conflict and intrigue in a technologically advanced, retro-futuristic city in the year 19XX. Like Lang's film, Tezuka's work both on page and screen has had incalculable influence, inspiring generations of artists and setting the stage for decades of manga and anime to come.

This 2001 feature-length adaptation of Tezuka's manga series begins with a quotation from the writing of Jules Michelet (whose writing also inspired *Belladonna of Sadness*): 'Every epoch dreams its successor.' This speaks

to the story's central themes of invention, innovation and radical social change, but also captures how the film stands at a junction between the past, present and future of anime. *Metropolis* is a cross-generational collaboration between two groundbreaking talents: director Rintaro, whose work revolutionized anime in the 1960s and 1970s, and screenwriter Katsuhiro Otomo, whose manga series and subsequent feature film *Akira* tore up the rule book in the 1980s. The two came together to create a spectacular tribute to Tezuka and his creations, using cutting-edge digital animation to do so. The film, Rintaro told *Science Fiction Weekly* on release, aimed to capture Tezuka's 'spirit'.

Rintaro knew that spirit well. Born in 1941, he entered the burgeoning Japanese animation industry as a teenager, and worked for Toei Animation on their

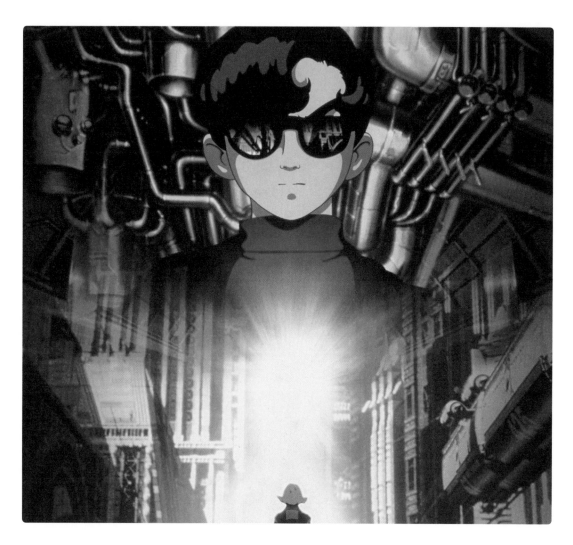

landmark early features, before joining Tezuka's Mushi Productions and having a hand in the groundbreaking TV projects *Astro Boy* and *Kimba the White Lion*. He would go on to greater success later in his career with space-opera epics *Galaxy Express 999* and *Harlock: Space Pirate* (both adapted from manga series by Leiji Matsumoto) and would work with Otomo in the 1980s on his early forays into anime, the feature *Harmagedon* and the anthology film *Neo Tokyo*, sowing the seeds of their collaboration on *Metropolis*. These two veterans were backed by an all-star team of animators, including those who had proven themselves as directors, such as Yoshiaki Kawajiri (*Ninja Scroll*) and Hiroyuki Okiura (*Jin-Roh*).

According to Rintaro, Tezuka never intended to adapt any of his juvenile work (*Metropolis* was published when the artist was only 20 years old), but the director had long had an interest in bringing it to the screen. He is also on record saying that Lang's film is one of his favourites, which might explain several nods to the original that aren't present in the manga, such as a central skyscraper that looms above the city like Lang's New Tower of Babel.

Opposite: Much like *A.I. Artificial Intelligence* (also released in 2001) *Metropolis* brought post-human debate into cinemas for the new millennium.

Above: Rock star. Gracing the international poster for *Metropolis* is the film's antagonist, Rock, the leader of an anti-robot organization.

These add detail to the film's dystopian themes of class struggle and its ethical questions relating to robots and free will while also inviting inevitable comparisons. Inevitable because Rintaro is on record saying that Lang's film is one of his favourites, and the 1927 *Metropolis* is essentially an on-screen grandfather to the cityscape of Neo-Tokyo that Otomo created for *Akira*.

Released in Japan in May 2001, *Metropolis* shared screens that summer with the similarly themed Steven Spielberg sci-fi *A.I. Artificial Intelligence*, and was somewhat overshadowed by the unprecedented blockbuster success of Hayao Miyazaki's *Spirited Away*. A release in English-language territories followed in early

Above: Rintaro's take on *Metropolis* updates Tezuka's vision, which was based on the bustle of inter-war Manhattan.

Opposite left: Eye-conic. Tima's features hark back to Osamu Tezuka's groundbreaking character designs that have been influential for decades.

2002, accompanied by a spirited recommendation from director James Cameron:

'*Metropolis* is the new milestone in anime, a spectacular fusion of computer graphic backgrounds with traditional character animation. It has beauty, power, mystery and, above all, heart. Images from this film will stay with you forever. My congratulations to Rintaro-san for this masterpiece.'

FURTHER VIEWING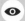

As *Metropolis* exists as a crossover between several visionary filmmakers – Fritz Lang, Osamu Tezuka, Rintaro and Katsuhiro Otomo – you could easily programme an entire marathon exploring its network of related films and series. Tezuka would further develop themes from his *Metropolis* manga in *Astro Boy* (aka *Mighty Atom*), his breakthrough both on page and on screen. This was an early gig

for anime wunderkind Rintaro in the years before he ventured into Leiji Matsumoto's creative universe with *Galaxy Express 999* and *Harlock: Space Pirate*. As for the steampunk style of *Metropolis*, Otomo would provide his own spin on the milieu in his later feature *Steamboy*, although in those stakes, Hayao Miyazaki's epic sci-fi adventure series *Future Boy Conan* is a tough one to beat.

METROPOLIS – REVIEW

Don't let the eyes fool you. They might look cute, but the shining gaze of the citizens of Metropolis masks some seriously sinister internal wiring. This isn't the city of Superman, this is a grimy, fascist, violent place where gleaming skyscrapers reach higher and higher to escape what's buried beneath them.

The story begins with celebrations for the completion of The Ziggurat, an enormous multistorey steel symbol of prosperity, built around a hidden weaponized skeleton. It's the glistening centre to an extraordinary city, full of firework displays, fantastical airships, pristine pavements and candy-coloured buildings – but it's all fondant. Beneath the facade is a rotten core: layers of the city are hidden underground, reserved for the most impoverished and disenfranchised after they've been swept from the streets above. And lower still are its bowels, the sewer system, where only the most derided citizens work... the robots.

Navigating these floors of wealth, excess, class and oppression are the delightfully noirish Detective Shunsaku and his nephew Kenichi. The two stumble into a plot involving anti robot revolutionaries, martial law, weapons of mass destruction and Tima, a super powerful robot with a human appearance, modelled after the villainous Duke Red's own late daughter. There's a lot going on, but handily a lot of the exposition is given to a robot, slightly pardoning the monotonous regurgitation with a winking hint of

self-awareness. As these characters delve deeper into the city, the unravelling of the city's urban planning becomes the film's most intriguing draw. Accompanied by a sultry jazz score, trench-coated characters skulk around alleyways, Parisian Metro gates and neon-lit bars. There are cobwebs and dust everywhere, the posters on the walls faded and peeled a long time ago, and a huge amount of the city and its people have been left to rot. The upper world hasn't helped evolve and expand what came before it, but buried it instead.

Tima seemingly offers a fork in the road for Metropolis. The forefront of technology, who embodies the unification of human and robot, she also wields the power to annihilate the city. The only non-masculine character in the story, Tima is perpetually being controlled by men on either side of the revolution and gradually discovers her autonomy. And it's through her that the future of Metropolis is decided, not by victory on one side or the other, but by blowing up the whole structure and starting again.

As a work of animation it's remarkable, and although the central mystery narrative might be functional to its form, Metropolis is a superbly ominous place to wear down some shoe leather.

Below right: Class mechanics. The grimy lower depths of Metropolis reveal the gleaming city's dark and dystopian foundations.

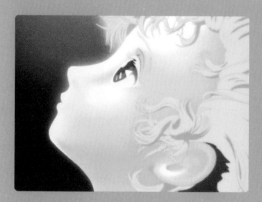

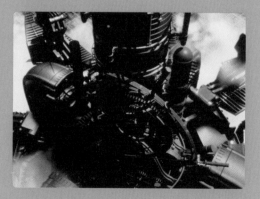

MILLENNIUM ACTRESS

千年女優

THE KEY TO ALL CINEMA

A TV crew is granted a rare interview with a reclusive actress, leading them and the viewer through decades of cinema history. As she recounts the story of her life and career, the lines between fact and fiction start to blur.

2001
DIRECTOR: SATOSHI KON
87 MINS

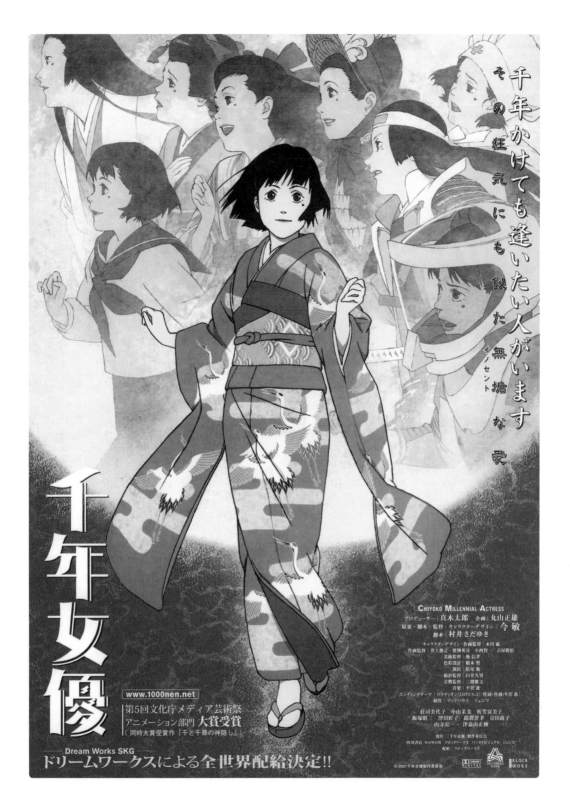

If we could go to bat for one filmmaker in the genius-filled field of Japanese animation, and make a case for them as a director on a par with world cinema's greatest, it would be Satoshi Kon. His life was cut tragically short aged 46, and yet even by then, he had created a small body of innovative and influential work that is almost unparalleled in anime, animation and cinema in general.

Born in 1963, Satoshi Kon was, like many filmmakers discussed in this book, a member of the generation that was raised by anime. He grew up in Sapporo, in the far north of the country, and dreamed of becoming an animator after watching the popular TV series of the day, including *Heidi: Girl of the Alps* and *Future Boy Conan* from Hayao Miyazaki and Isao Takahata, as well as *Mobile Suit Gundam* and *Space Battleship Yamato*. He was also a keen manga reader, and was just the right age to have his horizons broadened by the boom in manga aimed at older readers, including Katsuhiro Otomo's *Domu*.

For college, he headed to Tokyo and studied art at Musashino University, where he started to draw his own manga stories. One of those came runner-up in a competition organized by *Young Magazine*, and it was then that Kon met Otomo for the first time. Kon later worked with Otomo as an art assistant on his long-running *Akira* manga, as the young artist slogged his way up from the lower rungs of the business, creating short comics for the magazine that have now been translated and collected as *Dream Fossil*, before landing his first series, *Tropic of the Sea*, in 1990.

The ongoing relationship with Otomo was what finally brought Kon to both the film and anime industries, with two distinct projects in 1991: the live-action film *World Apartment Horror*, directed by Otomo from a story by Kon, and the anime *Roujin Z*, which was written by Otomo with Kon providing background art and key animation. He would then work with the other leading anime visionary of the day, Mamoru Oshii, on 1993's *Patlabor 2: The Movie*, also providing background art, while a segment in the 1995 Otomo-produced anthology film *Memories*, titled 'Magnetic Rose', found Kon with more creative control than ever before as writer, layout designer and background artist. In retrospect, the dream-like and unsettling horror short laid the foundations for his signature style – all he needed was a project of his own to direct.

That opportunity came when Otomo recommended to the anime studio Madhouse that Kon direct an adaptation of Yoshikazu Takeuchi's novel *Perfect Blue* that was in development. Kon took the gig, rewrote the screenplay with co-writer Sadayuki Murai, and shepherded the film through budget cuts and a pivot from straight-to-video to big-screen theatrical release. In the process, Kon had to remove hundreds of shots from his storyboards and cut sequences to the bone to save on time – in the process creating a fractured, non-linear approach to storytelling that perfectly complemented a film about a pop-idol-turned-actress driven to the brink of madness by the exploitation of young women in the spotlight, and the lingering threat of stalkers in the shadows.

Perfect Blue was a cult hit, and went down well on the international festival circuit, emboldening Kon to pursue more projects as director. A potential adaptation of Yasutaka Tsutsui's *Paprika* was floated but didn't come to fruition until 2006; instead, Kon was approached by producer Taro Maki with a creative challenge. Maki had considered *Perfect Blue*'s fragmentary structure to be what he called a *trompe l'oeil* film, referring to the style of artwork that literally means 'to deceive the eye', such as when a 2D image appears to be 3D. He urged Kon to continue in this vein, with animation that played with notions of fantasy and reality, blurring the lines between the two.

After considering a few potential ideas and directions, Kon settled on *Millennium Actress*, a project that he conceived as being the positive, complementary opposite to the dark and disturbing *Perfect Blue*. '*Perfect Blue* and *Millennium Actress* are two sides of the same coin,' he explained to *Midnight Eye*. 'When I started working on *Millennium Actress*... I had the intention of making the two films like sisters, through the depiction of the relationship between admirer and idol.' Here, instead of the world of pop music, Kon would explore cinema itself, using the life and work of a classic movie star as a route through Japanese film history.

By all accounts, Kon was an avid cinephile. On his blog, he posted a list of 50 films that inspired him, shortly followed by a second post of 50 more... and then a final post with yet another selection of 'movies that didn't make the list'. Taken together, these lists contained classics from Alfred Hitchcock, Billy Wilder and John Ford, alongside touchstones such as *Star Wars*, *Aliens*, *Blade Runner* and *Se7en*, plus a few oddball choices, such as Tim Burton's *Mars Attacks*, Harold Ramis's *Groundhog Day*, George Roy Hill's adaptation of Kurt Vonnegut's *Slaughterhouse-Five*, and the films of Terry Gilliam.

Millennium Actress, though, was to be a tribute to Japanese cinema with explicit and subtle references to

films including Akira Kurosawa's *Throne of Blood* and actors such as Setsuko Hara, a frequent star of Yasujirō Ozu's dramas, who, like the character in *Millennium Actress*, withdrew from the industry and lived for many years as a recluse.

The film received its premiere in July 2001 at the Fantasia Film Festival in Canada, and, like *Perfect Blue* before it, fared well on the international festival circuit. In Japan, it was more of a critical than box-office success, winning the Ōfuji Noburō Prize at the Mainichi Awards, which traditionally rewards 'animation excellence' and celebrates films with a more innovative, independent spirit.

Above: As a director, Satoshi Kon was a flag-bearer for a unique, unmatched style of animation.

Producer Masao Murayama, the head of Madhouse and one of Kon's most ardent supporters right up until his final, unfinished project *Dreaming Machine*, recalled in 2017 at a Scotland Loves Anime on-stage Q&A: 'I said to Satoshi Kon: "I like you. I like your work. There's a greatness in you but the mainstream just can't see it."' In his lifetime, Kon may never have had the commercial success or popular recognition of his mentors, Katsuhiro Otomo or Mamoru Oshii, but his greatness still resounds today.

FURTHER VIEWING

No chapter in this book has made us curse our 'one film per director' rule more than this one because every entry in Satoshi Kon's filmography is worth your time, from the pop idol psychological slasher *Perfect Blue* to the unlikely Christmas-themed caper *Tokyo Godfathers*, and the dazzling dreamscape sci-fi thriller

Paprika. His TV miniseries *Paranoia Agent* – essentially an anthology that offers an animated anthropological study of existential angst and social unease – is also essential, as is his unfinished manga *Opus*, which, like *Millennium Actress*, turns the relationship between art and artist into a formal roller coaster.

If you haven't seen them, you should really catch up with Satoshi Kon's films, but most of the time they won't let you. They're relentlessly quick, vivid and surprising stories that outwit and inspire at every turn. His characters, locations and entire form can change in an instant as personalities, dreams and memories collapse and transform on screen, making for propulsive, compulsive viewing and a near perfect, albeit far too short, filmography.

His first feature, *Perfect Blue*, examined the destructive nature of fame and fandom through the story of a pop idol who turns to acting and, as she falls victim to a stalker, her reality starts to fragment as the personal and professional violently combine. It's a harsh, lurid and painfully real exploration of toxic, celebrity-obsessed culture, and one that feels startlingly resonant still, even 25 years after its release. *Millennium Actress* presents the opposite, a projection of art and artistry that's far purer and loving, the other side of a coin expertly flipped by Kon.

The film is the story of Chiyoko Fujiwara, a legendary actress who's been in hiding for 30 years, and a film crew – including a super-fan director – interviewing her about her life. But being a Satoshi Kon film, the conversation isn't exactly shot, reverse-

shot. *Millennium Actress* is about both viewing and being viewed, the experiences of an actor revealing themselves to audiences, and audiences finding themselves in those stories. Chiyoko explains that in her young life she helped an artist on the run from the police. The artist gives her a key and tells her it's for 'the most important thing'. Carrying the key with her, the pursuit of this artist leads her down her own path in the arts, where across locations, costumes and genres she hopes to find him. As she tells this story, paralleled by her most famous roles, director Genya Tachibana and his cameraman Kyoji Ida are transported inside Chiyoko's films, first as voyeurs and eventually as *katana*-wielding participants. To Kon, to connect with a film is to be ensconced in it, and *Millennium Actress* constantly flows, uninterrupted, between reality and fiction, art and artist, performer and audience, in a heady love letter to cinema.

This trademark montaging, which features in all of Kon's work, is part of what makes his films so compelling. In *Perfect Blue* this technique captures the scary fluidity of psychosis, in TV series *Paranoia Agent* it's the fluctuation of perceived truth, and in his later work *Paprika* it's the gossamer veil between reality and dreams. It creates a space where objectivity and subjectivity are always curiously merging, unmooring the audience from a fixed

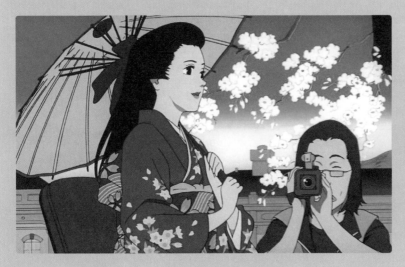

Left: *Millennium Actress* blurs the lines between reality and fiction, with the documentary camera crew following the actress through her films.

Opposite: The documentary director in *Millennium Actress* is Satoshi Kon's depiction of a more wholesome form of super-fan.

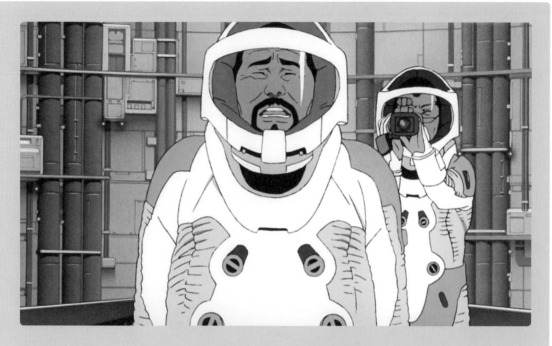

point of view, offering an exciting, liberating viewing experience. There's rarely a hard stop to a scene as Kon uses match cuts that carry a thread of action, colour or design from one scene into the next so that a character might seamlessly travel from a Manchurian train carriage to a palatial siege and beyond. Propelled by a pulsing, mighty synth-laden score from Susumu Hirasawa, it's not cinema as a collage of frames but as an unending, hypnotising tapestry.

So what's the key? It follows her throughout the film, first given to her by a man whose face is never clearly seen, always kept in shadow. This is because who he is doesn't really matter, and what the key opens doesn't matter either. Like Rosebud or the Maltese Falcon, it's our MacGuffin, a quite literal key that opens up the story. To Chiyoko it's 'the chase' that matters most, not what's at the end of it. For her, it's the creative pursuit – embodied by the elusive artist – that has the most value, not its potential spoils. Weaved into the story are references to Yasujirō Ozu, Godzilla and most prominently, *Throne of Blood*, which follows the plot of Shakespeare's *Macbeth*. The memorable, prophetic ghostly figure from Akira Kurosawa's retelling of the Scottish play interacts with Chiyoko a number of times, spinning tales of her fate while whirring a sewing wheel, whose cogs and threads mirror

celluloid projection. Late in the film, when reflecting on her life and career, she explains that she was always 'chasing shadows', which could be read as her pursuit of the missing artist but is equally about film itself, as what is the cinema experience, if not chasing projected shadows?

Kon's vision, however, isn't entirely rose-tinted. Chiyoko's experiences with slimy directors, industry deviants and nepotism are all sadly real and unchanged. Even the central dynamic that contains the film – the documentary team tracking Chiyoko down to recount her life – is questionable. Viewed through the lens of our modern online culture, in which the intimate details of celebrity life are consumed endlessly, Genya's parasocial relationship with Chiyoko highlights fans' inability to separate themselves from their favourite artists and the roles they play.

For Kon, though, the inseparable bond is with cinema. For all its industry flaws, exploitative repercussions and psychological dangers, his films show a man excited and enamoured by his tools and his canvas. Every one of his works stretches the limit of what can be achieved in animation and what can be perceived by audiences, and we'll happily, endlessly chase after them.

COWBOY BEBOP: THE MOVIE

カウボーイビバップ 天国の扉

RETURN OF THE SPACE COWBOY

This spin-off from the popular anime series finds bounty hunter Spike Spiegel and the crew of the spaceship Bebop taking on the task of tracking down a terrorist who has threatened all human life on Mars.

2001
DIRECTOR: SHINICHIRŌ WATANABE
115 MINS

Rarely seen without his trademark sunglasses, Shinichirō Watanabe is undoubtedly one of the coolest creators in the history of anime. His landmark space opera series *Cowboy Bebop* is a heady blend of style and sophistication that mixes futuristic sci-fi settings with the unruly social milieu of the Wild West – all set to a kinetic soundtrack composed by ace collaborator Yoko Kanno.

Cowboy Bebop was initially developed as a potential action-figure tie-in with Bandai, before the offbeat concept dissuaded the toymakers from backing it. With the creative team now left to their own devices, the series was allowed to blossom into something sleek, stylish and cineliterate – a real one-of-a-kind. On release, *Cowboy Bebop* became a sensation, especially internationally, with episodes broadcast in English-speaking countries on Cartoon Network's young adult channels. For a generation of anime fans, this was the series that got them hooked – and it remains a fan favourite over 20 years after release (even surviving that unholiest of things: a remake – see the box below).

While it was a true collaboration between a team of complementary individuals, including screenwriter Keiko Nobumoto and animation director Toshihiro Kawamoto, Watanabe's vision led the way. Born in 1965, he had a front-row seat to a wave of impactful anime that turned many fellow members of his generation into wannabe animators. And yet, Watanabe had broad tastes, just as turned on by *Lupin III* as he was 1940s film noir, the violent westerns of Sam Peckinpah, the Dirty Harry films, the Bruce Lee martial arts classic *Enter the Dragon* and Ridley Scott's sci-fi *Blade Runner*.

Right top and bottom: John Cho, Mustafa Shakir and Daniella Pineda (top) lead the cast of the unloved English-language Netflix series adapted from the beloved anime, with Alex Hassell (bottom) as the main antagonist, Vicious.

Opposite top: Bullet train. One of the film's standout action sequences takes place on a futuristic monorail system.

Opposite bottom: Crew cut. Meet the ragtag gang of misfits that make up the ensemble of *Cowboy Bebop*.

THE CURSE OF THE ENGLISH-LANGUAGE REMAKE

If you ever find yourself wanting to rile a devoted anime fan, simply ask them about American remakes of beloved Japanese series. The live-action adaptation of *Cowboy Bebop* shown on Netflix in 2021 was greeted with wide-scale derision by fans, causing the streamer to cancel plans for further seasons. But this merely continued a run of badly received English-language productions that includes *Death Note*, *Dragonball: Evolution* and *Ghost in the Shell*. Yet there are two potential exceptions to the commonly held rule that all American anime adaptations are misjudged, cynical or creatively bereft. One is the Wachowskis' colourful, spirited take on *Speed Racer* and the other is Robert Rodriguez's cult hit *Alita: Battle Angel*.

However, Watanabe pinpoints 1984 as the year when he fully committed to animation, with the release of three influential anime features: Hayao Miyazaki's *Nausicaä of the Valley of the Wind*, Mamoru Oshii's *Urusei Yatsura 2: Beautiful Dreamer* and *Macross: Do You Remember Love?*, the latter of which being part of the franchise Watanabe would later help steer in his directorial debut, *Macross Plus*. Reflecting on this pivotal year in 2020, Watanabe spoke to Andrew Osmond in the *All the Anime* blog and said:

'At the time, all those films exceeded any of the qualities of the live-action films being made in Japan. I always wanted to make films, so at the time I thought it was better to go into anime than live-action for film-making.'

The *Cowboy Bebop* series wore its film influences on its sleeve, and Watanabe had cinema on the brain while creating the series, so it was a natural progression, once the initial series had wrapped, to make a feature-length spin-off. Set between episodes 22 and 23 of the series, this feature reunited the core creative team, now equipped with more time and a much bigger budget, to create a film pitched equally at both hardened fans and a potential audience of newcomers experiencing *Bebop* for the first time.

Above: The Bebop, the grungy, battered home of our heroes and a great addition to anime's exhaustive supply of unique vehicles.

Opposite: Smoke gets in your eyes. The noir-referencing future people of Mars are still constantly lighting up.

FURTHER VIEWING

Shinichirō Watanabe is now regarded as one of the Japanese animation industry's top filmmakers, and he is one of the few whose work has been widely distributed and well-received internationally. *Cowboy Bebop: The Movie* remains one of his few forays into theatrical animation but his varied and genre-blending series work is frequently outstanding. It is often made in collaboration with many Bebop veterans such as composer Yoko Kanno and screenwriter Keiko Nobumoto. They're also, crucially for time-strapped film fans who fear the commitment associated with a 100-episode series, mercifully short. Catching up with the *Cowboy Bebop* series is a must, but also seek out the hip-hop samurai epic *Samurai Champloo*, the jazz-band teen drama *Kids on the Slope* or the sweet sci-fi *Carole & Tuesday* for further adventures.

COWBOY BEBOP: THE MOVIE – REVIEW

As one of the definitive anime TV shows, deciding to embark on *Cowboy Bebop* might feel intimidating, like having to finally commit to watching *Twin Peaks*. As with Watanabe's series, David Lynch's surreal murder mystery spawned its own film, *Fire Walk With Me*, and while that was great for fans, viewers without the benefit of having seen the show would likely look for an immediate route out of the woods, never to return. However, *Cowboy Bebop: The Movie* manages to pull off the impressive feat of being perfectly pitched for original fans and newcomers. Experts in the exploits of Spike Spiegel and Co. get a feature bonanza, with their favourite small-screen characters blown up and carrying a cinema release with ease; novices get an exciting, satisfying story and the pleasure of knowing there's hours of adventures still to discover.

The opening throws viewers immediately into the foiling of a grocery store robbery executed in casually violent fashion. Watanabe's Western influences become instantly clear, animating the action as if shot through the bowling shape of a fish-eye lens, placing adversaries at either edge of the frame, the desert of the shop floor separating them. It's a breezy dusting of Sergio Leone, one of many clear influences throughout. Gleaming neon streets evoke *Blade Runner*, but the irreverent slacker quality of the characters and the street level shaky camera feels lifted from a 1990s skate video, not a sci-fi dystopia. The city setting of Mars is an architectural hybrid of New York, Paris and Morocco; and as characters scarper round street corners and stylistic borders the result is a globetrotting escapade like that experienced by Indiana Jones (complete with a Kali Ma-style bloody grab of flesh) but contained within the same city. Combat is staged with the elegant precision of Bruce Lee and ponderous cigarette fondling comes from the Philip Marlowe handbook, but despite its reverence for multiple genres and styles, the film still manages to have its own personality.

The story follows the bounty-hunting passengers of the spaceship *Bebop*: reluctant lank Spike, thoughtful-yet-gruff Jet Black, canny gambler Faye and the eccentric, rubber-limbed teen hacker Ed. Thankfully we're spared any origin stories – the domestic rhythms of life on the *Bebop* are enough to neatly establish enough character traits and dynamics to form attachments, before throwing the gang into a plot involving the potential detonation of a biomechanical chemical weapon and its mysterious wielder. The stakes could be lifted out of a Bond film (and are actually quite similar to 2021's *No Time To Die*), but set pieces on a suspended monorail and Eiffel Tower-like structure far out-rank 007, the theatre of combat executed with operatic, almost divine, beauty at times.

The finer points of the story, such as the details of the virus, the villain's motivations and a romantic resolution, are bungled in the final third and are slightly incomprehensible. Frustratingly, after so much freewheeling fun, there are no bows to tie on the narrative, just some unnecessary knots. But regardless of its flaws, *Cowboy Bebop: The Movie* will spur old fans into a re-watch, and lasso new ones into its charming, unique world. Yeehaw!

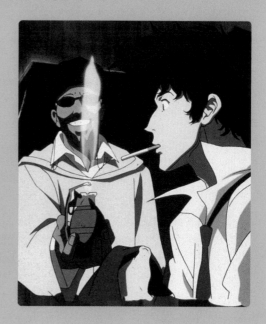

INTERSTELLA 5555

インターステラ5555

HARDER, BETTER, FASTER, STRONGER

To the tune of songs from Daft Punk's album *Discovery*, an alien pop group is kidnapped and brainwashed by an evil mastermind who plans to rule the universe with music.

2003

DIRECTOR: KAZUHISA TAKENOUCHI

65 MINS

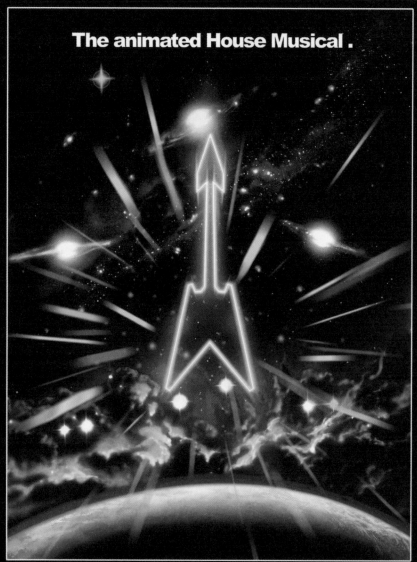

The animated House Musical .

Daft Punk & Leiji Matsumoto's

INTERSTELLA
5555

The 5tory of the 5ecret 5tar 5ystem

As the French house music duo Daft Punk were readying their second album, the million-selling dance-pop epic *Discovery*, it became clear that the sample-heavy collection of songs was forming something of a futuristic tribute to the music of the mid-1970s and early 1980s, from disco to New York garage. Deeper still, the album stood as an evocation of what Guy-Manuel de Homem-Christo and Thomas Bangalter identified as the open-minded optimism that era represented for them, given that they were young kids at the time.

While recording the album, they had toyed with the idea of a feature-length movie that could be scored by the songs, and it makes sense that their imaginations were drawn back to the anime shows broadcast on French TV during their youth – specifically, the seminal space opera series *Space Pirate Captain Harlock* and *Galaxy Express 999*, both created by the legendary manga artist and screenwriter Leiji Matsumoto.

With their friend, Cedric Hervet, they wrote a story that mixed 'science fiction with the decadent world of show business, [and] limousines with spaceships', which they presented to Matsumoto himself, with the finished album, on a trip to Tokyo in summer 2000. It was a childhood dream come true when he agreed to collaborate on the project. 'At last,' they wrote in the liner notes for the eventual film, *Interstella 5555: The 5tory of the 5ecret 5tar 5ystem*, 'we [were] ready to blast off into his baroque intergalactic universe.'

Frequent Matsumoto producer Shinji Shimizu came on board as producer, with *Sailor Moon* and *Dragon Ball* veteran Kazuhisa Takenouchi serving as director, working from character designs and concept artwork by Matsumoto himself. Starting production at Toei Animation in October 2000, the feature-length 'visual album' took over two years to create, receiving its world premiere at the Cannes Film Festival in May 2003 in the Directors' Fortnight programme.

By then, though, the world had heard the *Discovery* album, and had in fact seen several music videos clipped from the film, each corresponding to a hit single released over the course of 2000 and 2001: 'One More Time', 'Harder, Better, Faster, Stronger', 'Aerodynamic' and 'Digital Love'. This was the height of the music video era and at the crest of a wave of visionary, experimental, often eccentric videos that expanded the minds of pop fans, with directors like Michel Gondry and Spike Jonze in the prime of their creative careers. The concept animated band Gorillaz were also just around the corner. Even in that climate, these videos were distinctive, beautiful and exciting – especially for young English-speaking audiences who, unlike those in France, had likely never had the pleasure of seeing Matsumoto's work before.

FURTHER VIEWING

The field of feature-length animated 'visual albums' is surprisingly sparse, although many music videos from American acts have drawn influence from anime, most notably Michael and Janet Jackson's 'Scream' and Kanye West's *Akira*-cribbing (and Daft Punk-sampling) 'Stronger'. While not anime, the Beatles' animated musical, *Yellow Submarine*, proved to be influential on generations of Japanese animators, and shares some common ground with *Interstella 5555*, albeit taking viewers on a psychedelic journey rather than an intergalactic one. As this is a showcase of, and love letter to, Leiji Matsumoto, though, it is perhaps best followed with a deep-space exploration of the Leijiverse, from *Space Pirate Captain Harlock* to *Galaxy Express 999*.

INTERSTELLA 5555 – REVIEW

If, in the early 2000s, you were one of those kids who ran home after school to scroll endlessly through the music channels, chances are you've seen a lot of chunks of *Interstella 5555*, and (just like for this writer) it may well have been your first encounter with anime. What a discovery. Leaping through genres as gleefully as it does the colour spectrum, Kazuhisa Takenouchi's musical may have been mostly consumed in singles, but its ambition and depth are fully revealed as a long-player.

Long before James Cameron did it in *Avatar*, *Interstella 5555* holds up a mirror to society's materialism and exploitation, with the help of some blue aliens. Kidnapped mid-gig from their home planet and given a human-skin airbrush, Octave, Arpegius, Baryl and Stella's (known on Earth as The Crescendolls) journey from tragic victims to galactic saviours bops between a sci-fi adventure, a noirish espionage tale and a gothic mystery that's a rubber mask away from *Scooby-Doo*. Each chapter manages to evolve the look of the film, seamlessly skipping from luminous extraterrestrial night clubs to grim fantasy dungeons and nightmarish prismatic tunnels that would thrill Willy Wonka, while never breaking the story's rhythm. However, what's most exciting about the film isn't its style, but its reflexivity. As the story of these misunderstood aliens unfolds, so the elusive Daft Punk – infamous for their mystique and never showing their faces in public – offer up a story about themselves.

It's hard not to see Daft Punk's Guy-Manuel de Homem-Christo and Thomas Bangalter represented in The Crescendolls and their whirlwind of autographs, limos and hotel suites. Perfectly counted in by the anxiously ascending industrialism of Daft Punk's 'Harder, Better, Faster, Stronger' we see the commodification of artists, through micro-management, corporate packaging and merchandising. As the aliens are forced into this materialist human life, the narrative's creators – who hide themselves behind robotic masks – seem to be relaying their own anxieties of the spotlight

and the disconcerting reality of mass media.

As *Discovery*, the accompanying Daft Punk album, is very front loaded with hits ('One More Time', 'Aerodynamic', 'Digital Love', 'Harder, Better, Faster, Stronger' is an impressive opening streak) there is a midpoint lull to overcome where the musical thrust alone can't carry the film. However, thanks to a nefarious record exec turned supervillain and the beautifully realized spiritual transcendence of a super-fan, escalated stakes and surprising emotional heft carries the back half in stellar fashion.

Here, anime reveals itself to be the perfect medium for Daft Punk's self-mythologising. *Interstella 5555* provides a space that the pair can transform into whatever they like, collaborating with artists in a form that can visualize their thoughts, and reveal that they're human after all.

Opposite left: Blue is the colour, anime is the game. *Interstella 5555* gives Daft Punk the perfect avatar for their elusive musical identity.

Opposite right: Turning a super-fan into a hero, the film celebrates Daft Punk's audiences as much as the band themselves.

Above: Musicians unmasked. *Interstella 5555* captures the feeling of being a recording artist beset by industry pressures.

THE ANIMATRIX

アニマトリックス

A WORLD WHERE ANYTHING IS POSSIBLE

Released in tandem with *The Matrix Reloaded*, this anthology of short films, the majority of which were produced by Japanese studios, digs deeper into the universe of *The Matrix* and pays tribute to the mind-expanding anime that first inspired its creators.

2003

DIRECTORS: ANDY JONES, MAHIRO MAEDA
SHINICHIRŌ WATANABE, YOSHIAKI KAWAJIRI
TAKESHI KOIKE, KŌJI MORIMOTO, PETER CHUNG

101 MINS

With *The Matrix*, sibling directors the Wachowskis made no secret of their love of Japanese animation. So it should come as no surprise that, when the press tour for *The Matrix* reached Japan in September 1999, the Wachowskis jumped at the chance to visit the anime filmmakers and video game studios that had so strongly influenced them. Michael Arias, an American-born filmmaker based in Japan, and friend of Matrix visual effects supervisor John Gaeta, served as the siblings' fixer, setting up meetings that would eventually lead to a series of short anime films that would expand the world of *The Matrix*, given the gently punning collective title, *The Animatrix*. Arias would act as 'segment producer', along with Eiko Tanaka, a one-time line producer on Studio Ghibli's *Kiki's Delivery Service* and *My Neighbour Totoro*, who co-founded the animation studio Studio 4°C.

Apart from two shorts produced by American studios, *The Animatrix* consists of seven shorts split between Studio 4°C and another studio, Madhouse, and directed by a roster of established and rising-star anime talent, including *Cowboy Bebop* director Shinichirō Watanabe; *Ninja Scroll* director (and Madhouse co-founder) Yoshiaki Kawajiri; Kawajiri's protege (and future *Redline* director) Takeshi Koike; Studio 4°C co-founder and veteran animator Kōji Morimoto; and

another industry veteran, Mahiro Maeda, whose credits include *Nausicaä of the Valley of the Wind*, the *Neon Genesis Evangelion* franchise, and concept art and design for *Mad Max: Fury Road*.

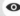

FURTHER VIEWING

For many film fans back in 2003, *The Animatrix* was a portal into the world of Japanese animation, and it still serves that purpose today – simply pick your favourite segment, and follow the filmmakers down the rabbit hole. For similar projects that let Japanese talent run riot over Hollywood properties, look to 2008's *Batman: Gotham Knight*, which was released, like *The Animatrix*, in support of a major Warner Bros. franchise, in that case Christopher Nolan's *Dark Knight Trilogy*. Or, more recently, 2021's *Star Wars: Visions*, which hands over the *Star Wars*' universe to a younger generation of Japanese studios, including Hiroyuki Imaishi's Studio Trigger (*Promare*).

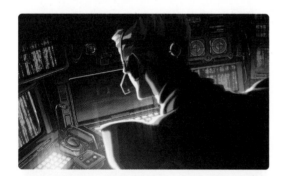

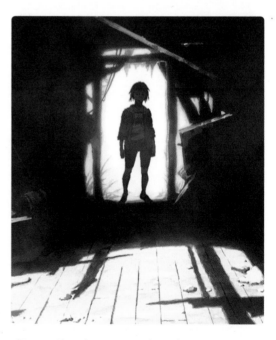

All images: Three distinctive visions that explore *The Matrix* universe, courtesy of Japanese animation's best and brightest creators.

THE ANIMATRIX – REVIEW

Rather than opening up a story in new directions, bad sequels can become a cul de sac, endlessly circling, resurfacing and eventually destroying the tales that were so exciting at first. The *Matrix* series has always avoided this. From the game-changing 'bullet time' of *The Matrix* to the self-reflexive interrogation of franchise culture in *The Matrix Resurrections*, these stories ride off-road, creating their own grimy, refreshingly sincere, nu-metal-infused map.

Tucked between *Matrix* cinema releases, *The Animatrix* is a thrilling collage of tales that strengthen the Wachowski sisters' remarkable cyberpunk series. As a companion to films that present an infinitely stretchable reality (although this anthology moves from hyper-real CGI characters to scriptural 2D animation and a noir tale that looks like it's been made on a rusty fax machine) it feels perfectly at home within the series' malleable verisimilitude.

Mahiro Maeda's chapter *The Second Renaissance* is a two-part micro-epic that envisions humanity's journey from hedonistic late-20th century tech-sploiters to becoming the flesh batteries that power the machine-led dystopia of *The Matrix*. Styled like a nightmarish retro-futurist postcard, this glorious work of exposition highlights the monstrosities of man as they force their robot creations into slavery and violence. Imagery lifted from the Pyramids of Giza, Tiananmen Square and Iwo Jima lays intense, graphic groundwork for all past and future Matrix tales, questioning who the heroes of this world really are – something wryly examined in all the feature film sequels, too.

The Animatrix isn't just filling in the gaps of the Matrix universe though. Whether foundational or seemingly ornamental, each of them enriches and expands the Wachowskis' vision. *Kid's Story*, from Shinichiro Watanabe, is a gloopy, nauseating anxiety dream, where undulating pencil-sketched characters crash against the harsh, green lights of new-millennium technology. Watanabe's later chapter, *A Detective Story*, is altogether different,

its future-noir black-and-white stylings seemingly etched on its hard-boiled lead's printer paper. Elsewhere, in *The Program* (Yoshiaki Kawajiri), as well as contextual building blocks about virtual training programs, comes stylistic inspiration ranging from woodblock prints to *Ghost in the Shell*. Sloping graphite rooftops on a bloody sky are the painterly backdrop for a looping, thrilling Samurai battle, which gives way to a grungy, high-contrast cyber base in the chapter's final moments, storytelling inspirations brought together, from ancient history to modern classics.

Director Takeshi Koike's *World Record*, following a sprinter who crosses the finish line into reality itself, is an intense (and literal) muscular burst of animation. There's a wrenching tactility to the thickly drawn, warped bodies here; heaving across screen, to make physical and existential pain for the characters, and the viewer. In stylistic contrast, you'd be forgiven for thinking *Final Flight of the Osiris* (Andy Jones) featured cut-scenes from the live-action films, its 3D CGI planting us firmly in the universe we recognize (complete with the same slightly awkward eroticism), albeit one that diverts into the uncanny cave system.

Slighter fare can be found in Koji Morimoto's charming *Beyond*, which features adventures in a 'haunted' building, its characteristics like zero-gravity and localized rain revealed to be glitches in the Matrix. With its youthful characters and bright urban setting, this low-stakes offering is a softly rewarding piece of world-building.

Arguably reshaping the Matrix universe more than any other chapter is *Matriculated* (Peter Chung), an extended set piece that flips between cartoonish thrills and golden-hued Lynchian liminality, which reveals that machines and humans can be on the same side (an idea given the spotlight 18 years later in *Resurrections*).

The Animatrix is a wonderland of animation, from its broad and brave approach to style to its narrative ambition. But unfortunately, no one can be told what *The Animatrix* is. You have to see it for yourself.

MIND GAME

マインド・ゲーム

CHECK YOUR HEAD

Mind Game tells the wild and often confounding story of a wannabe manga artist, Nishi, who reconnects with the love of his life, only to be killed in a scuffle with a football-obsessed yakuza. But a run-in with God gives him a chance to turn things around.

2004

DIRECTOR: MASAAKI YUASA

103 MINS

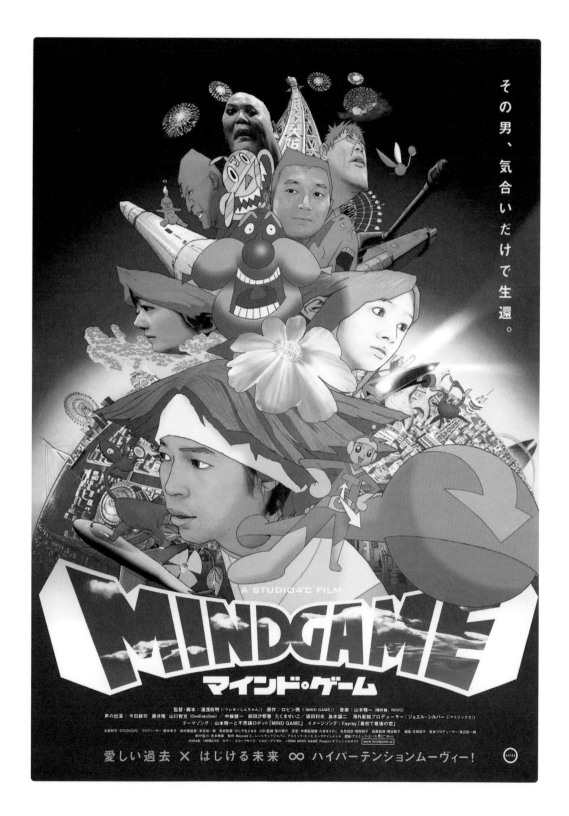

Hold on tight. You are about to enter the creative world of Masaaki Yuasa: often disorientating, always distinctive.

Born in 1965, Yuasa was the perfect age to have his mind blown by generation-defining anime *Space Battleship Yamato*, as well as Hayao Miyazaki's early directorial efforts, *Future Boy Conan* and *Lupin III: The Castle of Cagliostro*, but it was Disney's 1981 feature *The Fox and the Hound*, particularly the bravura technique of animator Glen Keane, that had the biggest impact on him, sparking the young Yuasa's imagination as he started to break down the art of animation and reconstruct it in his own image.

A diverse mix of international influences, including the wacky cartoons of Tex Avery, Paul Grimault's *The King and the Mockingbird*, the psychedelic animation of the Beatles' musical *Yellow Submarine*, and René Laloux's sci-fi fantasy *Fantastic Planet*, all contributed to Yuasa's unique style.

His expressive, eccentric approach made him ill-suited to the traditional entry-level role of 'in-between' animation, where junior artists must mimic the style of the senior 'key' animators, but Yuasa soon broke through as a storyboarder and key animator in his own right, working on the stylized slice-of-life comedy series *Chibi Maruko-chan* and *Crayon Shin-chan*. Later, he went freelance and contributed to several projects for a number of studios, including Isao Takahata's unconventional newspaper comic-strip adaptation, *My Neighbours the Yamadas* at Studio Ghibli.

Eventually, the opportunity arose to direct a feature with producer Eiko Tanaka of Studio 4°C, an adaptation of the offbeat manga *Mind Game*, by Robin Nishi. Taking his experimental, polystylistic tendencies to fever pitch, Yuasa incorporated a variety of different (and some would say conflicting styles) into the film, including manipulated live-action photography. This approach was informed by the rough-hewn style of the manga itself, as Yuasa explained to *Japan Times*:

'[The original manga] is drawn in a rough style, very much like a gag manga. When I thought about how to preserve that rough feeling, I came up with the idea of throwing various styles into the mix, almost at random. It may sound strange, but I wanted it to look as though we hadn't worked very hard on it, though of course we had.'

This approach stood in stark contrast to the standard practice in contemporary anime. Knowing he didn't have the budget for a polished production, Yuasa leaned into the eccentricity in order to make 'the most interesting film you can with the money you have'.

It's no surprise that *Mind Game* proved to be a bit too unconventional for popular tastes, but its status as a cult classic was assured, and it played around the world to considerable acclaim at festivals and in front of fellow animators such as Bill Plympton and Satoshi Kon, who described it as 'outstanding'.

FURTHER VIEWING

In the years following *Mind Game*, Masaaki Yuasa became widely regarded as one of the anime industry's most accomplished and prolific filmmakers, applying his distinctive, idiosyncratic art style to a variety of genres across film and television. After forming the independent studio Science Saru in 2013 with Korean-born producer, director and animator Eunyoung Choi, Yuasa's productivity kicked into a new gear. His features included *Lu Over the Wall* (a quirky riff on Studio Ghibli's *Ponyo*), the Japan Academy Prize-winning one-wild-night romantic comedy *The Night is Short, Walk On Girl* (both 2017), the more polished *Ride Your Wave* (2019) and 2021's *Inu-Oh*, which received its world premiere at the prestigious Venice Film Festival. But his crowning achievement might be the joyous, internationally acclaimed series *Keep Your Hands Off Eizouken*, which follows three school girls' efforts to form an anime club and create their own short films, culminating in an infectious celebration of youthful enthusiasm, imagination and the craft of animation itself.

Above: One of *Mind Game*'s standout sequences is a wacky and elastic car chase through the city.

MIND GAME – REVIEW

The divine can take many forms in film, from Morgan Freeman's blindingly dressed deity in *Bruce Almighty* to sparkling 1990s alt-rock royalty Alanis Morisette in *Dogma* to simple celestial twinkling stars in *It's a Wonderful Life*. In *Mind Game*, after being shot in the head by a gangster, young manga artist Nishi is greeted by the Almighty, whose form is refreshingly sublime. Constantly changing, in one frame God has a faecally shaped head and a snaking tongue, then a photorealistic goldfish bowl for a face, then a 1980s wrestling look, then a Medusa head. At one point there's even a flatulent porcine styling in this pinballing holy configuration. *Mind Game* is an intriguing, tireless story, but in this encounter you can see that director Masaaki Yuasa's worship is directed first and foremost to the endlessly pliable form that he's working in.

Watching this film is like watching a scrapbook come to life. Roughly sketched, jagged bodies seem relatively human, then they'll swell to monstrous proportions in an instant before shifting further into Picasso-eyed photo cut-out collages. Attempting to match this frantic form is Nishi's adventure from callow living doormat to respectful member of society, which includes watching him brawl with the yakuza in a diner, die, broker a return to life, lead a furious car chase and start squatting inside the stomach of a giant whale. The first half of the film is a heady, intoxicating, relentless experience. Nishi acts as a vessel for, and an opportunity to interrogate, toxic male fantasies. The centre of his own story, he's constantly ogling large-breasted women and blaming his failures on others. And in a moment of ultimate hetero-male immasculation, after being unable to protect the woman he loves, he's shot through the anus and killed.

Made just after the 2002 FIFA World Cup, which took place in Japan and South Korea, *Mind Game* binds the beautiful game to its slightly gruesome story. Nishi's purgatorial reflection on his demise plays on a giant screen in front of him, showing his failings from multiple close-up, slow-motion angles, like a video assistant referee for death. After negotiating a second chance at mortality, Nishi enacts his revenge on the

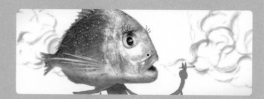

Top: Almighty cod. Nishi receives divine inspiration when he meets his maker in one of the opening scenes of *Mind Game*.

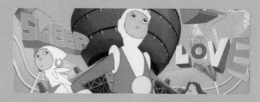

Above: All you need is... Masaaki Yuasa peppers his film with visual references to the Beatles' animated musical *Yellow Submarine*.

yukaza, bundles two women from the diner into a car, and races through death-defying squeezes that 'even Zidane and Figo couldn't get through'. His leering, puerile gaze still intact, it's only after crashing off a bridge and into the belly of a whale that Nishi changes.

Inside the whale, Nishi and his passengers meet an old man, who's built a village of treehouses inside the animal's stomach. In a film of two halves, the Swiss Family Robinson-style hijinks of this section slow *Mind Game*'s pace. It's occasionally dawdling, but necessary – not just to give audiences their own cinematic orange slice – to force Nishi to reflect, converse and actually see other people as rounded human beings. After bonding with his companions, a psychedelic dance montage involving phallic skipping ropes is at first surprising, but ultimately reveals an uninhibited, open Nishi, who can be a team player, no longer seeing himself as a disgruntled perpetual substitute.

A mercurial and fascinating collage, *Mind Game*'s narrative thrills don't quite match its stylistic highs, but for its sheer ambition and totally unique presentation, Yuasa's creation is endless fun to play.

TEKKONKINKREET

鉄コン筋クリート

STREET FIGHTERS

Two orphans wage war with local hoodlums and
other aggressive forces in order to defend their vibrant
neighbourhood of Treasure Town.

2006
DIRECTOR: MICHAEL ARIAS
110 MINS

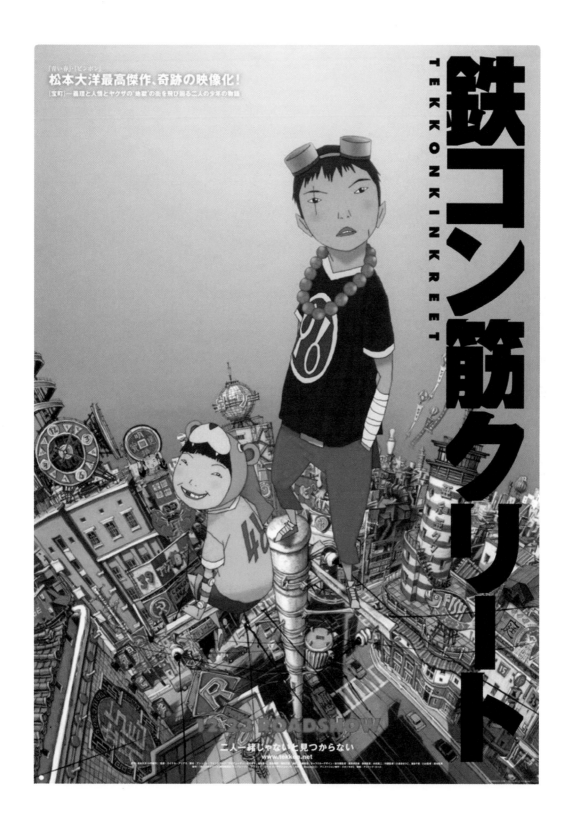

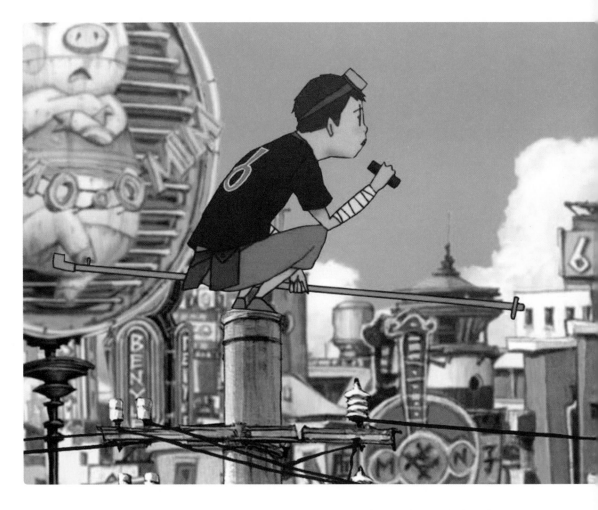

The majority of the filmmakers who work in Japanese animation are lifers. Inspired by manga or anime from a young age, they enter the industry after graduating from college and rarely look back. It's a system that has taken in and gobbled up talent for decades. That said, there is one conspicuous exception to that production-line process: the multi-hyphenate, LA-born Michael Arias, the first American to direct an anime film.

Arias's route to anime is unconventional, to say the least. Starting as a camera assistant for the visual effects company Dream Quest Images, he would work on Oscar-winning effects for the likes of *Total Recall* and *The Abyss*, and later collaborated with industry legend Douglas Trumbull on the theme park project *Back To The Future: The Ride*. His work would take him back and forth across the Pacific, working with the video game company Sega, as well as on film projects directed by

Spike Lee, David Cronenberg and Robert Altman. He then developed software to combine both hand-drawn and computer-generated animation, which was used for Hayao Miyazaki's record-breaking blockbuster films *Princess Mononoke* and *Spirited Away*.

The project that would become his directorial debut put down roots in 1996, when Arias's roommate recommended him a series by cult artist Taiyō Matsumoto called *Tekkonkinkreet*. 'It's going to make you cry,' he said, and it did. Arias, a self-confessed manga neophyte at the time, admits in the foreword to the English language edition of the book: 'I never thought a comic book could do that to me'. Elsewhere, he has described *Tekkonkinkreet* as a 'humanist masterwork' on a par with feature films he adored such as Federico Fellini's *La Strada*, Akira Kurosawa's *Dodes'ka-den* and Shohei Imamura's *Pigs and Battleships*.

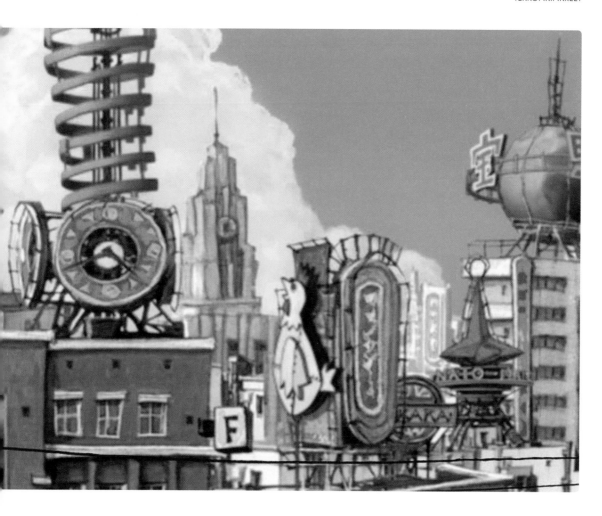

It would take over a decade until *Tekkonkinkreet* made it to the big screen. It first manifested as a short, CG-animated pilot created by a 12-person team, including Arias as CG director and Koji Morimoto as director. However, despite a warm reception for the initial work, plans to expand the pilot fell apart. Yet some key aspects of this production endured, not least Arias's obsession with the music of British electronic duo Plaid, who would eventually score the feature-length *Tekkonkinkreet*. It was while Arias was working on the pilot film that a young carpenter building the team's office furniture gave him both a ticket to a Plaid gig and a copy of their album 'Not for Threes'. 'Plaid's music embedded itself in me,' Arias wrote in a piece commemorating a live performance of the score at the Barbican in London in 2013, 'and insinuated itself deep into the fabric of *Tekkonkinkreet*.'

Arias's unique status as an intermediary between cultures and industries made him the perfect fixer for the Wachowski siblings when they visited Japan hoping to meet their idols in animation and video games. Those meetings grew into *The Animatrix*, which Arias produced, and its success led to *Tekkonkinkreet* finally getting the green light, helped in no small part by producer Eiko Tanaka of Studio 4°C, who shepherded the project and encouraged Arias to take the reins as director himself.

Above: Treasure town. *Tekkonkinkreet*'s setting is an intricate and beautiful urban landscape, gifting viewers with endless discoveries.

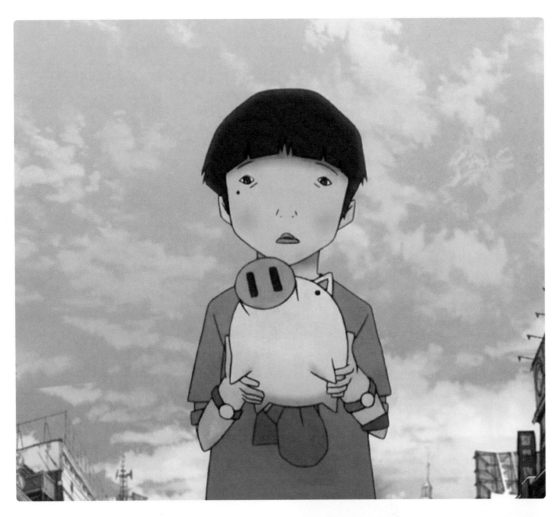

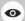

FURTHER VIEWING

Tekkonkinkreet remains the creative peak of Michael Arias's eclectic career, and his efforts as a director, including the live-action *Heaven's Door* and anime feature *Harmony*, have yet to receive the same level of acclaim. More recently, Arias has enjoyed a fruitful sideline as a translator of manga, specifically the work of *Tekkonkinkreet* creator Taiyō Matsumoto: he wrote the English language editions of highly praised series such as *Sunny* and *Ping Pong*, the latter having previously been turned into an anime series by director Masaaki Yuasa.

Top: Piggy bank. Michael Arias has described anime budgets as, typically, being 10 per cent of what you'd expect from similar Western productions.

Above: Dynamic duo. Violently protective adolescent Black (left) defends both the streets he calls home, and his companion, White (right).

Opposite: Baby driver. The childish and innocent White lives in a fanciful world of their own imagination.

TEKKONKINKREET – REVIEW

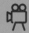

Tekkonkinreet is not a film that gradually builds its world around you, easing you in, brick by contextual brick. It drops you into it. Swooping from above, viewers fly over the urban mesh of Treasure Town – a cluttered, colour burst of jagged construction, as if the playground of a child's imagination has navigated city planning regulations – and are plonked in the middle of a chaotic street. It's an exciting, stomach-leaping introduction to one of the most intricately constructed, beautifully strange and emotionally connective landscapes in anime. And once you land, there in front of you is a kid, walking in quite wobbly fashion, muttering about underwear.

This is White, the owner of a delightful array of hats, as well as being the painfully earnest, wildly creative half of a vigilante duo known as The Cats. The other half is Black, a troubled, violent, fiercely protective adolescent, raising himself and White on the streets of Treasure Town. They've been entirely let down by their society, so they've turned society into their playground, bouncing around it like superheroes. When their beloved town falls victim to a gangster's plan for gentrification and commodification, Black and White take it upon themselves to prevent this, but in doing so the yin and yang of their relationship becomes tragically imbalanced.

Treasure Town's characters, navigating this turf war, are slightly exaggerated: they have thin outlines, angular limbs and small facial features, regularly trussed by Boris Karloff-style stitches. Although there are some supernatural elements (including jarring purple bodyguards, seemingly taken from another film), the story is about street crime, abandonment and mental health; and the bodies, and the pain felt by them, feels reflected and grounded by their design. A seedy, gangster drama told by an American, Arias' film recalls the family of mafia pictures told by the greatest American chronicler of the genre, Martin Scorsese. Arias' long tracking shots move elegantly, dreamily, around his beautifully constructed world. A world, like Henry Hill's or Frank Sheeran's, where violence is temptingly glamorous, but its repercussions are deadly to the body and the soul.

Tekkonkinkreet, for all its bombastic spectacle, is a quietly tragic film. It highlights the evils, and successes, of consumerist construction, the inescapable grind of debt, the perils of family and *family*, the loss of childhood innocence and the fracturing of mental health while trying to survive in a world of such experiences. There's no complete resolution, but there is a glimmer of hope, and a huge amount of empathy and understanding towards these characters, grasping at the frayed fringe of society. Their quirks aren't written out, their troubles aren't solved, but their story, told with so much excitement and such grace, is a treasure.

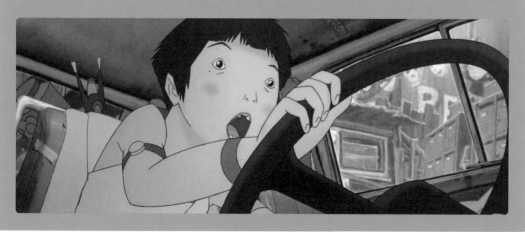

EVANGELION: 1.0 YOU ARE (NOT) ALONE

ヱヴァンゲリヲン新劇場版:序

RIP IT UP AND START AGAIN

Teenager Shinji Ikari reconnects with his estranged father, the leader
of a top-secret programme that is developing giant biomechanical
robots to combat a mysterious threat to human existence on earth,
known as the Angels.

2015
DIRECTOR: HIDEAKI ANNO ET AL
98 MINS

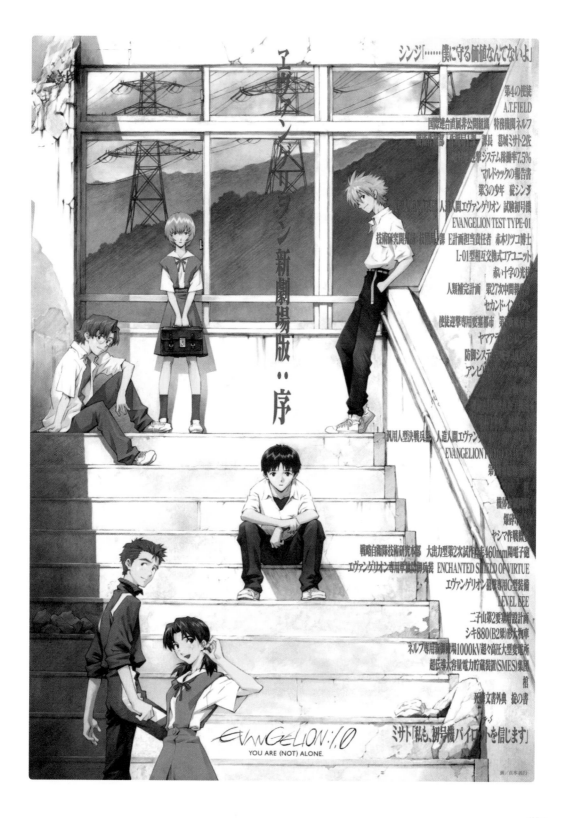

It's hard enough to get the chance to realize your creative vision once, let alone have another crack at the same material. And yet, there are a fortunate few filmmakers who have returned to their work time and again. George Lucas comes to mind; he wouldn't leave his original *Star Wars* trilogy alone, forever tinkering with the films for every new theatrical and home video release – in defiance of a consistent outcry from fans – until he finally threw in the towel and sold the job lot to Disney in 2012. In the history of filmmaking, though, there may be only one other creator who has a similarly fraught relationship with their work and their audience: Hideaki Anno.

Hideaki Anno's breakthrough in anime is a storied one. Born in 1960, Anno might be the poster child for the first generation of 'otaku' Japanese animators who were raised on anime, manga and live-action genre movies. He grew up in Yamaguchi Prefecture in the south of Japan, where he shot his own home-made movies with an 8mm camera. He initially flunked his college entrance exams, preferring to work as a paperboy while indulging in his hobbies, but later enrolled at the Osaka University of Arts. There, he met fellow students with whom he would later form Gainax, and became so wrapped up in their amateur animation projects that he neglected to pay his university tuition fees and was eventually expelled.

He was already well on his way to making a name for himself, though, creating the two fan favourites *DAICON*

III and *IV Opening Animations* with his future Gainax collaborators, and subsequently landing a gig contributing key animation for the series *Super Dimension Fortress Macross*. His big break came after he responded to a call for animators to help produce Hayao Miyazaki's fantasy epic *Nausicaä of the Valley of the Wind*. Travelling to Tokyo, portfolio in hand, he walked into the production studio and right up to Miyazaki's office door to present him the work personally. The director was so impressed by what he saw that he assigned the newcomer to animate a standout sequence in the closing act of the film, featuring the hulking, monstrous God Warrior.

Nausicaä was released in 1984, the same year that the old *DAICON* crew professionalized their operations under the name Gainax. Their high-profile feature-length debut, *Royal Space Force*, would ultimately fail at the box office, but Anno would call the studio his home for two decades, bar the odd holiday at other studios, such as contributing key animation to Isao Takahata's *Grave of the Fireflies*. At Gainax, Anno directed the series *Gunbuster* and *Nadia: The Secret of Blue Water*, the latter developed from a proposal from Hayao Miyazaki which had been gathering dust at Toho since the mid-1970s. According to an official biography, it was during the production of *Nadia* that Anno 'learned firsthand the horrors that lurk within the production of a TV animation series', leaving him drained and disillusioned with anime.

It took several years for Anno to return with a new series, the ultimate collision of religious mysticism, psychoanalytic theory, veiled autobiography and awkward teenagers piloting giant robots: 1995's 26-episode behemoth *Neon Genesis Evangelion*. It was a huge success, giving the anime industry a shot in the arm in the middle of a difficult decade in its history. It spawned a multimedia franchise and garnered an audience of diehard fans, both at home and abroad. And yet, it did not quite stick the landing. A controversial and confounding pair of episodes that formed the series finale split the fandom, with the more negative parties directing death threats at the creator himself.

Initially, Anno said he was satisfied by the conclusion. In an infamous exchange during a Q&A at an American convention, when an attendee expressed disappointment and confusion over the ending, Anno remarked: 'Too bad.' But the impassioned audience response took its toll, and Anno fell into a deep depression. It was only later that he was coaxed back into the fold for a series of theatrical releases that attempted to fix the conclusion, culminating in *The End of Evangelion*, a challenging and confrontational

FURTHER VIEWING

As alluded to above, the *Neon Genesis Evangelion* franchise is sprawling, confounding and, in many ways, self-contradictory. *You Are (Not) Alone* kickstarts the *Rebuild of Evangelion*, Hideaki Anno's fresh retelling of the series, so feeds neatly into its sequels, each with similarly convoluted titles: *Evangelion: 2.0 You Can (Not) Advance* (2009), *Evangelion: 3.0 You Can (Not) Redo* (2012) and *Evangelion: 3.0+1.0 Thrice Upon a Time* (2021). Beyond that, the original 26-episode series and its confrontational feature-length conclusion *The End of Evangelion* are rougher around the edges, but rightly inspired a rabid cult fanbase that rages to this day. When it comes to Anno's long and eclectic career, *Evangelion* tends to hog the limelight. For a taste of his early promise, marvel at the God Warrior sequences in *Nausicaä of the Valley of the Wind* or enjoy his series-length, Miyazaki tribute *Nadia: The Secret of Blue Water*. His experimental live-action films *Love & Pop, Shiki-Jitsu* and *Cutie Honey* are perfect showcases for his more idiosyncratic creative impulses, while the recent *Shin Godzilla*, which subversively tied up the monster movie genre in bureaucratic red tape, proved to be a hit both with critics and at the box office.

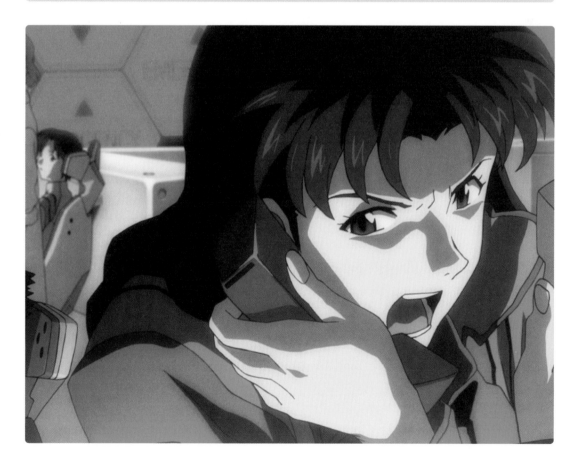

Opposite: Pilot scheme. Along the way, Shinji meets other youngsters who commandeer their own Eva units, including the enigmatic Rei Ayanami.

Above: Red alert. As well as being an explosive action story, *Evangelion* is equally focused on the challenges of human communication.

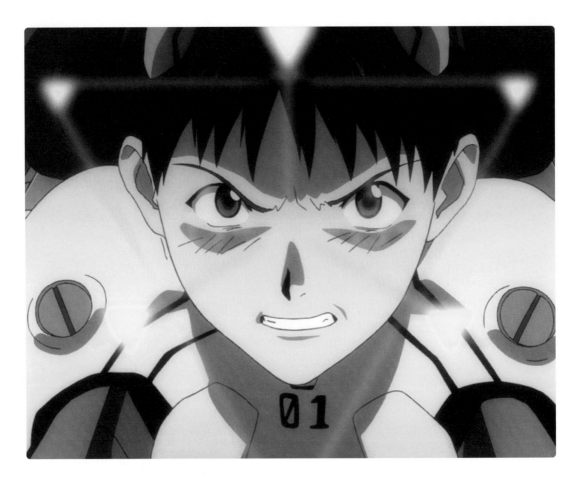

film that turned the camera on both the creator of the work and his fans to offer a 'true', definitive ending.

However, not long after the series' 10th anniversary, Anno found himself returning once more to the series, initially inspired by the idea that Japanese pop culture needed new evergreen franchises that could be adapted for fresh retellings with every generation (much like *Godzilla*, *Kamen Rider* and *Ultraman*, three live-action series he would later supervize, as part of a shared cinematic *Shin* universe). Could Evangelion fit the bill? The *Rebuild of Evangelion* series was a four-feature exploration of that idea, with Anno returning to the characters, setting and themes with a new perspective. 'The time has changed,' he told Collider. 'The world is now a different place from back then. And I am different.'

To mark this new phase, Anno left Gainax and set up a new studio, Khara, adopting the Greek word for 'joy', and embarked with a broader canvas and a vast budget, starting with *Evangelion 2.0: You Can (Not) Advance*,

which roughly lines up with the narrative terrain sketched out in the first handful of episodes of the original series. Anno described this as a safe, familiar starting point: for newcomers fresh enough, and for the hardened faithful offering enough points of difference to intrigue (from high-def digital animation techniques to sly winks and references), effectively bringing the audience together before a departure into the unknown. And while it's often said that journeys are more important than destinations, the *Rebuild* series ended in 2021 on a high: *Evangelion: 3.0+1.0 Thrice Upon a Time* received critical acclaim and a Japanese Academy Award, finishing in the top spot in the year-end tallies at the Japanese box office. It also benefited from the largest international rollout enjoyed by any of Anno's works to date, thanks to a distribution deal with Amazon Prime Video.

Above: Get in the robot, Shinji. The struggles of *Evangelion's* protagonist for acceptance and happiness mirror those of creator Hideaki Anno.

EVANGELION: 1.0 YOU ARE (NOT) ALONE – REVIEW

The *Evangelion* franchise is stuffed with Christian imagery. There are explosions shaped like crucifixes, a spear named after the one that lanced Jesus and a flood of characters seemingly christened from *The Big Book of Old Testament Names*. There's debate about how much all that biblical knowledge actually adds to the series, and how much is just for cosmetic pomp, but with this film, and indeed the entire franchise, it's clear Hideaki Anno knows a thing or two about resurrections.

You Are (Not) Alone is a great way of trying *Evangelion* on for size, because this sprawling, chaotic, but extremely beautiful story is not one that fits all. On the small screen, the story of teenage Shinji Akari and his Sisyphean cycle of getting in and out of a giant robot to fight invading alien forces, is a strange, repetitive and avant-garde tale. The first half of the series leads with city-levelling destruction, while the back half is more interested in razing its characters entire psychological make-up. It's fascinating to watch unfold, the series drifting from monster-of-the-week action spectacle to existential, self-reflexive monologues over 26 short episodes.

The first of the *Rebuild* films – which retell the story in feature length, with new characters, details and a slight reshuffling of the narrative – *You Are (Not) Alone* manages to be a superbly entertaining blockbuster, a rewarding emotional experience and an enriching addition to the world of *Evangelion*. Not bound to the tight, attention-grabbing restrictions of TV, this is a more luxurious and satisfying viewing experience than the equivalent opening episodes of the show. Anno takes time to build the world of Evangelion, not just through verbal exposition (of which, admittedly, there's still quite a bit) but through the detailing of his dystopia. There's huge pleasure found in the patient approach to world building made possible by long form. The city of Tokyo-3, built over an enormous cavity in the earth and featuring retractable skyscrapers, is given the glorified sightseeing tour such a unique work of engineering deserves. The same observational clarity goes for the operating systems of NERV, the agency fighting the aliens: their software and interfaces are all beautifully designed and intricately engaged with. On a limited budget, the TV series had to rely on recycling the same shots of buildings and computer screens, limiting its scope. Here, the composed curiosity for this city and its mechanics not only makes for a fascinating, enveloping experience, but makes the threat of destruction more intense.

There are numerous battles between Evas (the robots, piloted by Shinji and other troubled teens) and Angels (the aliens), the episodic nature of which is unsurprisingly better served in episodes, thus making the film feel repetitive in structure. However, these battles also showcase Anno's skill with character creation and animation. Having shown his prowess for gloopy, nightmarish giants with his unforgettable God Warrior in *Nausicaä of the Valley of the Wind*, he privileges us here with even more towering, horrifying creations. The Evas are a surprisingly human and bulbous amalgam of sinewy flesh and metal that crunches, pops and squelches in combat, raining blood across the city. The Angels are more fluid, their unknowable, almost liquid form and screeching sounds offering a terrifyingly mysterious enemy and a showcase for the animator's skill at creating hypnotizing momentum.

In terms of character, there's a primary focus on Shinji, with the rest of the ensemble laid out on the narrative chess board, but not really played with much – yet. Shinji is a frustrated and repressed teenage boy, his search for paternal, platonic and romantic relationships stunted at every turn, his rare outbursts perfectly suited for weaponization. With some rejigging of the series structure, though, Shinji is given a rare sense of satisfaction and appreciation by the finale, making a surprisingly neat arc for a story that wasn't initially written for this form. Viewed individually *You Are (Not) Alone* may not convince viewers that *Evangelion* is one of the holy texts of anime, but as an intriguing taster for the curious, its second coming will certainly leave some converted.

REDLINE

レッドライン

FASTER AND FURIOUSER

Fasten your seat belts! This full-throttle gearhead anime sees daredevil driver JP fight for survival in the fast and furious world of underground racing, with the dream of competing – and maybe even winning – the galaxy's most popular race, the deadly, risk-filled Redline.

2009

DIRECTOR: TAKESHI KOIKE

102 MINS

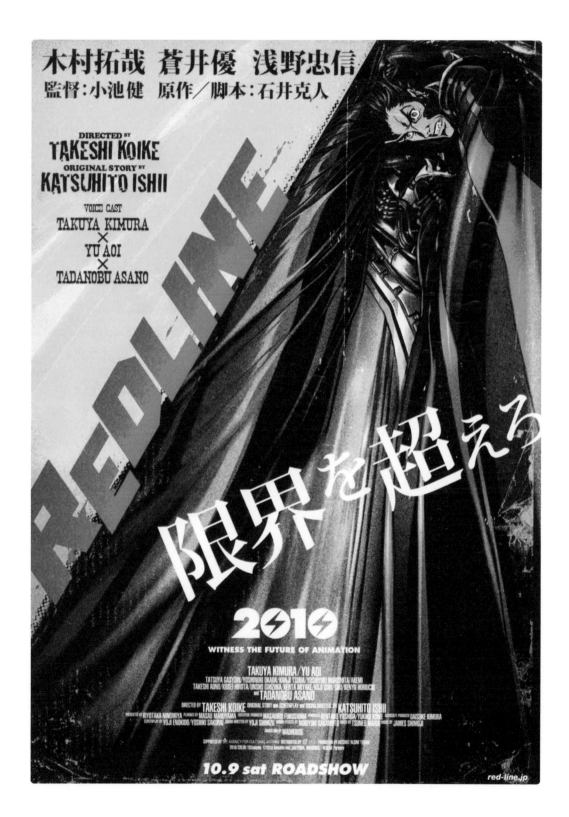

When Quentin Tarantino decided to include an anime interlude in his stylish, homage-laden martial arts action flick *Kill Bill Vol.1*, he went straight to the source and commissioned Production I.G., the studio behind worldwide cult hits such as *Ghost in the Shell*, to do the honours. His friend Katsuhito Ishii, a director whose films have a surreal, oddball vibe that sometimes resembles live-action anime, was tasked with contributing character designs. Ishii left the project inspired to create a feature-length animation that harnessed the same expressive energy as the Kill Bill sequence, and one that would court the same Western audience as Tarantino. 'When we were first putting the film together,' Ishii recalled, 'we were imagining the audience as those kids in America's Midwest who have nothing fun to do but fiddle with cars. We wanted to send a message to those kids... and it'd be great if they watched it without even realising it's not from their own country.'

The result was *Redline*, a hi-octane, sci-fi racing film that puts pedal to the metal and never pauses for breath. Working with the animation studio Madhouse (*Ninja Scroll*, *Metropolis*), Ishii's favoured director was Takeshi Koike, one of the company's star animators who

had made his directorial debut with the *World Record* segment of the *Animatrix* anthology film, and who was at that point leading on the pilot of one of Madhouse's globally minded projects, *Afro Samurai*. Ishii would work as producer, providing character designs, world-building and a creative spark to inspire Koike, a fan of chaotic Hollywood car race comedy *The Cannonball Run*, to run wild. 'Projects like that are usually a no-go,' Ishii told the *Japan Times*. 'But the president of Madhouse at the time, Masao Maruyama, really valued Koike's opinion, and Koike really wanted to do it.'

In defiance of prevailing contemporary trends in the early 2000s, *Redline* was fully hand-drawn, with reportedly 100,000 individual drawings created over

Below: Pet stop. *Redline*'s intense, all-encompassing sci-fi world features aliens and anthropomorphic animals appearing alongside human characters.

Opposite top: Wacky races. *Redline*'s roster of racers is stuffed with colourful and compelling characters, such as Sonoshee McLaren.

Opposite bottom: Need for speed. *Redline* heightens its gas-guzzling action by stretching cars across the screen.

the course of a protracted production that dragged on for several years. But it was all in service of the intended effect that Koike and Ishii wanted to capture – as if the very screen was throbbing with energy as cars and characters warp and distort at high speed, in concert with James Shimoji's pounding, pulsing score. 'You can't get that feeling from CG,' Ishii explained, 'that feeling you get when you finish watching. It's kind of like feeling drunk.' Koike agreed and said: 'The excitement of hand-drawn animation is necessary for my work. That's what it means to draw by hand.'

Below: Burnout. To reach the finish line, both JP and director Takeshi Koike push everything to the limit.

Opposite: Under the bonnet. Beyond the big race, *Redline* satisfyingly sketches out the seedy underbelly of unique alien worlds.

REDLINE – REVIEW

Some of the films in this book need to be approached with a meditative open mind while others need steely focus. This one needs a seat belt. *Redline* is an unrelenting kinetic explosion that alloys the murky galactic underworlds of *Star Wars* with the lineal g-force of *Mad Max: Fury Road*. Ride along with it and you'll get a frantic, physical and surprisingly beautiful front seat in one of the most intense, and most fun, anime films of the 21st century.

The story of 'Sweet' JP and his quest to win the biggest car race in the galaxy is both extremely complicated and decidedly simple. *Redline* serves up rich world-building that will satisfy sci-fi fans hungry for another tome of intergalactic lore but the details never impinge; they're always strengthening the narrative core, which is just about who gets the chequered flag. The planets in *Redline* aren't sleek, wax-polished utopias, but grimy, seedy dens of mischievous illegality – and all the better for it. The minutiae of extraterrestrial life, subcultures, TV news and nightlife are parked in between engine revs, painting a vivid interplanetary landscape of familiar sporting camaraderie and competition. And it's painted like nothing else.

Once the pedals get pressed, *Redline*'s rubber form burns on screen. Drawn in high-contrast thick lines, characters and cars stretch and squeeze as if the power of their engines is pulling them beyond time itself. JP and his fellow racers bounce around every corner, plastering it in their vibrant paintwork and exhaust fumes, their wacky racing compellingly madcap but so well-staged it never gets baffling. It's off the grid, in the sidelines and viewing towers of *Redline* that more depth to the story is sketched. In the media circus that surrounds the drivers, those same elastic faces are distorted through camera lenses, replicated and exploited in news shows and advertisements, with characters caught in their own persistent race between greed and integrity.

Despite JP's overcompensating vehicles and pompadour hairstyle – and some self-aware gratuitous nudity that needn't have made it past storyboarding – there's a strange adolescent charm and innocence to *Redline*. Even with its extreme cartoonishness and utter disconnect from reality, it's hard not to get slightly invested. A giant living weapon (lifted straight from *Nausicaä of the Valley of the Wind*) wielded by a fascistically styled army adds some unnecessary bonus destruction to proceedings but a delirious final act deployment of Chekhov's nitrous oxide soon makes it forgotten. *Redline* is unhinged, breathless and unique. Take it out for a spin and you'll be high off the fumes.

GIOVANNI'S ISLAND

ジョバンニの島

COME AND SEA

As the Second World War comes to an end, two brothers' lives are
irrevocably changed when the island of Shikotan, where they live, is
occupied by Soviet forces.

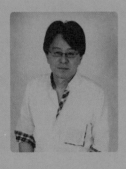

2014

DIRECTOR: MIZUHO NISHIKUBO

102 MINS

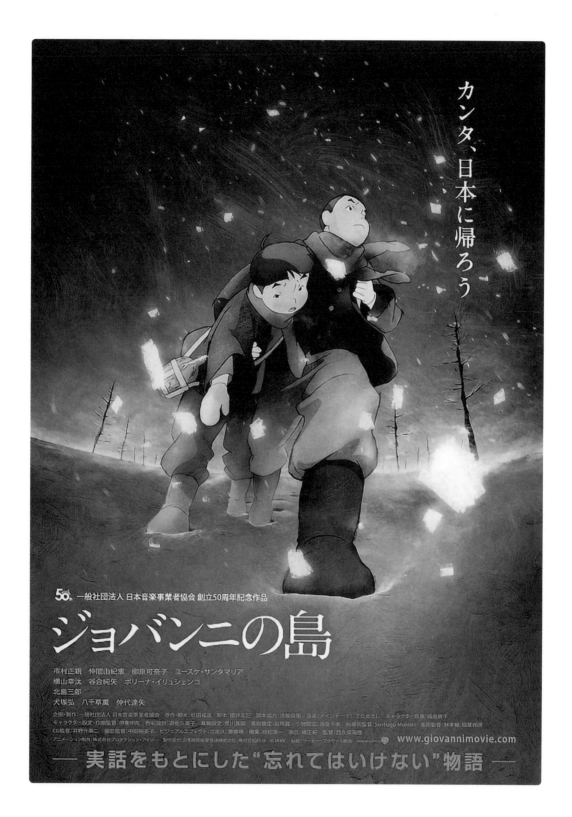

With a career stretching back to the 1970s, director Mizuho Nishikubo has an enviable CV, working on series ranging from the historical epic *The Rose of Versailles* to the international co-production *The Mysterious Cities of Gold*. However, even three decades into his career, there was one genre he still wanted to crack. Speaking to Anime News Network, he said: 'I've always been very interested in the historical period from the 1930s onward, when Japan relentlessly throws itself into conflict one step after another. I confess I had always wanted to confront myself with a story set in that period.'

Then a project landed on his desk, set in the final days of the Second World War and addressing a rarely discussed part of its history: the occupation of the Kuril Islands, an archipelago between Japan and Russia which has been disputed territory since 1945. The idea had been developed by writer-director Shigemichi Sugita, initially as a novel and then as a live-action feature, and what would become *Giovanni's Island* finally found its home at animation studio Production I.G. Inspired by the childhood memories of a gentleman named Hiroshi Tokuno, the story follows a 10-year-old

boy called Junpei living on the island of Shikotan as the Soviet occupation occurred.

The decision to adapt the story for animation allowed the filmmakers to avoid tricky political waters when depicting disputed territory, and gave Nishikubo a broad canvas for his creative vision. To complement the very real historical details of the film, he added a fantastical element, drawing heavily from Kenji Miyazawa's metaphysical children's story, *Night on the Galactic Railroad*. Not only would the story provide 'a sort of psychological driving force' for the characters, who read the book in the film, it would also contribute to the thematic texture of *Giovanni's Island*, lending the question that Nishikubo understood to be the heart of Miyazawa's story: What is true happiness for all?

Below: Young girl Tanya, the daughter of the occupying Russian commander, befriends Shikotan islanders Junpei and Kanta.

Opposite top: Brothers in arms. Siblings Junpei and Kanta struggle to survive in a time of conflict.

Opposite bottom: Stepping stones. To enrich your viewing of *Giovanni's Island*, follow it with metaphysical fantasy *Night on the Galactic Railroad*.

This ambitious intertwining of the present, the past and the imaginary seeped through into the film's mixture of animation styles. The frame narrative presents a more realistic animated world marked by digital techniques, while childhood memories shift between the vivid and the washed-out. These looser character designs and pencil-crayon backgrounds contrast with the world of the imagination, which alternates between electric-blue surrealism of a celestial train ride and vibrant scenes of doodles come to life. To achieve this mix of styles and tones, Nishikubo needed a crack team of animators, and he worked with some of the best, including the great Toshiyuki Inoue, a prolific and in-demand artist whose credits are impeccable. Reportedly described by Mamoru Oshii as 'the perfect animator', Inoue has left his fingerprints on many films in this book, from *Akira*, *Royal Space Force* and *Ghost in the Shell* to *Jin-Roh*, *Miss Hokusai* and *Millennium Actress*.

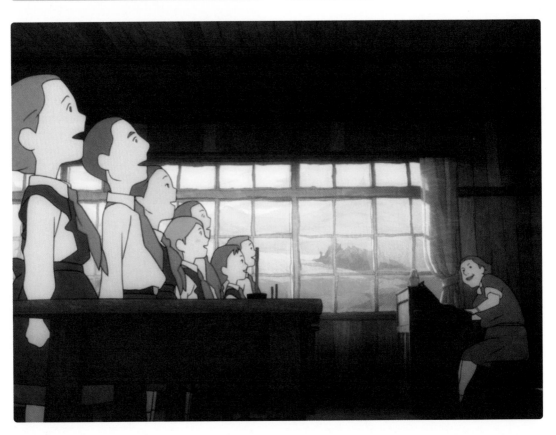

Above: Class warfare. The film depicts the occupation of the island of Shikotan, which saw Japanese and Russian families forced together.

Opposite: The medium of animation allowed director Mizuho Nishikubo to recreate the disputed territory of the Kuril Islands.

GIOVANNI'S ISLAND – REVIEW

Giovanni's Island is one of the most tender, carefully observed and inspiring films you'll find in these pages. Set in the last days of the Second World War during the Soviet occupation of the island of Shikotan, it's a story sparkling with joy and appreciation for life, and showing how, even when all of that joy has been destroyed, the right stories can help it germinate again.

An adaptation of *Night on the Galactic Railroad* has its own chapter in this book, but the impact of Kenji Miyazawa's most famous work is such that *Giovanni's Island* wouldn't exist without it either. Mizuho Nishikubo's film, like Miyazawa's work and Gisaburō Sugii's adaptation, follows two young characters as they navigate a strange and confusing world on the road to facing their mortality. Their father, the chief of the island's fire department and a bastion of defence against the Soviets, reads to them from the book, and the boys are even named after its lead characters. In both stories, the chance of a magical train ride appearing from the stars offers a guide track through life, and a route to navigating the traumas of the home.

Taking place in the fallout of the war, and focusing on child protagonists, the film recalls canonical works like *Grave of the Fireflies* and the *Barefoot Gen* series but navigates its own way through the rubble. The art style, which rests softly coloured and roundly shaped characters on a wash of intense crayon backgrounds, gives it a distinct visual quality. The innocence of the characters is reflected in their simplicity, while the landscapes, struck with visible lines, offer a sense of memorialization and an engrossing artistic tactility. In contrast to the detailed reality, when the boys recall their beloved imagined railroad, the screen flows with loose fantastic colour and movement that defies physics, enchanting them into their escape.

The first half of the film takes huge effort to capture the minutiae of life on Shikotan, from avian life to school assembly hymns. Paper planes and train sets connect Japanese and Russian children, their languages transcended by the instant ability to befriend beyond borders; and it's the observation of these pure actions that makes the back half of the film so heart wrenching. The long shadow of the war creeps over the story gradually, before fully enveloping it. Charming playground national rivalries disappear, rations are stolen, families are split up and innocent children escape into imagined galactic train rides for as long as they can. It's a beautiful story, but after wiping away the tears, you'll struggle to go back for a return journey.

MISS HOKUSAI

百日紅

STATE OF THE ART

The story of Katsushika Ōi (known as O-Ei), a talented artist living in 19th-century Japan who supported, and was overshadowed by, the work of her father: the legendary, influential artist Katsushika Hokusai.

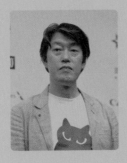

2015

DIRECTOR: KEIICHI HARA

90 MINS

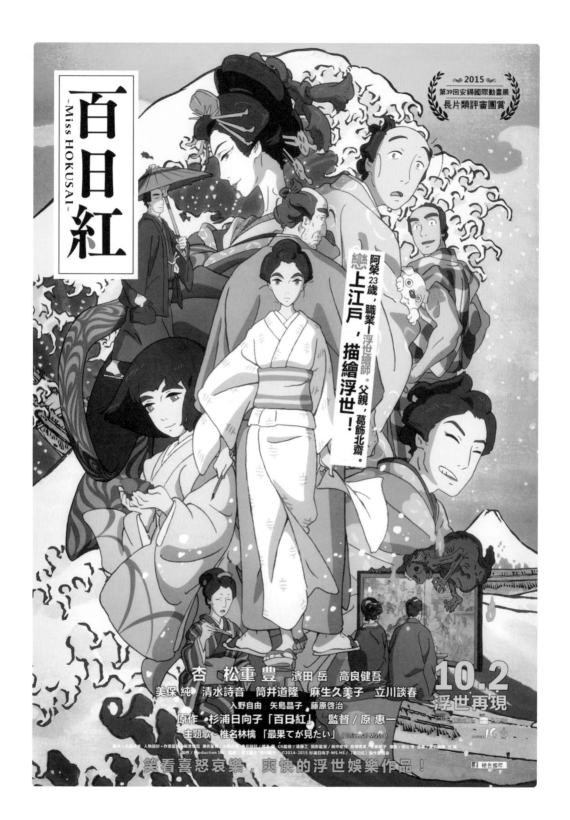

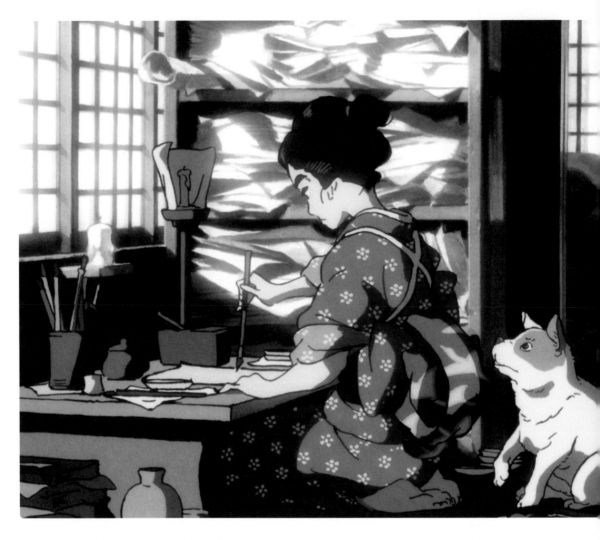

Born in 1959, Keiichi Hara started working at the animation studio Shin-Ei in 1982. For over 20 years he worked on Shin-Ei's hugely popular family franchises *Doraemon* and *Crayon Shin-chan*, directing the latter on television and the big screen for a dozen years. In Japan both franchises are national treasures, and Hara served as one of *Crayon Shin-chan*'s key creative forces, writing and directing several features, including the highly acclaimed *The Storm Called: The Adult Empire Strikes Back* in 2001 – a film lauded by esteemed Japanese film magazine *Kinema Junpo* as one of the greatest animated feature films of all time.

After serving for two decades in the franchise realm, Hara branched out into independent work, quickly establishing himself as a distinctive voice on the international

stage. 2007's *Summer Days With Coo* and 2010's *Colourful* were both nominated for Animation of the Year at the Japanese Academy Awards and screened at festivals around the world, the latter picking up the Audience Prize and a Special Distinction award at the Annecy International Animated Film Festival. Hara then changed lanes, directing the live-action biopic *Dawn of a Filmmaker*, following the early years in the life of director Keisuke Kinoshita (*The Ballad of Narayama*, *Twenty-Four Eyes*) and making clear the inspiration that he draws from Japanese filmmakers such as Kinoshita and his contemporary, Yasujirō Ozu.

His next feature, *Miss Hokusai*, would reach further back in Japanese cultural history to tell the story of Katsushika Ōi, the artist who worked in the shadow of her father, Katsushika Hokusai, the pioneering ukiyo-e painter

and printmaker. The script was adapted from the historical manga series *Sarusuberi*, by Hinako Sugiura, which ran in the magazine *Weekly Manga Sunday* throughout the mid '80s. Hara had been a fan of Sugiura's work for decades, telling Anime News Network: 'I discovered Sugiura's work when I was in my late 20s, and I always thought her manga were very cinematic. *Sarusuberi* is my favourite among Sugiura's works. I love its seamless transitions between the mundane and the supernatural, and the masterful depiction of human emotions and interaction among characters.' It's fortunate, then, that when he was between projects and still tempted by the idea of adapting the manga for the big screen, the film came directly to him: production I.G. head Mitsuhisa Ishikawa approached him with the offer to direct. 'Of course, I didn't say no.'

Above top: Portrait of the artist as a young woman. *Miss Hokusai* explores the craft and lifestyle of a painter working in the 19th century.

Above bottom: Paws for thought. *Miss Hokusai*'s detailed animation brings the vivid details of an artist's studio (and its inhabitants) to life.

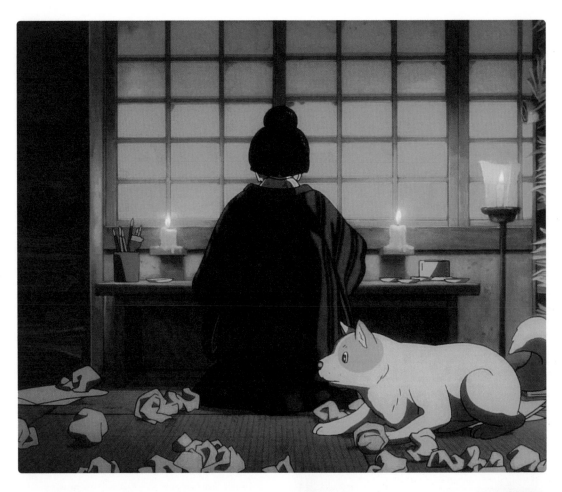

FURTHER VIEWING — 👁

For more contemporary films that follow young women as they develop their artistic voices, try Mamoru Hosoda's *Belle* or Yoshifumi Kondō's beautiful and wise Studio Ghibli gem *Whisper of the Heart*. Or, if you'd prefer films that use history as a backdrop for artistic journeys, look to *In This Corner of the World* and *The Wind Rises*, two dramas in which characters hone their crafts (painting in one; engineering in the other) all while in the shadow of war. A more left-field suggestion, though, is Satoshi Kon's *Millennium Actress*, a film that creatively intertwines a reclusive actress's life story with the films in which she starred.

Above top: Highlighting patience, dedication and endless re-drafting, this film is essential viewing for all burgeoning artists working in any form.

Above bottom: Brushing up. *Miss Hokusai* recreates examples of contemporary Japanese painting as a tribute to its enduring appeal.

Opposite: O-Ei struggles against not just her father's legacy, but the pressures and expectations women faced in 19th-century Edo.

MISS HOKUSAI – REVIEW

It's a shame that the English language release of *Sarusuberi* was called *Miss Hokusai*. This is the story of O-Ei, the daughter of one of Japan's most famous painters, and her life beyond her father's name, as she stepped out from under the Great Wave. She's an inspiring artistic and political figure, rejecting expectations of women and art, painting over the patriarchy, and becoming so much more than just 'Miss Hokusai'.

Forgive this titular betrayal, though, because the film itself is wonderful. Relatively episodic in structure, it follows the brusque but thoughtful O-Ei, who works in her father's busy studio. Surrounded by other artists, she navigates tasks of both creative and personal intimacy, her pragmatic processes occasionally colliding with the mysterious astral realm of artistic inspiration. After accidentally ruining a painting of a dragon, she must quickly mimic her father's style, and the storm outside helpfully, majestically, reveals a dragon to her. Another curious episode focuses on a tortured woman whose neck expands in the night, a ghostly, luminescent spirit snaking out of it, visible to the painters observing. These are the visions of artists who see the fantastical drama of nature and vividly empathize with the pain inside others.

The strongest narrative thread is between O-Ei and her half-sister O-Nao, a blind and sickly child, whom Hokusai refuses to visit. Through O-Nao the film opens up to explore the sensory experiences of nineteenth-century Edo (now Tokyo): the sounds of street traders and carriage wheels and the touch of a river on the fingertips evoke a reaction from her that is stronger than the reactions of any of the painters to their own work. When O-Nao first experiences the soft thumps of snow falling from a tree on her head, her joy recalls the moment when a furry forest troll feels rain through an umbrella in Hayao Miyazaki's *My Neighbour Totoro*. It's these moments with her half-sister that show O-Ei that observing the world is not the same as experiencing it – a lesson that the film shows her father never undersyood, and one that comes to define O-Ei's differing and valuable artistic approach.

Stylistically the film reserves a lot of the visual winks and references to Hokusai that a less confident work might use as a crutch. O-Ei's Edo is slight and unfussy, with the result that sparing familiar imagery – like a sister's boat ride into a recognizable crashing wave – has more pointed, triumphant impact. It's in minor details that the animation is at its strongest, showcasing the intricacies and skill of brushwork or the dopey yawns and padding around of a bored studio dog. One surprising flourish is in the final seconds of the film, when the skyline of Edo cuts to the same viewpoint of modern Tokyo. It's a reminder that the cultural icons who built the artistic identity of the present megacity are not necessarily the people you expect.

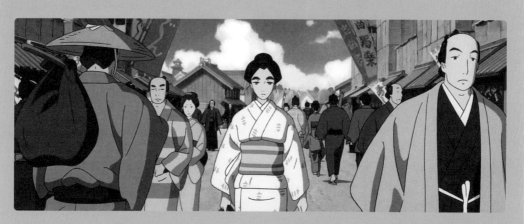

YOUR NAME

君の名は

YESTERDAY, TODAY AND FOREVER

A pair of high schoolers develop a magical and inexplicable connection when they start to swap bodies at random. After spending time in each other's shoes, they decide to try and meet – something which, it turns out, is easier said than done.

2016
DIRECTOR: MAKOTO SHINKAI
107 MINS

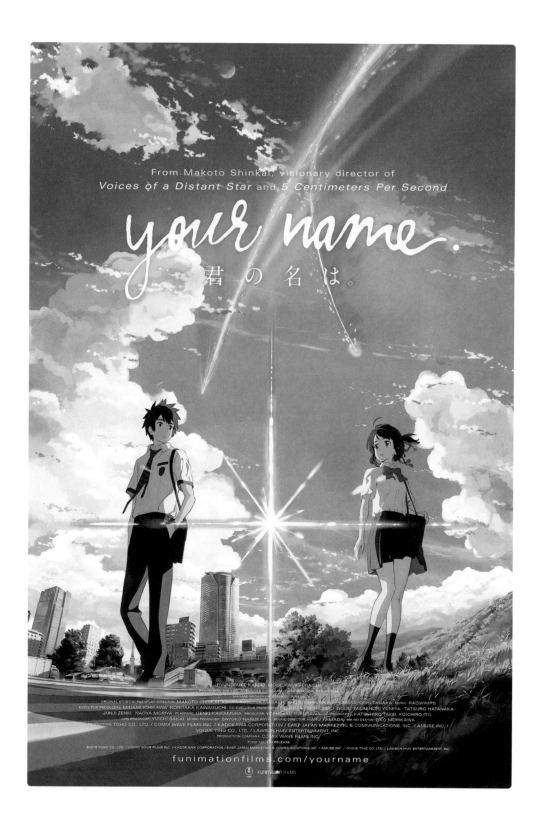

It seemed unthinkable at the time. For over 15 years, Hayao Miyazaki's *Spirited Away* had reigned as the highest-grossing Japanese film of all time on the global stage, bothered only by Miyazaki's subsequent films *Howl's Moving Castle* and *Ponyo*. Then, a high-concept teen romance directed by Makoto Shinkai, a rising anime star who started his career self-animating his work in his spare time, became a runaway smash hit at home and abroad, and eventually toppled *Spirited Away* from pole position internationally.

Your Name's time in the top spot might only have been short – a canny re-release found *Spirited Away* reclaiming its crown, and then the juggernaut blockbuster *Demon Slayer the Movie: Mugen Train* scaled to unforeseen heights in 2021 – but its success was historic, and signalled a necessary change in the animation industry, a generation shift both for those making and those watching anime.

Born in 1973, Makoto Shinkai grew up in Nagano Prefecture, in what he has described as 'the sticks'. As a youngster, animation blew his mind. When he was in junior high school, he had his horizons broadened by a trip to the cinema to see Miyazaki's *Castle in the Sky*. Looking

back in 2017, he recalled: 'that was the first movie I went to see with my pocket money, that I paid for myself – and it was great. There was nothing like it.' He later caught up with Miyazaki's earlier films, *Nausicaä of the Valley of the Wind* and *The Castle of Cagliostro* on VHS, watching them over and over again, planting a seed that would take decades to grow.

From there, his route to animation was wayward. A keen reader, Shinkai studied Japanese literature at university, and became an avid devotee of contemporary fiction, in particular Haruki Murakami and his distinctive approach to everyday lives and themes. After graduating, Shinkai found himself working for the video game company Nihon Falcom, a long-running developer and publisher with a reputation that rests on role-playing adventure game franchises such as *Ys* and *The Legend of Heroes*.

Below: The writing's on the arm. *Your Name's* young characters use unlikely ways to communicate with each other between body swaps.

Opposite: In one of *Your Name's* most moving sequences, our time-crossed lovers finally meet, if only momentarily.

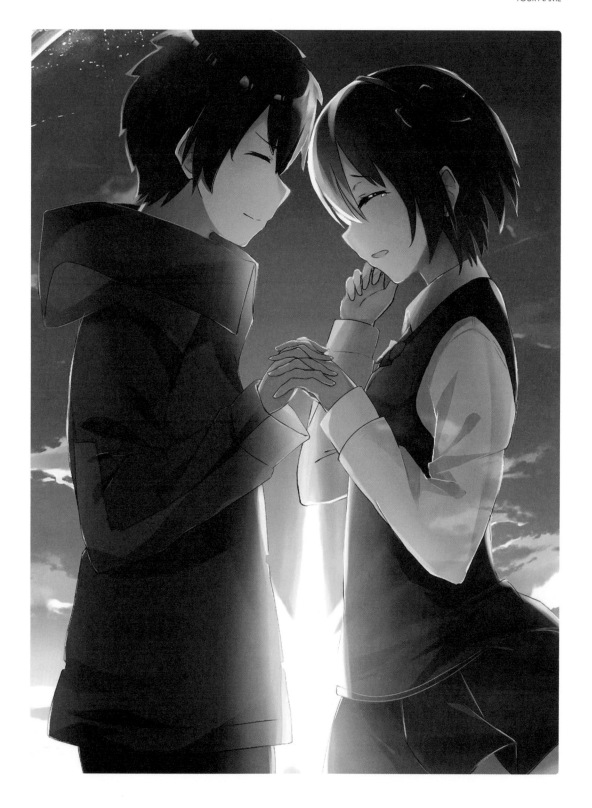

FURTHER VIEWING

Weathering With You, Shinkai's follow-up to *Your Name*, is a similarly high-concept tale of boy-meets-girl, albeit with an environmental twist, as the girl has a curious connection to the climate in Tokyo. Elsewhere, the slice-of-life romance genre yields many heightened, heartbreaking gems, from Shinkai's own *5 Centimeters per Second*, to the time travel-themed *The Girl Who Leapt Through Time*, *When Marnie Was There* and *Fireworks*. Hardcore *Your Name* fans, though, might want to go directly to the source: thanks to Shinkai's photorealistic approach to his filmmaking, you can visit locations for many of the key scenes from the film in Tokyo, and, if you wish, recreate them (as we did in 2019).

There, Shinkai was given the freedom to hone his talents, contributing art, graphics and animation to several of the company's games.

Toshihiro Kondo, one of Shinkai's contemporaries at Falcom who would later become the company's president, told Eurogamer that this era was full of opportunities for young and industrious workers to make their mark: 'When I entered the company, and when Makoto Shinkai came into the company, neither of us had any real skills. But the company was able to see the ability within us and other employees, and foster that ability and allow it to grow.'

It was during this tenure at Falcom that Shinkai started to moonlight on his own projects, creating the short film *She and Her Cat* almost entirely by himself. The resulting short was five minutes long, and he distributed it by burning 5,000 CD-R copies and selling them through fan circles and conventions. This DIY approach continued with the

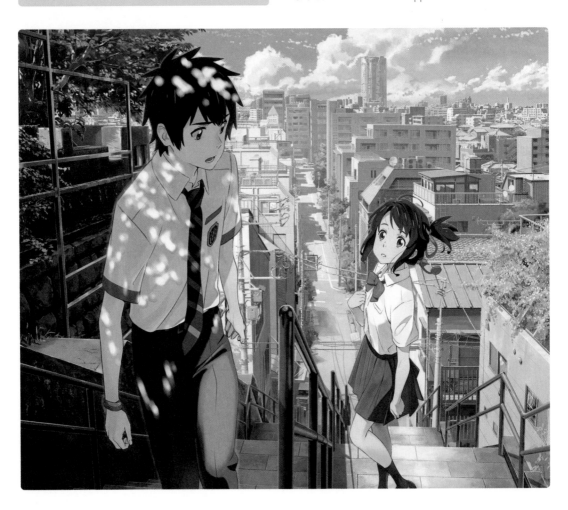

25-minute short *Voices of a Distant Star*, which was wholly animated on Shinkai's home computer, a Power Mac G4, over the course of seven months. Another grassroots hit, it has been touted as a watershed moment for a new generation of animators, the point where consumer technology granted those outside the industry the power to create and innovate in their own way.

After this much-hyped breakthrough, Shinkai made his feature-length debut in 2004 with the alternate history, sci-fi romance *The Place Promised in Our Early Days*. While he worked with a larger team on the project, he retained a few key creative credits for himself, including editing, storyboarding and cinematography – roles he would continue to perform on many of his later films.

However, much like his idol, Haruki Murakami, Shinkai would move between longer and shorter-form works, including the fan-favourite drama anthology *5 Centimeters per Second*; the Miyazaki-style, feature-length fantasy adventure *Children Who Chase Lost Voices*; and the mid-length *The Garden of Words*, a high-definition experiment that captured Tokyo in the rain with breathtaking detail.

Unlike many of his contemporaries, Shinkai remains a true independent, consistently working with the small animation company CoMix Wave Films, overseeing adaptations into manga and prose novels, and creating work that reflects the multimedia diet of the day, often falling into the cracks between traditional TV series and features. When asked about the theatrical release of *The Garden of Words*, he told Anime News Network that he hadn't envisioned the film on the big screen: 'I wanted this movie to be something that people can enjoy on their computers, tablets and personal home theatre screens; to enjoy like music in their spare time and provide a little bit of relaxation.'

But then came *Your Name*, the blockbuster behemoth that stole Miyazaki's crown. Much of its success when it was released in 2016 was chalked up to how the film gave Japan a much needed moment of catharsis, five years after the Tōhoku earthquake that precipitated the Fukushima nuclear disaster. The film's knockabout body-swap romance gives way to disarming poignancy, when it is revealed that the characters are separated not just by physical distance but by time as well, living either side of a terrible, tragic calamity. 'I've changed and society has changed, so my motivation is different with this film,' Shinkai said. 'I wanted to create a story of recovery. You can't change the past in real life, but you can change the past in a movie.'

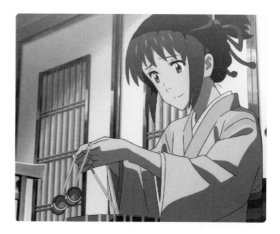

Opposite: 'Your name is?' – the final moments of *Your Name*, and its location, have become legendary for anime fans.

Above: *Your Name*'s collision of urban and rural, contemporary and traditional, yields many small moments of well-observed beauty.

THE NEXT MIYAZAKI

It's a question that has plagued anime for over a generation: who is the next Hayao Miyazaki? Many of the filmmakers in this book have been touted as the heir to the throne once the Studio Ghibli legend finally, definitively, retires, including Hideaki Anno, Mamoru Hosoda, Hiromasa Yonebayashi, Hiroyuki Okiura and Sunao Katabuchi. Since the record-breaking success of *Your Name*,

Makoto Shinkai has become the front runner, but such thought experiments are best left as idle chatter: animation is made better by the rise of a new generation of artists who are distinctively themselves. 'It's inevitable, because Miyazaki is so famous,' Shinkai has said. 'But... you can't be Miyazaki, you can only be the second Miyazaki, and that isn't something to aim for.'

Tokyo is, understandably, one of the biggest tourist destinations in the world. Millions make the journey, whether they're exploring its huge cultural history, its mouth-watering menus or its eye-popping, ear-pounding multistorey arcades. When the authors of this book were lucky enough to go, sites of historical interest were sighted, sushi plates were piled into double digits and far too much money was lost on claw machines. But on one day we got lost in some thin, grey alleys on the west side of Tokyo because, even with infinite megacity experiences available to uncover, it was absolutely essential for us to visit a nondescript concrete public staircase. That's what *Your Name* can do to you. It wallops you with spectacle, delirious romance and brilliant detail, and you'll travel halfway around the world to get closer to its moments of magic. And get teary-eyed looking at some steps.

Featuring body swaps, wibbly-wobbly timelines and meteoric annihilation, Shinkai's megahit is breathless viewing and those steps are its wonderfully modest final location. It's here that the film (literally) ties a ribbon on its narrative in simple, gentle fashion, before ascending – with most viewers' hearts – into anime history. The story of two teenagers, a city-dwelling boy (Taki) and a girl from the countryside (Mitsuha), who inexplicably start to swap bodies, *Your Name* is a stunning work of animation as well as being an ambitious, rich and rewarding speculative tale.

Taki's Tokyo is a shimmering urban vision – bright, sleek and so astonishingly intricate that it's hard to believe the film is not live action. The type of images traditionally created by the camera – like time lapses, racking focuses and lens flares – further enhance the documentation of this hyper-reality. Sunsets bounce off high-rise steel and windows, washing the city in a dreamy glow. In comparison, the sharp edges and contrasts of the city wash away in Mitsuha's rural home. The cold blues and greys of skyscraping vistas are replaced with earth tones and softly detailed trees and fields. The micro details of the pair's environments are as fascinating as the scenery too. When they realize they're switching bodies, they leave each other messages in their phones, to keep track of events for when they switch back, and so inadvertently spark a deeper connection.

Smartphones are an integral part of modern life, but model types and software can date a story instantly and silent finger tapping on screen is rarely cinematic. However, Shinkai refreshingly leans into the modern dependence on devices, putting a huge amount of effort into the detail and motions of their use. The swoosh of switching apps, the framing of the perfect food photo and the emoji-filled typing of earnest, emotional teenagers get appropriately realistic screen time; and the rhythms of each swipe, snap and tap add to the escalating drama. This same tactility is seen in Mitsuha's work as a caretaker for a Shinto shrine. Observed with respect and anthropological curiosity by Shinkai's focused animation, Mitsuha is bound to historical traditions, crafting a traditional form of sake out of saliva and rice, or patiently braiding together strands of coloured cord that 'represent

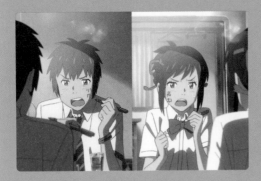

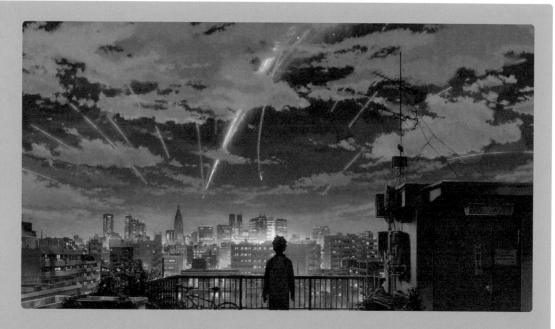

the flow of time'. Whether they're modern, or ancient, the urban and rural activities of Mitsuha and Taki flow together, transcending any temporal binding and highlighting the timelessness of their intriguing, powerful romance.

Your Name is made so compelling by its ability to surprise. A scene of high definition, which showcases the animator's prowess at replicating reality, might be followed by a moment of crisis, when the image erodes into grainy, burning celluloid; or the crisp blue sky might suddenly be filled by the startlingly cartoonish bubbles of a character's thought cloud. This same confidence is there in the jolting, looping narrative too. The film begins by observing the patterns and characters of Mitsuha's life for almost 20 minutes, before making the shock reversal to Taki's point of view and world, and then settling into body-swapping antics. Then, at the halfway mark, that seeming narrative crux disappears, replaced by something far

more apocalyptic. It's a bracingly propulsive story, built on elegantly raised stakes, with seeds of story planted in the rushes of one drama, only to flourish in another. Crucially, each development is bound to emotion rather than logistics. When an impending natural disaster looms, the threat is so intense not due to egregious images of splattering destruction, but because of the composed, enriching environments created, the endearing, unique people within them and what their fate may be. Shinkai isn't interested in the mechanics of fantasy ideas, but instead their ability to be a tool for viewing an alternate view on the world, and making an empathetic connection through that experience. The how doesn't matter.

Just as Taki and Mitsuha seem to be bound together beyond the rules of science, as is their story, to the soundtrack that accompanies them. Composed by Japanese rock band RADWIMPS, the dynamic score moves from blazing electric guitar solos to wistful and delicate piano lines, perfectly in sync with the film's balance of melodrama and meditation. Your Name wonderfully sprinkles magic onto the mundane and grounds the fantastical, beautifully braiding the operatic and the ordinary, and making a trip to see some concrete steps in a back alley a vital, holy pilgrimage.

Opposite left: Vice versa. Your Name's body swap conceit sees two teenagers experiencing each other's lives – with hilarious consequences.

Opposite right: Write handed. Chalking up huge box office receipts, Your Name had audiences in the palm of its hand.

Above: Stargazing. Makoto Shinkai's signature style finds cosmic and ecstatic wonder in modern settings.

A SILENT VOICE

聲の形

SHADES OF GREY

Adapted from Yoshitoki Ōima's manga, *A Silent Voice* follows Shoya Ishida, a bully-turned-loner who wrestles with the guilt of tormenting a deaf girl, Shoko Nishimiya, back in elementary school. One day, Ishida is given an opportunity to fix past mistakes when he reunites with Nishimiya.

2016
DIRECTOR: NAOKO YAMADA
130 MINS

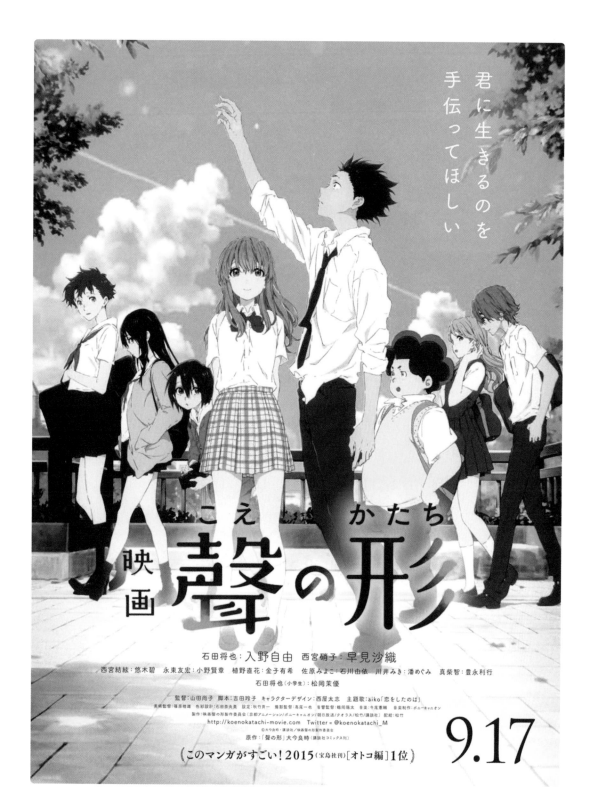

It's a sad and unavoidable fact that when looking at anime (and specifically, feature-length Japanese animation) there are very few female directors of note. The field is overwhelmingly dominated by men, and filmmakers often give careless quotes that reinforce outdated or patently absurd gender stereotypes as a reason for that. However, there are female filmmakers breaking through, most notably Naoko Yamada, star animator and director, who is one of the finest anime filmmakers of her generation.

Born in 1985 in Kyoto, Yamada was a young anime fan, copying images from *Dragonball* and *Patlabor* as she watched them on TV, and falling in love with the likes of *Doraemon*, *Crayon Shin-Chan* and the films of Studio Ghibli. A later viewing of the animated art film *Belladonna of Sadness* left a strong impression. At university, she

studied oil painting and had ambitions of moving into live-action filmmaking. To this day, her tastes remain varied, cineliterate and global, and she counts the filmmakers Yasujirō Ozu, Alejandro Jodorowsky, Sergei Parajanov, Sofia Coppola and Lucile Hadžihalilovic among her favourites.

But Yamada was destined to pursue animation, coming across a job advertisement for an entry-level role at Kyoto Animation at her university career centre. Starting as an in-between animator on the Rumiko Takahashi adaptation *Inu Yasha*, she quickly established herself as a key animator, rising through the ranks while working on the studio's popular series *Air* and *The Melancholy of Haruhi Suzimiya*, eventually graduating to the role of director on the likes of *Clannad*, *Nichijou* and the hugely successful

high school band series, *K-On!*. The latter was her first collaboration with writer Reiko Yoshida (an anime veteran who, among dozens of credits, wrote the screenplay for Ghibli's *The Cat Returns*). A trailblazer, Yamada directed her first episode of television at the age of 23 and her first film at 25.

A Silent Voice, her third feature (and her first that wasn't a spin-off from an established series), was released in 2016 to acclaim at home and abroad. It debuted in cinemas during the record-breaking release of *Your Name*, and competed with that film and *In This Corner of the World* for that year's animation awards, receiving nominations from the Japanese Academy and the Mainichi Film Awards, and winning prizes from the Tokyo Anime Awards and the Japan Movie Critics Awards.

Yamada may now be a major player in Japanese animation, but her love of live-action cinema continues to inform her directing style today. When asked by Andrew Osmond of *Neo Mag* about her fondness for animation, given that many of her projects could feasibly be told in live action, she replied:

'One of the most important things for me in making this film in animation was that I could control everything. Colours; what lens you use; the characters... Every movement of everyone, of everything, even a blink, I can control it as I want it to be. I can control the whole world in the film.'

Above: Loco-emotion. Trains provide pivotal locations in anime, from *A Silent Voice* to *Night on the Galactic Railroad*.

FURTHER VIEWING ⊙

The emotional, everyday textures of *A Silent Voice* open up a whole world of 'slice of life' anime, a subgenre in which Yamada, Yoshida and their colleagues at Kyoto Animation have excelled. *Nichijou* and *K-On!* serve as perfect chasers to *A Silent Voice*, while Yamada's more recent feature *Liz and the Blue Bird* won similar acclaim and international recognition. For another female filmmaker who has thrived in the male-dominated industry of anime, look to Mari Okada, the prolific screenwriter who made her directorial debut in 2018 with the fantasy drama *Maquia: When the Promised Flower Blooms*, an achingly bittersweet meditation on motherhood. In the anime series space, check out Madhouse veteran Sayo Yamamoto, who provided design work for the 'World Record' segment of *The Animatrix* and storyboards for *Redline*. She also directed episodes of series such as *Samurai Champloo*, before directing the series *Lupin III: The Woman Called Fujiko Mine* and the LGBT-themed figure-skating anime, *Yuri on Ice*.

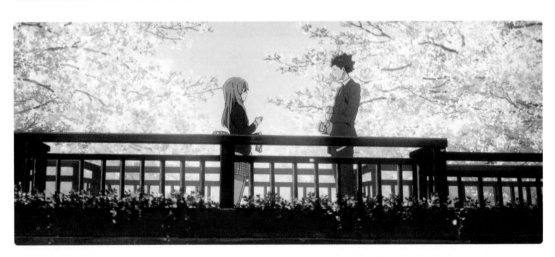

Top: Super group. Despite centring on a single relationship, *A Silent Voice's* supporting cast is full of really memorable characters.

Above: A relationship blooms. Shoko and Shoya's lives entwine and grow together in spite of the bullying that defined their childhoods.

A SILENT VOICE – REVIEW

Exploding with emotion and relentlessly wrestling with philosophy, Yamada Naoko's *A Silent Voice* is a perfect concentration of teenage anxiety, but with far more than an adolescent world view. A confronting, moving and at times repulsive work, this story of redemption is brightly coloured but exists almost exclusively in grey areas.

An opening suicide attempt, followed by a flashback to younger years, suggests the beginnings of a sympathetic tragedy, but lead character Shoya is a hard man to absolve. Making up the first act of the film, these memories show Shoya's deeply unpleasant and unflinchingly realized mental and physical bullying of deaf classmate Shoko. From hosing with water to bloodily ripping out hearing aids, it's discomforting to spend time with Shoko, let alone forgive him. But that's what the film does, it places audiences in the rare and objectionable position of being the school bully and asks for redemption.

After being ostracized for his extreme behaviour, Shoya comes to realize the cruelty of his actions, but rather than kill himself, he attempts to make up for them. Through his pariah status and mental anguish, the film is able to open up stylistically, moving from standard slice of life fare into a more abstract and expressionist space. Big, bold crosses appear on faces, literally stopping Shoya from looking people in the eye. In conversation, even if standing right next to someone, he's rarely shown occupying the same screen space; instead he is placed at the edge of frame, looking out of it, clouds of awkward emptiness surrounding him. Dutch angles and celluloid live-action techniques, like double exposures and light leaks, further push this warping, while simultaneously keeping the story grounded in a recognizable, if contorted, reality.

Although stylistically impressive, *A Silent Voice* is most fascinating for the thematic depth it entrusts to its adolescent characters. Shoya's redemption doesn't come easy, and arguably his slate is never fully clean, and what value does attempting to clean it actually have? The film asks whether a dedication to penance

Above: *A Silent Voice*'s Shoko is a rare but impactful example of anime focusing on a character from the deaf community.

can make a person good, whether there is in fact a selfishness and egotism to that dedication and whether forgiveness can ever be truly achieved. It might seem heavy, but the depth of emotion is felt at the extreme emotional level of any teenager, respectfully meeting them at their own level. Shoya and his classmates all exist in a murky moral space that is seldom reserved for youths, their repellent qualities ultimately making them more embraceable.

Along for the redemption ride comes a collection of Shoya's classmates, all individually searching for their own version of absolution, making the film feel occasionally scattered and frenetic as the unwieldy web of atonement expands. However, each of these individuals offers Shoya a new lesson in understanding the various facets, good and bad, that form him. Surrounded in constant melodrama, the most affecting moments in the film become its silent and gentle signals: sharing a meal, offering an umbrella in the rain, looking, listening. Here, redemption can be found in big actions, but supportive, everyday gestures are equally sacred. Emotional, expressive and markedly dark, Naoko Yamada's film showcases a bold, empathetic and unique cinematic voice.

IN THIS CORNER OF THE WORLD

この世界の片隅に

THE ART OF WAR

A young woman with a flair for illustration and painting comes of age as the Second World War begins, in her town not far from the city of Hiroshima. We watch knowing that the devastating bombings ending the conflict loom.

2016

DIRECTOR: SUNAO KATABUCHI

129 MINS

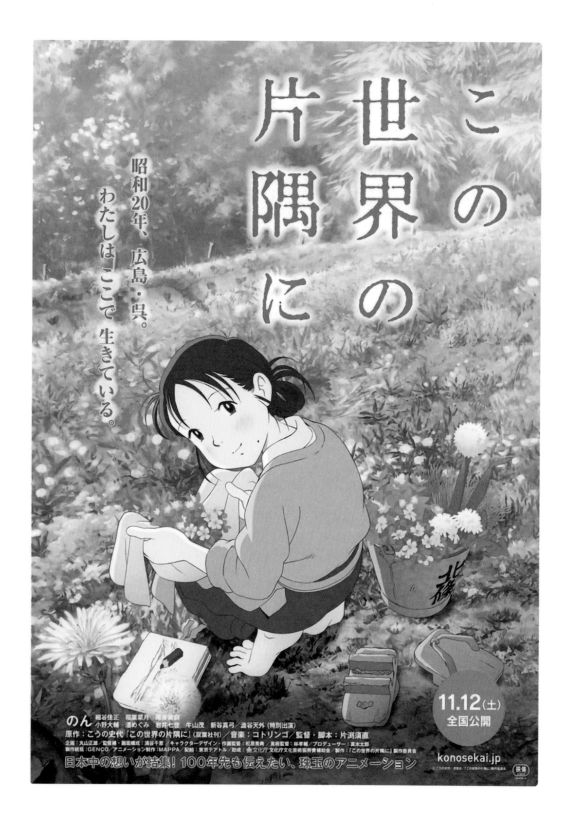

Working in animation can be a long, hard slog. The pay is often dreadful, the hours are unrelenting and the end goals of stability and success can be ever-elusive. When the crowd-funded animated drama *In This Corner of the World* finished in the Top 10 highest-grossing Japanese films of 2016, and later won the Best Animation prize at the Japanese Academy Awards, director Sunao Katabuchi had been toiling in anime for over 30 years. Often working in the orbit of some of the titans of the industry while never quite breaking through himself, Katabuchi once remarked in a Reddit Q&A 'my work is not my reputation, it's my relationship with people that has led to my career.'

Born in 1960, Katabuchi first encountered animation at the tender age of two-and-a-half at the cinema run by his grandfather, where he saw the Toei Animation feature *The Little Prince and the Eight-Headed Dragon*. That film was something of a breakthrough for animator Yasuo Ōtsuka, who would become one of young Katabuchi's idols. Later, Katabuchi recalls sitting down to watch the landmark 1978 anime series *Future Boy Conan*, full of excitement due to Ōtsuka's role as animation director and character designer. It was only afterwards that he became aware of the lead director of that series, Hayao Miyazaki, who would become a key figure in Katabuchi's career.

Katabuchi was still at university studying film when he joined the writing staff of the anime series *Sherlock Hound*, collaborating closely with Miyazaki before the project was put on hold due to a dispute with Arthur Conan Doyle's estate. He then ping-ponged between Japan and Hollywood, working on an early version of the ambitious trans-Pacific production *Little Nemo: Adventures in Slumberland*. When Katabuchi was involved, *Little Nemo* was to be produced by Star Wars veteran Gary Kurtz, with potential directors Hayao Miyazaki and Isao Takahata working from a script by science-fiction legend Ray Bradbury. However, it was not to be, and the project languished in development hell for the majority of the decade as creatives came and went. The film that eventually became *Little Nemo* had a disastrous release in 1989.

It was trounced at the box office by *Kiki's Delivery Service*, the first undisputed hit from Miyazaki and Takahata's fledgling Studio Ghibli. That film was, initially, set to be Katabuchi's directorial debut, after he was tapped to succeed Miyazaki (who was taking a break from production following *My Neighbour Totoro*). However, again, it was not to be: reportedly, financial backers would foot the bill only if Miyazaki was at the

Above: Street Corner. The locations and backgrounds of *In This Corner of the World* recreate 1940s Hiroshima in delicate detail.

Opposite: A different perspective. *In This Corner of the World* offers up a new angle on the wartime drama.

helm. Whatever the reason, Katabuchi was demoted to assistant director mid-production.

In the 1990s, Katabuchi made his mark off-screen, first by tutoring a new generation of Ghibli staffers hired in the period of expansion following the success of *Kiki's Delivery Service*, and later landing with producer (and Ghibli veteran) Eiko Tanaka at Studio 4°C. There he was encouraged to develop what would eventually become his 2001 directorial feature debut, *Princess Arete*, an adaptation of the English-language novel *The Clever Princess* by Diana Coles. The process would be slow, though, with a development team of just two people, namely Katabuchi and his trusted collaborator: his wife, Chie Uratani. Uratani's credits encompass everything from *Kiki's Delivery Service* to *Mind Game*, *The Animatrix* to *Tekkonkinkreet*, and with her husband she has fulfilled the role of animation director and assistant director. Katabuchi once said in an interview with Anime World News: 'I don't draw myself anymore. My wife, Chie Uratani, is in charge of the drawings. My inspirations come from trying to figure out what inspires my wife's imagination.'

Following *Princess Arete*, Katabuchi's credits ranged from writing screenplays and directing cinematics for

Namco's video game franchise *Ace Combat*, to directing the action-packed adaptation of Rei Hiroe's modern-day pirate manga *Black Lagoon* for Madhouse. It was there that his long-gestating second feature project, 2009's Miyazaki-esque *Mai Mai Miracle*, was produced. Critically acclaimed and screened at festivals around the world, the film was pronounced dead on arrival when first released in Japanese cinemas.

Katabuchi has said that this failure tarnished his reputation as a filmmaker, leading him to turn to crowdfunding and extreme budgeting when developing and researching his next project, an adaptation of Fumiyo Kōno's manga *In This Corner of the World*. After over six years in production, and a change in studio from Madhouse to producer Masao Muruyama's new company, MAPPA, the film premiered in October 2016 at the Tokyo International Film Festival, going on general Japanese release a month later. A resounding popular and critical success, the film eventually recouped ten times its budget at the box office, and was picked by the prestigious Japanese film magazine *Kinema Junpo* as their film of the year – only the second animation to receive that honour, following *My Neighbour Totoro*.

FURTHER VIEWING

In This Corner of the World fits neatly into a subgenre of Japanese animation that looks at the events of the Second World War from the perspective of young innocents. *Barefoot Gen* and its sequel were groundbreaking in this regard, and are still affecting if now a little dated in their animation style. And then there's Isao Takahata's *Grave of the Fireflies*, a feel-bad drama following two siblings slowly succumbing to malnutrition in the aftermath of the campaign of firebombings on Tokyo. This is undeniably one of the greatest animated films ever made. However, approach with caution: its reputation to upset viewers dates all the way back to its initial cinema release, when it was bundled with another Studio Ghibli film, Hayao Miyazaki's endearing future classic *My Neighbour Totoro*. Many young viewers never trusted the Ghibli name again.

When her town is spattered by a bombing raid, Suzu, the artistic and loveable heart of *In This Corner of the World*, sees the explosions above as bursting clouds of watercolour, lighting up a heavy, grey sky. She, like the film, finds small specks of beauty in a terrifying and violent world, and shows how seemingly minor acts of creativity can be an essential act of self-care. Suzu's story is mostly set near Hiroshima in the last years of the Second World War, so there is an inescapable melancholy that hangs over the story, as tragic inevitability lurches towards her, its specific impacts stomach-twistingly unknowable. It's amazing, really, that within such anxious, anticipatory viewing we find ourselves focusing on so much joy, imagination and kindness. Although the events around Suzu define the war, they do not define her.

The story begins with Suzu as a child, whimsical and clumsy, with a fairytale mind that blurs the appearance of reality. To her, ogres and brothers are one and the same, and they make a perfect subject for a self-drawn manga to giggle at with her sister Sumi. As a young artist, Suzu's surroundings are full of colour and life, the magic of the everyday flying into her drawings and worldview. When she marries, becoming a housewife to a navy worker just as war appears on the horizon, her paints and paper disappear. However, it's in navigating this new life that more tools for expression reveal themselves.

In the domestic space, that same spark of crafty imagination moves from paint and paper to needles and pans. When she needs to adjust a kimono to a new outfit with trousers, the fabric is spotlit on screen, anatomized by Suzu and satisfyingly reconstructed. In the thick of war, and with precious rations to speak of, Suzu crafts a groan-inducing feast, each movement of her culinary symphony framed to highlight the skill and precise affection in every bite. The way she moves through frames emphasizes her curiosity at what the world has to offer: while she takes in her surroundings, her steps are slow and light, careful not to disturb. As the war transforms, that glacial meditation evolves into quiet pain and stoicism as Suzu loses multiple family members, including her young niece, as well as her right forearm, to a bomb.

The warm, natural colours of the film's beginning desaturate alongside the happy-go-lucky first half of the story, with softly outlined characters and pastel landscapes invaded by the scratchy monochrome bricks of military vessels. After Suzu loses her arm, her background loses all definition, becoming rough and chaotic brushstrokes instead. Yet, even after almost all the colour has drained from her face, she perseveres. Once the war is over, blackout rules are stopped and a shade that had cloaked Suzu's dining room bulb is lifted, so that everyone can see the plain dish of rice she has lovingly prepared. It's an understated, powerful moment, bathing Suzu and her family in the shared light; we feel their collective pain, relief and appreciation for small, infinitely valuable gestures of care, and created by their artist in residence.

Right: No dry eyes. Suzu's compassion and stoicism will wring out tears from many viewers.

Opposite: Drawn together. *In This Corner of the World* was adapted from the manga series by renowned artist Fumiyo Kōno.

MODEST HEROES: PONOC SHORT FILMS THEATRE

ちいさな英雄－カニとタマゴと透明人間

SHORT AND SWEET

An anthology of three short films produced by Yoshiaki Nishimura and his company Studio Ponoc, each showcasing the talents of a roster of veteran animators who had previously worked for Studio Ghibli.

2018

DIRECTORS: HIROMASA YONEBAYASHI,
YOSHIYUKI MOMOSE, AKIHIKO YAMASHITA

53 MINS

What do you do when the animation studio you work for closes down, seemingly for good? The answer, of course, is that you strike out on your own. That's the position in which Yoshiaki Nishimura found himself in 2014, when Studio Ghibli announced that it would be suspending production after Hayao Miyazaki once again announced his retirement. The young producer had quickly established himself as one of Ghibli's rising stars, helping shepherd Isao Takahata's final masterpiece, *The Tale of the Princess Kaguya*, through its protracted production. He had also collaborated with director Hiromasa Yonebayashi on the heartfelt teen drama *When Marnie Was There*. And then, barely a month before Marnie's theatrical release, it was announced that Ghibli was closing.

Nishimura moved quickly and founded his own company, Studio Ponoc, in April 2015, using the Croatian word for 'midnight' to allude to the dawning of a new day for animation – albeit with an ambition to continue Ghibli's goal of producing high-quality films that could be equally enjoyed by children and adults alike. 'We wanted to carry on bringing that significant, meaningful work into the world,' Nishimura explained. 'That was our vision.'

Ponoc poached many of the veteran artists left in the lurch by Ghibli's production hiatus, and even pilfered a set of work desks from the shuttered studio, in order to produce their first feature, the accomplished Miyazaki tribute *Mary and the Witch's Flower*, directed by Hiromasa Yonebayashi. A hit at the Japanese box office on release in 2017, *Mary and the Witch's Flower* finished sixth in the end of year tallies for domestically produced films and travelled around the world, showcasing Nishimura and Ponoc's interest in global audiences.

Having proved that they were capable of making a film in the Studio Ghibli mould, Ponoc's next move was to challenge themselves even further, with a series of shorts that would act as incubators for new talent, stories and modes of expression. The approach was not too dissimilar from a long line of anime anthology projects that often showcased new, exciting voices and visions, from *Robot Carnival* and *Memories* to *Genius Party* and *The Animatrix*.

Ever the hands-on producer, Nishimura picked the directors for the project and, in lieu of assigning screenwriters to each film, he gave each a kernel of inspiration in the form of a suggested topic, theme or challenge.

Hiromasa Yonebayashi returned, following *Mary and the Witch's Flower*, for the short *Kanini & Kanino*, and was encouraged by Nishimura to leave his beloved

Above: Out of his shell. Producer Yoshiaki Nishimura had an unlikely topic for one of the shorts: living with egg allergies.

Opposite top: Feeling crabby. The ambitious *Kanini & Kanino* is told using an entirely made-up language for its water-dwelling characters.

Opposite bottom: Yoshiaki Nishimura and director Hiromasa Yonebayashi first worked together on the affecting Studio Ghibli feature, *When Marnie Was There*.

female characters behind in favour of exploring themes closer to home, specifically the family dynamic while the Yonebayashi household was expecting a newborn.

For *Life Ain't Gonna Lose*, Yoshiyuki Momose, a Ghibli veteran and one of Isao Takahata's most trusted collaborators, with credits ranging from *Grave of the Fireflies* to *The Tale of the Princess Kaguya*, was tasked with tackling the everyday, but potentially life-threatening, topic of egg allergies, drawing inspiration from one of Nishimura's childhood school friends.

And for Akihiro Yamashita, one of Ghibli's leading artists and a stalwart Miyazaki collaborator, Nishimura had the most ambitious prompt. As animation director and key animator on the likes of *Howl's Moving Castle*, *Ponyo*, *The Wind Rises* and *Spirited Away*, Yamashita had proved to be a virtuoso when animating movement. 'I wondered,' Nishimura later said, 'if an animator who is great at expressing movement and emotion could tackle the challenge of animating an invisible man.' Yamashita reportedly replied that it would be impossible but Nishimura persevered, intrigued to see the result in a short that would be known simply as *Invisible*.

These three shorts formed a programme billed as *Modest Heroes*, reflecting a shared thematic framework that looked at everyday life and existence through expressive and vibrant animation. Initially, the plan was for there to be four shorts in the anthology, with Nishimura's old colleague and mentor Isao Takahata directing, but those plans were scrapped when Takahata passed away in April 2018.

In a way, as *Mary and the Witch's Flower* was a tribute to Hayao Miyazaki, *Modest Heroes* stands as a celebration of Isao Takahata's iconoclastic, stylistically diverse approach to animation. It also exhibits Nishimura's ambition to use the studio's small-scale independence to innovate and adapt, shifting from features to shorts and beyond – further evidenced by the project that followed, a short film directed by Momose, called *Tomorrow's Leaves*, that commemorated the Tokyo 2020 Olympics.

Modest Heroes was released in Japan in the summer of 2018 and made its way to the United States soon after, thanks to a distribution deal with animation specialists GKids. More notably, though, the anthology was distributed worldwide via Netflix in 2019 – staking out new territory before Ponoc's mentors at Ghibli, who had always been hesitant to license their films for digital platforms, joined them the following year.

FURTHER VIEWING

All roads seem to lead back to Ghibli, but perhaps that's not unsurprising in this case, as the three *Modest Heroes* directors each cut their teeth at the studio. So you could easily revisit classics like *Spirited Away*, *Porco Rosso*, *Howl's Moving Castle* and *The Wind Rises*, or reappraise Yonebayashi's directorial efforts, *Arrietty* and *When Marnie Was There*, or even appreciate Momose's work as designer and director for the Ghibli-related RPG video game series *Ni No Kuni*. Additionally, the anime anthology series *Genius Party* and *Short Peace* both offer diverse, dizzying displays of imagination and creativity in bite-sized portions.

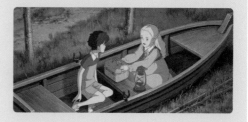

MODEST HEROES – REVIEW

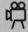

An anthology film can be tricky. Distinct items, carefully wrapped in a complete package and sold as a whole, are inevitably separated by viewers who select their favourites and relegate the others to the bottom of the list. It would be tough to make any chapter from *Modest Heroes* suffer this fate though. With each viewing, this delightful compendium of short stories reveals its subtle creative and emotional power.

The opening short *Kanini & Kanino* follows two small river-dwelling anthropomorphized crab creatures as they navigate the choppy waters of, well, choppy waters. While their mother leaves their home to give birth, their father is swept downstream, leaving the siblings to fend for themselves and find him. Director Hiromasa Yonebeyashi, who helmed Studio Ghibli films *Arrietty* and *When Marnie Was There* (and Studio Ponoc's Hayao Miyazaki tribute act, *Mary and the Witch's Flower*), carries over some thematic and stylistic familiarities from his old workplace, combined with the exciting, experimental parameters of silent film.

Kanini and Kanino's speech is primitive, but what they're saying doesn't matter – Yonebayashi's focus is on their world and their actions. Live action-style racking focus (where the focus changes over the course of the shot) highlights planes of natural beauty; astonishingly animated glimmering water and sharply detailed forest surroundings are lingered on with admiration, as if waiting for their David Attenborough narration. The formal grounding of this fantasy makes the power of nature seem enormous. Even if it's just a small glade, the swelling stream that separates the family seems biblical. Combined with superb, wistful, *Princess Mononoke*-evoking orchestration from Takatsugu Muramatsu, this film's appreciation and sense of wonder about the natural world will feel natural to Ghibli fans. Due to their small size and point of view, Kanini and Kanino experience the minor delicacies of nature with awestruck wonder and respect, and without the complication of language, it's something any small-sized human viewer will surely experience, too.

If *Kanini & Kanino*, with its rich colouring, woodland setting and fantasy quality, is *Modest Heroes*' version

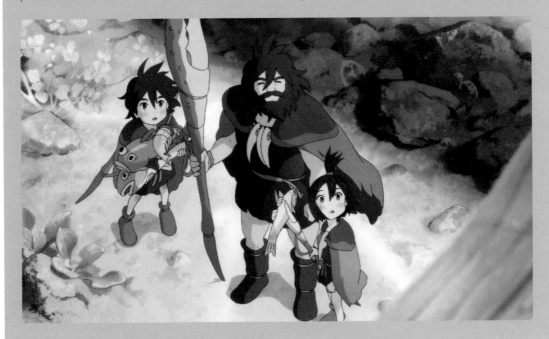

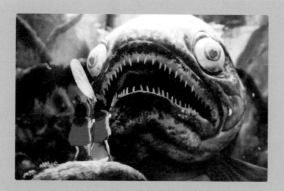

Opposite: Nishimura encouraged Hiromasa Yonebayashi, whose wife was pregnant at time of production, to focus his short on a family.

Left: Modest heroes, big adventures. Kanini and Kanino face off against an intimidatingly toothed adversary.

of a Hayao Miyazaki film, the second short, *Life Ain't Gonna Lose*, is their Isao Takahata homage. From its anthropological curiosity to its formal expressionism, the fingerprints of Ghibli's late co-founder are all over this story of a young boy's battle with his allergy to eggs.

Yoshiyuki Momose's film has the highest level of narrative realism in the collection and, intriguingly, the most formal experimentation, too. It's not a kitchen sink drama (although a fridge-freezer does become quite important), but a beautiful, inspiring expression of the fears and dedication found in the parental and childhood experience. The characters have softly detailed round faces with grey, rather than black, outlines that offer an enveloping warmth. Like Takahata's masterpiece *Only Yesterday*, there's a centring of the observational and emotional. Often the edges of frame aren't even filled, leaving the characters and narrative spotlit in the middle. In that spotlight is the deathly egg-allergic Shun, his mother and the daily challenge of navigating their egg-centric world. The processes of prick tests, school lunches and restaurants are studied with curiosity and regard, never making Shun an outsider but instead highlighting his individual experience.

The standout moment when the inevitable happens is stunning. After eating the wrong ice cream, balls of flesh form, drip and turbulently splatter around Shun. His rapidly sketched character movements become visible, the bones of his form frantically grasping at a world melting away. It's a frightening moment that abstractly illustrates the intense danger of a hidden but genuine threat and, like the whole short, highlights the heroism found in the everyday battle of navigating what for most people is mundane reality.

The third and final short in the *Modest Heroes* collection is less easy to trace back to the Studio Ponoc family tree.

Despite being a modern stalwart of Ghibli, Akihiko Yamashita's *Invisible* clambers out of the legendary studio's shadow, as a refreshingly distinct work of grungy melancholy.

Capturing the machinations and frustrations of daily life for an invisible man, Yamashita's work has the intrigue and thrills to capture young audiences and, as an analogy, can skewer any grown-up who has ever felt existential transparency. Limping through life and ignored by co-workers, the invisible man (clothed, but with no body) has to weigh himself down at all times in case he simply floats away and disappears completely. The result is a collection of tragically comic, socially anxious human interactions followed by a staggering set piece in which he's thrown into the air, caught in a storm like a lost balloon. The weightless body thrashes and squirms in a distressingly elastic manner while the sky whips around him, the remarkable animation making you feel like a wet sock on a spin cycle. *Invisible* is a triumph of physical animation, but its impressive style is there to underscore the key story: a sensitive examination of mental health and loneliness – and the empathetic power that can come from simply being seen.

Without as clear a stylistic lineage to Studio Ponoc's lineage, *Invisible*'s placement at the end of the collection feels like a statement of intent. The first two shorts show where they've come from, revealing their Ghibli heritage and evolving it. Now, even though they're still working from the old desks, *Invisible* shows they're ready for new challenges. These are stories that each have their own remarkable merits, working in harmony, without a dud in sight. A selection box where every item is your favourite.

CHILDREN OF THE SEA

海獣の子供

THE SEA OF LIFE

A young girl spends her summer holiday nosing around the aquarium where her father works. There, she befriends two strange boys who were reportedly raised by dugongs, and the new friends become involved in a worldwide event that is affecting the planet's sea life.

2019

DIRECTOR: AYUMU WATANABE

111 MINS

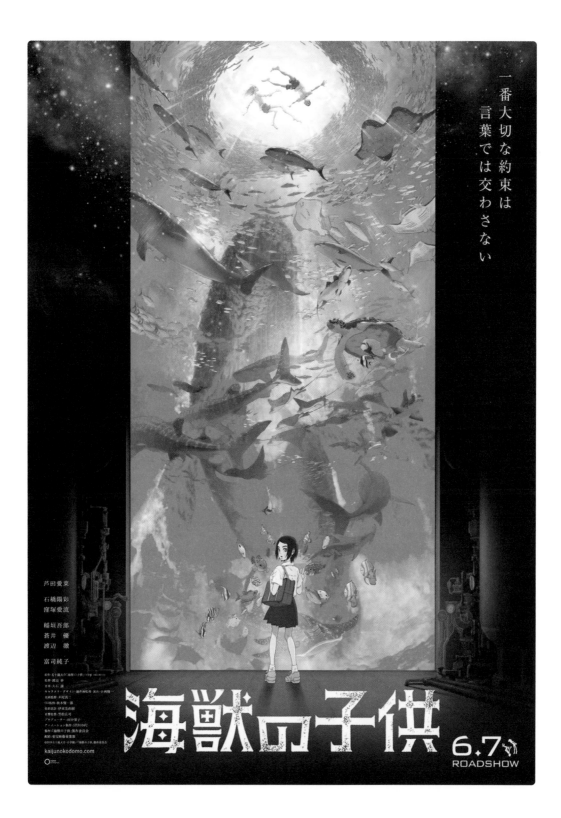

Sometimes a single review can stir up waves of hype. Reporting from the Tokyo International Film Festival in 2019, *Daily Telegraph* critic and anime devotee Robbie Collin gave a full 5 stars to the environmentalist fantasy *Children of the Sea*, calling it 'a surging tsunami-crash of creativity and beauty that leaves you gulping for breath... It leaves you with a sense that the art form's boundaries have been nudged a little wider as you watched.' Such raves make an impression.

While the review seemed to come out of nowhere, *Children of the Sea* came from a respectable pedigree. It was produced by Eiko Tanaka at Studio 4ºC, whose previous internationally renowned gems include *Tekkonkinkreet* and *Mind Game*, and was directed by a veteran of Japanese animation, Ayumu Watanabe. He led a team headed by animation director and character designer Ken'ichi Konishi, a Studio Ghibli regular who had also worked closely with Satoshi Kon on *Millennium Actress, Tokyo Godfathers* and *Paprika*.

Born in 1966, Watanabe entered the animation industry in 1986, and established a long-running relationship as both staffer and freelancer with the studio Shin-Ei, eventually directing entries in the comedy mega-franchise *Doraemon*. Reflecting on those years, Watanabe said:

'I learned everything I needed to know about animating films from *Doraemon*. Films have an audience waiting for them, and I was able to experience the wonder of sharing emotions with them. I also learned the harsh reality of when things didn't go well, either.'

Later, his reputation flourished with anime series such as *Space Brothers, Mysterious Girlfriend X* and *After The Rain*. *Children of the Sea*, adapted from a long-running manga series by acclaimed artist Daisuke Igarashi, was his fourth feature film.

The interest of anime fans the world over was piqued by the film's score, composed by Studio Ghibli veteran Joe Hisaishi. 'It was my dream to have Hisaishi compose

CHILDREN OF THE SEA

for me,' gushed Watanabe to Crunchyroll. 'I am a huge fan of his. I heard his music for the first time when I was a teenager and was fascinated.' Elaborating on the unique quality of Hisaishi's music to act almost as a supporting character in a film, Watanabe describes it as 'an entity that overlooks the story, the theme simply flows with occasional silent moments to casually snuggle up next

to the audience. When you realize it, the score envelops those who are watching. That is the kind of music Hisaishi-sensei creates.'

Above: A bigger splash. *Children of the Sea* offers up an unconventional tale of girl meets boy.

FURTHER VIEWING

For more aquatic adventures, look no further than Hayao Miyazaki's *Ponyo*, a delightful riff on *The Little Mermaid*, in which a small fish magically transforms into a young girl, and inadvertently throws the natural order of the planet off its axis. Masaaki Yuasa's *Lu over the Wall* captures a similar vibe, albeit with more of a wacky sensibility;

his subsequent film *Ride Your Wave* is more of a straightforward seaside romance in which young lovers bond over surfing. Or, if *Children of the Sea*'s cosmic digressions are more to your taste, Gisaburō Sugii's *Night on the Galactic Railroad* literally takes the viewer on a consciousness-expanding celestial journey.

Plunging into *Children of the Sea* is a refreshing, bewildering and breathtaking experience. Following Ruka, a class pariah drawn to a pair of mysterious water-dwelling boys, and their cosmic journey into the fluid textures of the universe, it swells with dextrous visual and storytelling ambition. Equally interested in illuminating the wonders of the universe, the oceans and simple urban life, *Children of the Sea* is a moving tale of friendship, and a glorious, experiential cosmic collage.

At the aquarium where her father works, the lonely Ruka first meets orphan Umi. He is one of two dugong-raised amphibious siblings, and soon after she meets his more melancholy brother, Sora. They are characters in search of human and environmental connection, closed off by emotional and physical barriers, who flow from having awkward but charming human-out-of-water meetings to hosting dazzling meetings with creatures from across the world's oceans. A recurring visual throughout the film is a large glass aquarium wall, where spectators can gawp at all kinds of sea life, and it's here that Ruka admires Umi's aquatic gymnastics. The wall becomes a screen within our screen, signposting what we're watching: the theatre of nature and its possible synchronized swim with humanity.

The wide-eyed wonder the film has for the world can be seen in its characters' faces. Ruka's pupils are huge marbles that take up half her face, soaking in as much of the planet's glory as they can. Fine line work brings out eyelashes, brows and lip creases; details that, when Ruka descends into watery depths with Umi and Sora, are mirrored in the exquisite and bright intricacies of whales, dolphins and crabs. When she embraces the creatures, thick, frenetic blue pencil lines sweep over the waves, rushing the image with vitality. In contrast, when a grim tide washes dead creatures to shore, their overlapping grey bodies evoke the unearthly horror imagery of HR Giger.

Joining the more domestic and cerebral elements of the narrative is a lyrical approach to editing which keeps the story rolling. Ruka is surrounded by empty desks at school, in contrast to the school of fish joyfully encircling Umi in the

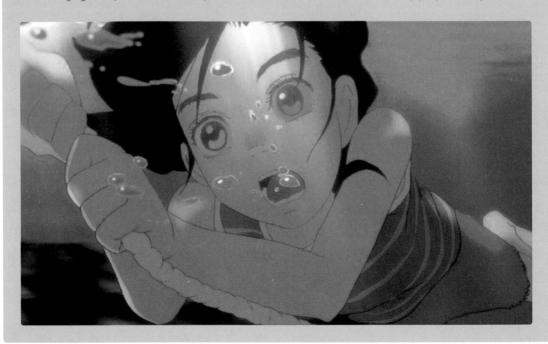

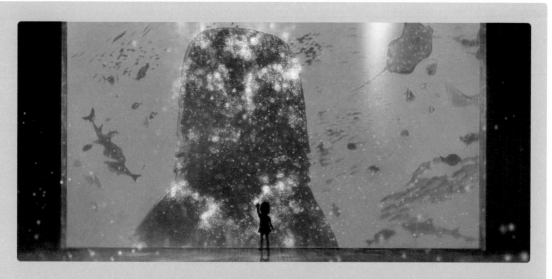

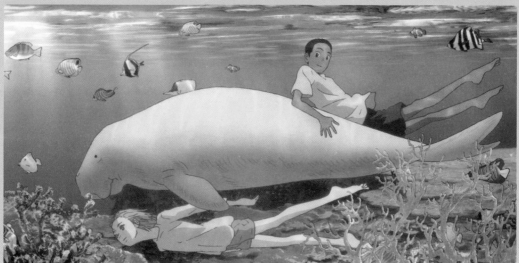

following image. Match cuts leap from washing machine to truck wheel. The reds of a flower, a streetlight and umbrella are linked and revisited, the viewing experience held by these rhymes. The rhythm is hypnotizing, helping to glide over dull expository elements and easing the movement into a more abstract balletic finale. If Terrence Malick directed animation, it would look like this.

The crescendo of the film is a sparkling mosaic linking space and sea, in a dialogue-free sequence that collides galaxies, earthly microorganisms and lots of seawater in a vortex of overlapping, crashing colour. If you're happy to set aside total narrative sense, and let *Children of the Sea* wash over you, the result is one of animation's highest watermarks.

Opposite: With its cosmic visuals and hypnotic rhythm, take a deep breath before diving into *Children of the Sea*.

Above top: The age of aquarium: Watanabe's film gives audiences a front row seat to the cinema of nature.

Above bottom: Dugong with the wind. *Children of the Sea* highlights the indelible relationship between human life and the natural world.

PROMARE

プロメア

PLAYING WITH FIRE

A global disaster known as the Great Earth Blaze introduces the world to the Burnish, a population of humans graced with pyro-kinetic powers. Futuristic firefighters Burning Rescue are the planet's first line of defence against further catastrophe – but the true danger may lie elsewhere.

2019

DIRECTOR: HIROYUKI IMAISHI

111 MINS

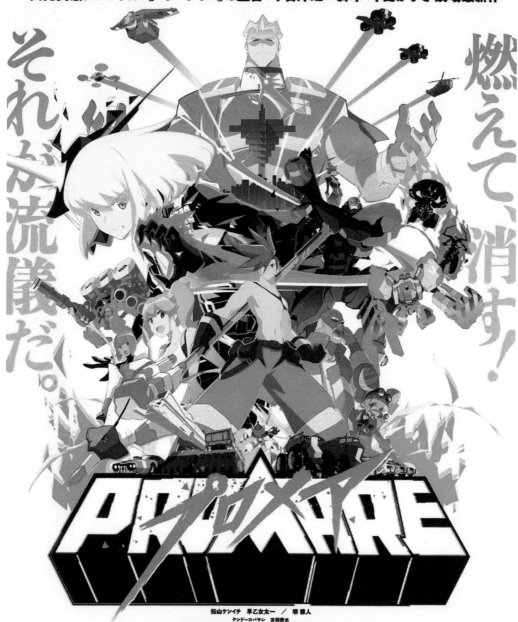

Formed in 2011, Studio Trigger may be one of newer voices on the block, but the reputation of their staff dates back decades. Before they hit out on their own, many of Trigger's personnel, including co-founders Hiroyuki Imaishi and Masahiko Ōtsuka, had worked at the animation studio Gainax, lending their talents to projects such as *Neon Genesis Evangelion*, *FLCL* and *Panty & Stocking with Garterbelt*. The 2007 Gainax series *Gurren Lagann*, Imaishi's first project as series director, brought many of Trigger's key players together, including producer Hiromi Wakabayashi, screenwriter Kazuki Nakashima and character designer Shigeto Koyama (who, alongside credits on the Rebuild of Evangelion series, designed Baymax for the Disney feature *Big Hero 6*); Imaishi himself was series director for the first time.

Trigger's goal was to produce distinctive, original animation, which they did from the off with the series *Little Witch Academia* and *Kill La Kill*, the latter reuniting much of the creative team behind *Gurren Lagann*. To fund certain aspects of their development and production, the fledgling studio embraced crowdfunding platforms such as Kickstarter and, later, Patreon, forging a strong relationship with their audience. Then came the opportunity to make a new, original feature, directed by Imaishi and written by Nakashima, starting with a mere kernel of inspiration: fire.

In an interview with Famitsu translated by Crunchyroll News, Nakashima describes a tense early development process where an initial script, closer in scope to something like *How to Train Your Dragon*, was thrown out by Imaishi. It was only after the core team went out for dinner afterwards that inspiration struck, as they were chowing down on a familiar but delicious favourite: hamburgers. Nakashima recounted to Famitsu: 'Up until that point we struggled and made this objective for ourselves of, "Let's put away our usual habits and try to do something we've never done before," but our way of thinking turned around and we thought, "What's wrong with doing things the way we normally do?" We realized, "The only thing we can make is hamburgers, and yet we're overthinking things almost like we're trying to make a hamburger out of rice."'

The creative block was broken, and Imaishi started doodling characters on napkins at the restaurant. 'Once we decided to go with our usual style, the concept for the entire film was pretty much set,' Imaishi told Famitsu. 'And we decided from the beginning to go full throttle and show intense action.'

Above: Kray Foresight, the governor of Promepolis, is a public hero thanks to his fight against the Burnish.

Opposite top: With their lithe robotic suits and fiery powers, the Mad Burnish are, at least initially, *Promare*'s primary antagonists.

Opposite bottom: A perfect match. Mad Burnish leader Lio Fotia is the great and mysterious foil to *Promare*'s hero, Galo Thymos.

FURTHER VIEWING

The visually dazzling, deliriously OTT style of *Promare* builds on two previous anime projects directed by Hiroyuki Imaishi: the pre-Trigger mecha series *Gurren Lagann*, and Trigger's first production, the action-packed high-school series *Kill la Kill*. Bundle the three for a sensory overload, triple bill that barely pauses for breath. Trigger's short form contributions to the *Star Wars: Visions* anthology series would be the perfect chaser. Then, reach further back in Imaishi's filmography to his contributions as key animator for Takeshi Koike's fast and furious racing feature *Redline*, another prime example of sugar-rush, style-over-substance animation that is packed with spectacular sequences and full of distinctive, exaggerated characters and which, crucially, doesn't take itself too seriously.

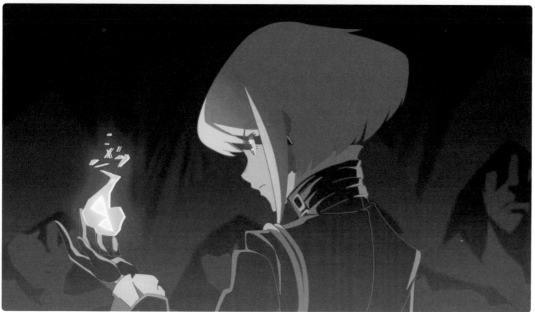

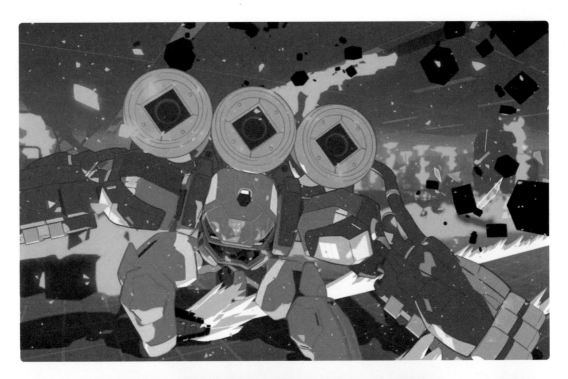

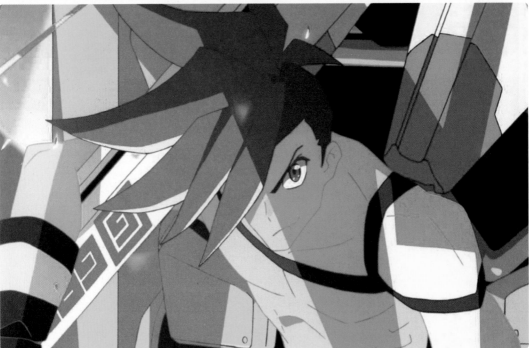

Top: *Promare* revels in its colourful and creative designs, from its angular cityscapes to its vibrant and imaginative mech suits.

Above: Protagonist Galo Thymos, Burning Rescue's newest and most ardent recruit, believes he can extinguish fire with his burning soul.

PROMARE – REVIEW

In the world of *Promare*, the slightest excitement can cause some civilians to instantly catch fire due to an emotional energy spike. If that was the case for viewers, the cinema would be a conflagration after the first few seconds. Hiroyuki Imaishi's film is a blitz of bright colour, thundering music and blazing momentum, which will have viewers stopping, dropping and rolling in the aisles.

Primarily a vehicle for bridging gaps between action sequences, the narrative of the film resides with Burning Rescue, a team of firefighters on a mission to stop flame-happy terrorists and whose latest recruit is the hot-headed and hilariously vain Galo Thymos. There is a tendency to over-explain a relatively simple plot, which gets a bit tiresome, but knowing there are more gloriously staged incendiary antics always moments away makes wading through the exposition worthwhile.

Tasked with protecting their sleek and angular world, a city of clean and bright geometric shapes, Burning Rescue do battle with the anarchy of fire. In this grid-lined order explosions are both shocking and satisfying, flames and debris painting the city in waves of purple pyro-pyramids, each pulse of combustion synced to a shredding guitar wail.

It's not all punching, posing and appropriately high-octane stunts, though. In the fragments of story caught between the ember of set pieces comes a surprisingly deep, politically engaged drama examining propaganda, fascism and elitist power structures. Known as the Burnish, the people who have pyrokinetic outbursts are ostracized. They're persecuted by a fascistic society, who are disgusted by anything they touch and who will eventually put them into prison camps. And fascinatingly, for most of the film, the hero is helping make that happen.

Promare gradually reveals how government initiatives can cause more damage than they stop, and how simple complicity in subjugation can be blinded by jingoism. It flips its lens on the terrorists, shifting them from fundamentalists to freedom fighters, something Galo comes to embrace – literally. As capitalist greed leads to the environmental annihilation of the planet, a kiss of life between Galo and his former enemy saves the day. The men find the balance between fire and water, dousing the planet's troubles and showing the world-changing power of intimate emotional connection.

Despite essentially being one big set piece, *Promare* manages to bundle in surprising sociopolitical and emotional complexity with its many other pleasures. This is breathless and beautiful animation and even when the credits have finished, the thrill of it is hard to extinguish.

Below: Combining digital and hand-drawn techniques, *Promare*'s eye-popping action sequences are dazzling and distinctive.

ON-GAKU: OUR SOUND

音楽

DIY ANIME

On a whim, a trio of high school hoodlums give up their delinquent
lifestyle and decide to form a band – with only two drums, two
bass guitars and zero musical talent between them.

2019
DIRECTOR: KENJI IWAISAWA
71 MINS

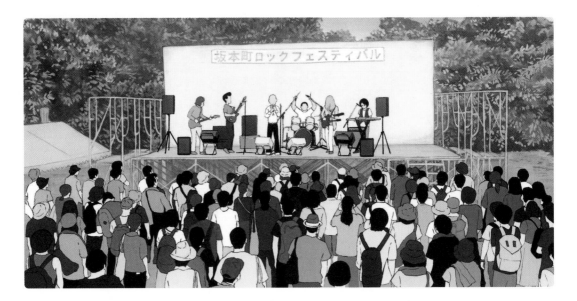

Pick almost any other chapter in this book and you will find films made by teams of some of the most skilled artists and animators in the world. That isn't the case here.

By director Kenji Iwaisawa's own admission, *On-Gaku: Our Sound* was a production powered by 'effort and guts'. Made over the course of seven-and-a-half years on a shoestring budget cobbled together from loans, savings, crowd-funding and odd jobs – and reportedly costing one tenth the amount of a standard anime feature – the result is pure, independent filmmaking, with 40,000 hand-drawn frames mostly produced by Iwaisawa himself, with the aid of a small team of enthusiasts and amateurs recruited via social media. 'It was mostly a gathering of people who had no experience in creating anime,' Iwaisawa explains in the press notes for the film. 'Hardly any professional animators were involved.'

Born in 1981, Iwaisawa is the dictionary definition of an independent filmmaker. Apprenticing with the legendary Japanese cult filmmaker Teruo Ishii after graduating from high school, Iwaisawa worked in film production while producing his own short films on the side, including forays into short animation. The challenge of creating a feature-length, independently financed animated film – something he felt was 'unprecedented' – led to *On-Gaku*, an adaptation of the indie manga by Hiroyuki Ohashi. To get around the lack of animation know-how, Iwaisawa filmed live-action footage to trace over and animate, using the technique known as 'rotoscoping', to stylized, hyper-real effect. That approach, sometimes deployed elsewhere in

anime but rarely so extensively, can be time-consuming, which worked in Iwaisawa's favour. 'I didn't have the budget,' the director explains, 'so I was prepared to complete it using time, no matter how long it took.'

Such a homegrown approach to the production was perfectly in tune with the material – self-taught animators animating the story of self-taught musicians, finding their sound, and creating something fresh, offbeat and distinctive in the process. *On-Gaku* played around the world, premiering at festivals in Ottawa, London and Rotterdam, and garnering acclaim even during the pandemic-afflicted years of 2020 and 2021. Back home, the film was nominated for Best Animation Film at the Mainichi Film Awards, in competition with blockbuster anime films including the record-breaking *Demon Slayer: Mugen Train*. It was awarded the Ōfuji Noburō Award, which tends to reward more experimental, independent or artistic animation, putting *On-Gaku* in esteemed company with previous winners, such as *Mind Game*, *Tekkonkinkreet*, Masaaki Yuasa's *Lu Over the Wall* and Naoko Yamada's *Liz and the Blue Bird*.

Above: School of rock. *On Gaku: Our Sound* joins the alumni of great underdog music stories.

Opposite top: Anime calling. *On-Gaku* features several nods to classic album covers, including, as seen here, The Clash's *London Calling*.

Opposite bottom: Fracas of the Mohicans. Kenji faces off with a gang of punks, but the resulting bout takes a surprising turn.

FURTHER LISTENING

For another hit of infectious musical energy, look no further than the delightful Kyoto Animation series *K-On!*, about four high school girls forming a band of their own. But it might be more in keeping with *On-Gaku*'s Easter egg-filled spirit to dive headfirst into the classic rock albums the film playfully references throughout. Keep your eyes peeled for nods to The Clash's *London Calling*, the Beatles' *Abbey Road*, Mike Oldfield's *Tubular Bells* and King Crimson's *In the Court of the Crimson King*, as well as nods to Pink Floyd, The Who, Led Zeppelin, and Emerson, Lake and Palmer. A perfect playlist for any wannabe muso.

ON-GAKU: OUR SOUND – REVIEW

With a story featuring crates of prog music references to dig through, *On-Gaku: Our Sound* could easily be an exclusionary, beard-stroker's delight, but thankfully, even if you've never listened to Mike Oldfield or Pink Floyd, all are welcome in the front-row seats to scream along with this delightful film. Like much of the music it idolizes, the story is euphoric, touching and totally chaotic, yet perfectly coordinated in its own specific rhythm. Delinquent students Kenji, Ota and Asakura journey through the entire lifespan of many legendary bands, from formation, innocent first twangs and psychedelic inspirations, to break up and glorious reunion, all in the space of 71 minutes.

After inadvertently coming into possession of a bass guitar, and despite not having any musical experience, the violent Kenji (apparently his 'spaghetti fist' is one of the strongest moves out there) ropes in his two friends, who have the same zero level of prowess, into forming a band: Kobujitsu. They don't know what they're doing, they don't know how to do it, but, crucially, they love it. The trio, made up of two basses and drums, endlessly hammer at their instruments. The minimalist repetition might seem amateurish, but to fellow student and music lover Morita and his band, it's magnificent. Despite playing wistful, finger-plucked folk songs, seemingly at odds with Kobujitsu's post-rock sensibilities, the two groups embrace and celebrate each other's styles.

The faces in *On-Gaku* are made of clean shapes, ovals, triangles and squares, bringing an accessibly innocent quality to the characters. Theirs is a simple, warming land of watercolour backgrounds and flatly coloured outfits, and when the right piece of music plays, it literally changes the world. When listening to each other, backgrounds transform into collages of legendary album covers, skies become split-fount ink rainbows and characters float on gleaming waves of sound, their shapes shifting from thickly and richly coloured to frantically scratched pencil sketches, such is the awesome power of their music. Refreshingly, passion is more important than skill in *On-Gaku*. What is so mind-

expanding for the characters is not necessarily the intricate details of the songs they hear, but the intensity and affection of how the songs are played, inviting us not just to love music, but to love *loving* music.

Beyond the enlivening choruses of musical exultation, *On-Gaku* has a sense of comic timing to match its superb sonic rhythm. Kenji, voiced in hilariously solemn fashion by psychedelic rock band frontman Shintaro Sakamoto, is a wonderfully deadpan creation, full of strange elongated pauses and erratic, cartoonish movement. His disconcertingly wide Alex DeLarge eyes, both philosophically searching and totally blank, are an unpredictable canvas of emotion that brings a comical awkwardness to each scene. These drawn-out moments of itchy silence harmonize perfectly with slapstick beats and jazz recorder-infused Benny Hill chases, making for a perfectly pitched comic symphony.

Opposite: Practice makes perfect. *On-Gaku* perfectly captures the ramshackle spirit of clueless teens playing music together for the first time.

Above: Come together. The band in *On-Gaku* recreate the iconic album cover of the Beatles' *Abbey Road.*

Right: Bands reunited. Kenji arrives in suitable rock-god fashion, just in time to take the stage by storm.

For all its idiosyncrasies, *On-Gaku* has a tender and kind emotional core, seeing music as an act of generous communication. Most of the characters here are not skilled linguistic communicators, but through their songs they're able to reach more depth with each other than any words would allow. Music becomes a communal home for these outsiders, where the key to entry is simple curiosity. Kobujitsu's DIY approach to their art mirrors the film's writer, director and animator Kenji Iwaisawa, who wrestled the film into existence and whose storytelling skill and unrelenting devotion to his work is hugely inspiring. So, when you finish watching this infectiously spirited film, and inevitably decide that it's finally time to start that band, you know who to blame.

BELLE

竜とそばかすの姫

A NEW REALITY FOR A FAIRY TALE FAVOURITE

When a shy teenager joins the vast virtual world 'U', she is
transformed into the glamorous pop diva Belle, whose songs
enchant billions of other users. But her online fame comes at a
cost and puts her on a collision course with the community's most
mysterious user: the Beast.

2021

DIRECTOR: MAMORU HOSODA

124 MINS

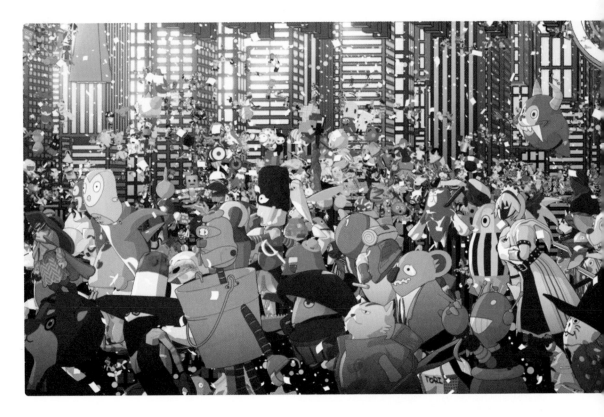

One question guaranteed to elicit extreme reactions from any group of anime fans is the trusty classic: 'who is the next Hayao Miyazaki?' It's very hard to answer, since Miyazaki is a one-off in terms of talent, timing and opportunity – but a few names reliably come up, no doubt much to the exasperation of the filmmakers in question.

One of those 'next Miyazakis' is Mamoru Hosoda, who fits the bill better than most if only because, for a brief time in the early 2000s, he *was*, for all intents and purposes, positioned as the next Miyazaki when he was handed the reins of the Studio Ghibli feature, *Howl's Moving Castle*. In the end, Miyazaki came out of retirement and replaced Hosoda on the project, but animation has been richer for it. We could theorize about how *Howl's Moving Castle* could have turned out differently, or instead enjoy the spoils of the much more independent career Hosoda has had since.

Born in 1967 – the same year as the actual 'next Miyazaki', Hayao's son Goro – Hosoda is a member of the generation that grew up at the same time as Japanese animation, and he credits two cinema trips as a young boy in 1979 to see Miyazaki's *Lupin III: The Castle of Cagliostro*, and Rintaro's adaptation of Leiji Matsumoto's

Galaxy Express 999 with sparking his dream to become a director. That they were feature-length films was a quality that stuck with Hosoda – he wanted to become a filmmaker, not an animator. He told us:

'When you work in anime, people often ask... did you want to draw manga? Or did you want to work in TV? But I've never even considered that. It was always about film for me. The way that a director could create a unique world in each film. And I'd always wanted to make something that people would watch in a cinema.'

Equally inspired by live-action filmmakers, Hosoda nods to Akira Kurosawa and Spanish art-house master Victor Erice as two directors who have influenced him since he was a student, their two contrasting careers (Kurosawa prolific, Erice much less so) making him keenly aware of the quality of a creator's body of work across multiple films.

It would be a long time until Hosoda directed a feature of his own, though. At the very start of his career, one of his first ports of call for an entry-level job was Studio Ghibli, but he received a personal rejection letter from Miyazaki, who encouraged him to hone his craft elsewhere. Instead, he spent several years at Toei Animation, working his way

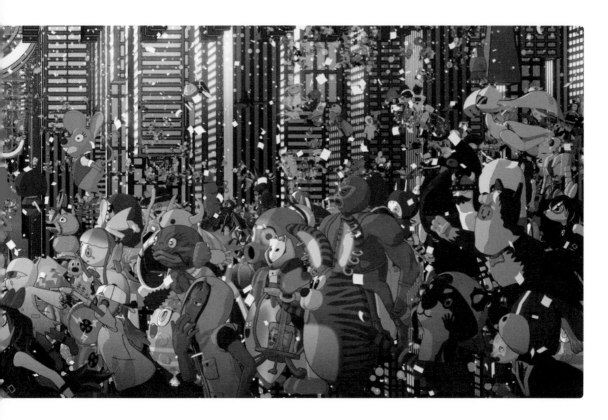

up from in-betweener to key animator on projects ranging from *Dragon Ball Z* to *Sailor Moon*.

Very early in that tenure, in 1992, he considered giving up on animation altogether, ground down by the long hours, intense workload and very low pay – but another visit to the cinema spurred him on anew. With the Japanese release of Disney's *Beauty and the Beast* in 1993, Hosoda was entranced, particularly by Glen Keane's character animation. Not only did this give him fresh resolve, it also planted a seed that would take almost three decades to bear fruit, when he put his own spin on the *Beauty and the Beast* fairy tale by making *Belle*.

But first, Hosoda had to make it into the director's chair, which he finally did on two of Toei's long-running popular series, *Digimon Adventure* and *One Piece*. Jumping ship to Madhouse, he left franchise work behind and directed the beloved *The Girl Who Leapt Through Time* and *Summer Wars*, two films that started an unbroken streak of Animation of the Year wins at the Japanese Academy Awards.

In April 2011, he went independent and formed Studio Chizu with producer Yuichiro Saito. The company name means 'map', denoting an ambition to chart unexplored

Above: Filled with billions, the world of U is Mamoru Hosoda's third attempt at putting a virtual reality on screen.

CARTOON SALOON

Speaking of 'the next Miyazaki'... perhaps we have all been looking in the wrong place. Based in Kilkenny, Ireland, Cartoon Saloon have established themselves as one of contemporary animation's most accomplished studios, with a knack for combining folkloric flourishes with distinctive, dazzling animation. They draw inspiration from the landscape, storytelling traditions and art history of their home country in films such as *The Secret of Kells* and *Song of the Sea*. It's no surprise to see them collaborating with Hosoda – not least because their 2020 film, *Wolfwalkers*, shares more than a few thematic threads with Hosoda's *Wolf Children*.

territories in the world of animation. *Wolf Children*, *The Boy and the Beast* and *Mirai* followed, each reflecting Hosoda's ongoing interest in parenthood, first as an outsider, then as he had children of his own and watched them grow up.

Already a renowned figure in both fan and industry circles, Hosoda found new recognition in 2018, when *Mirai* premiered in the Director's Fortnight programme at the Cannes Film Festival and was nominated for an Oscar the following year, the first anime film to do so that wasn't produced by Studio Ghibli.

For his next film, *Belle*, Hosoda decided to explore themes both familiar and fresh, returning to the film that deeply inspired him in 1993 – *Beauty and the Beast* – to provide a narrative framework for an exploration of the impact of social media on our lives in the 2020s, inspired, in part, by his young daughter's first anxious encounters with the outside world:

'At nursery she's very shy and very timid...' he told us. 'And I started to worry. How will she survive when she grows up and she's got a phone and she's got to navigate social media and worry about what other people think of her, how will she manage?'

In an uncommon move for an anime production, but a perfect one for our interconnected, remote-working times, Hosoda built an international team of collaborators to bring *Belle* to the big screen. These included production designer Eric Wong in London, legendary Disney character designer Jin Kim (*Tangled*, *Frozen*, *Encanto*) in Los Angeles, and in Kilkenny, Ireland, Tomm Moore, Ross Stewart and their team at Cartoon Saloon. The latter provided background art for certain fantasy scenes in the digital world of 'U'. 'I don't want to be restricted to just working with Japanese people,' said Hosoda. 'I want

Above left: The Belle character was designed by Disney legend Jin Kim, providing us with a Beauty for the social media age.

Above top right: Those pesky pop-ups. The anxieties of virtual life imaginatively explode on screen in *Belle*.

Above bottom right: But Hosoda never forgets that the 'online' and 'physical' worlds are inextricably linked, with our hopes and fears overlapping between the two.

to look around the world to find the people that I need to make my films... to show people the possibilities of animation.'

Belle premiered in the Official Selection at the Cannes Film Festival in 2021, receiving a standing ovation after its first screening, while back home it proved to be Hosoda's biggest box-office hit to date, finishing as the third highest-grossing film of the year.

FURTHER VIEWING

Bundling *Belle* with *Digimon Adventure: Our War Game!* and *Summer Wars* forms a neat trilogy of films made over two decades that sees Hosoda drawing poignant and personal stories out of his characters' (and by extension, contemporary society's) relationships with the internet as technology develops. However, as an anime director who has, since *The Girl Who Leapt Through Time*, largely dedicated himself to feature filmmaking, Hosoda has amassed a rich filmography that rewards viewing as a cohesive, auteurist body of work: watch closely, and witness the maturation of the man, as filmmaker, storyteller and father.

BELLE – REVIEW

It's a tale as old as time, seen in French monochrome, Disney animation and 3D live action, but *Beauty and the Beast*'s best adaptation is *Belle*, from director Mamoru Hosoda. Set in glimmering forests, dazzling virtual reality worlds, in front of computers and around dinner tables; Hosoda's films all have a fairy tale quality to them, placing magic tantalizingly within arms' reach; and never has that magic felt as alluring, thrilling and poignant as in *Belle*.

An interrogator and champion of the online experience, Hosoda has explored virtual realities in 2000's *Digimon Adventure: Our War Game!* and his 2009 actioner, *Summer Wars*. Alternate realities can be found in his grounded fantasy works too, with *Wolf Children* (2012), *The Boy and the Beast* (2015) and *Mirai* (2018) exploring worlds in which human-animal hybrids and hidden worlds exist alongside ours. *Belle* revisits these long-term fascinations, focusing on a teenage girl called Suzu in a virtual reality called 'U', where avatars represent subconscious personalities.

In U, the meek and musical Suzu – grieving for her mother – can express herself, becoming pop superstar Belle, but a violent beastly avatar shatters her experience, destroying one of her concerts. Rather than responding with violence, Suzu sees herself in this brooding figure, and tries to help the creature known as The Dragon. Hosoda reconfigures the familiar dual identity of the Prince and the Beast into a reflection of physical and virtual personas, bringing an almost 300-year-old fairy tale into the metaverse.

This recurrence of twin worlds in Hosoda's films makes for undeniably inventive but often frustrating viewing, his high-concept ideas running parallel to his character's emotional experiences, rather than entwining with them. In *The Girl Who Leapt Through Time*, a focus on the machinations of time travel steals from character investment. In *Wolf Children*, a detailed and measured allegory for the feral personalities of kids becomes warped by an unforeseen cataclysm, washing away the story's intimacy. *The Boy and the Beast*, which takes place between our world and one governed by animals, suffers the most from this. A third

act shift, which dissolves the emotional core of the film, scraps a tender tale of paternal experience for city razing emo angst.

Summer Wars (which also includes a virtual world) bucks this trend, finding a sweet tension between the dual apocalypses of meeting the in-laws and saving the world. A symmetry in the animation between the macro and micro, combined with neatly balanced editing across separate narratives, aligns the propulsion of a disaster film with intensely felt domestic sentiment. *Belle* revisits this half-online, half-physical setting, but expands it to a grander scale. U is a vibrant and swarming space, a floating linear city extending infinitely into the distance, like train carriages made of motherboards. In comparison, Suzu's physical world is a tactile, sleek and oppressive maze, where hyper-detailed whiteboards and smartphones reflect her fragmented identity.

Despite the possibilities that the world of U offers, *Belle* is a simple story about kindness and how the internet can be a tool in cultivating it. While we know the alter ego of Belle, the physical identity of The Dragon is the mystery that the film hinges on. In his aggression, Suzu sees her own pain and fears, but also valour. In seeking him out, she's able to uncover not a beast, but a stoic victim of abuse who shields others against domestic violence. Attempting to thwart Suzu are the self-appointed 'Justices': a jumped-up, corporate-sponsored virtual police, more interested in intimidation than protection, whose gatekeeping, restrictive vision for the internet is satisfyingly scorned. In contrast, Suzu's heroism is a refreshing, extremely empathetic force, and a strong counteraction to tech-phobic stories about online culture.

In *Belle*, the internet is a space for self-validation, as well as a borderless community that can provide support. Despite all of U's visual ingenuity, from glitching gothic castles to flying whales, the most awesome online discovery is our ability to connect. Here, Hosoda perfectly balances his high- and low-concept ideas, casting a hopeful vision of the future, in which universes, meta or otherwise, and emotions, virtual or otherwise, are all valid and all equally 'real'.

INDEX

Page numbers in **bold** refer to main film entries incl. pictures and captions, ***bold italic*** to director portrait photos, *italic* to all other captions.

A
A Silent Voice 4, 5, 36, **146–51**
Abbey Road Studios 179, *181*
Akemi Ôta 12, 16
Akira 9, **44–51**, 54–6, 60, 66, 69, 74, 76, 80, 82, 86–7, 89, 98, 110, 130
Akira Committee 49
Amano, Yoshitaka 67
The Animatrix 49, 61, **100–3**, 111, 122, 124, 150, 154, 160
Anime Encyclopedia (Clements, McCarthy) 12
Anime Limited 9, *191*
Anno, Hideaki 36, 40, 42, ***114***, 143
Arias, Michael 102, ***108***
art house 20, 22, 24, 49, 67, 184

B
Bandai 40, 42, 49, 69, 74, 92
Bangalter, Thomas 98, 99
Baymax 172
BBC 46
Beatles 22, 98, 106, *107*, 179, *181*
Belladonna of Sadness **20–5**, 34, 80, 148
Belle 136, **182–7**
Björkman, Stig 22
Blade Runner 48
Buffy the Vampire Slayer 56

C
Cartoon Network 92
The Castle of Cagliostro, see Lupin III
Chabrol, Claude 22
Children of the Sea **164–9**
Chirico, Giorgio de 36
Choi, Eunyoung 106
Chung, Peter 100, 103
Cinelicious 22
Clash 179
Clements, Jonathan 12, 40–2, *191*
CoMix Wave Films 143
Cowboy Bebop: The Movie 48, 67, **90–5**, 102
Crunchyroll 167, 172

D
Daft Punk 96, 98, 99, *99*

Daicon 42
DAICON 40, 116
Demon Slayer: Mugen Train 9, 178
Digimon Adventure 12, 185, 186, 187
Discotek 9
Disney 10, 12, 12–13, 16, 19, 22, 30, 34, 106, 116, 172, 185–7
Dragon Ball 9, 12, 98, 185

E
Easter eggs 49, 124, 179
Emerson, Lake and Palmer 179
Eno, Brian 69
Erice, Victor 184
Evangelion: 1.0 You Are (Not) Alone **114–19**

F
Famitsu 172
Finders Keepers 22
Fukai, Kuni 22
Fukuda, Yoshiyuki 22
Futaki, Makiko 49

G
Gainax 40, 42, 116, 118, 172
On Gaku: Our Sound **176–81**
Galaxy Express 999 12, 81, 82, 98, 184
Geinoh Yamashirogumi 51
Ghost in the Shell 36, 46, 54, 55, 56, **64–71**, 74–6, 77, 92, 103, 122
Giovanni's Island 35, **126–31**
GKids 9, 161, *191*
Godzilla 40, 89, 117, 118

H
Hara, Keiichi ***132***
Hara, Setsuko 87
Hervet, Cedric 98
Hiroshi Okawa 12
Hisaishi, Joe 166–7
Homem-Christo Guy-Manuel de 98, 99
Hosoda, Mamoru 30, 36, 136, 143, ***182***, *191*
Hosono, Haruomi 35

I
A.I. Artificial Intelligence 81
Imaishi, Hiroyuki 102, ***170***
In This Corner of the World 136, 149, **152–7**
indie manga 178
Inoue, Toshiyuki 49, 130

Interstella 5555 **96–9**
Isao Takahata 11, ***14***, 28, 31, 35, 67, 86, 106, 116, 130, 154, 155, 160–1, 163
Iwaisawa, Kenji **176**

J
Jackson, Michael 98
Jin-Roh: The Wolf Brigade 67, **72–7**, 81, 130
Jones, Andy 100, 103
Journey to the West 12, 34

K
Kamen Rider 118
Kanno, Yoko 92, 94
Katabuchi, Sunao 143, ***152***
Kawajiri, Yoshiaki ***58***, 60, 81, 100, 102, 103
Kazuko Nakamura 12
Kikuchi, Hideyuki 60
King Crimson 179
Kitakubo, Hiroyuki ***52***
Kobujitsu 180–1
Koike, Takeshi 61, 100, 102, 103, ***120***, 172
Kon, Satoshi 9, 48, 54–5, ***84***, 106, 166
Kondō, Yoshifumi 136
K-On! 149, 150, 179
Koyama, Shigeto 172
Kurosawa, Akira 184
Kurtz, Gary 154
Kyoto Animation 148, 150, 179

L
Laloux, René 106
Lang, Fitz 78, 80, 82
Led Zeppelin 179
The Legend of Heroes 140
Legend of the White Snake 12
LGBT themes 150
The Little Norse Prince 12, **14–19**, 28, 30, 31
Luca 30, *30*, 31
Lucas, George 116
Lupin III 12, **26–31**, 67, 92, 106, 124, 150, 184

M
Madhouse 60
Maeda, Mahiro 100, 102, 103
Magic Boy 12, 34
Maki, Taro 86
Manga Entertainment 11, 49, 55, 60, 61, 66, 69

The Matrix 69, 69, 100, 100–3
Matsumoto, Leiji 98
Mazinger Z 12
Metropolis 12, 48, **78–83**, 122
Metropolis (1927) 48, 78, 82
Millennium Actress 49, **84–9**, 130, 136, 166
Mind Game 49, **104–7**, 154, 166, 178
Miss Hokusai 130, **132–7**
Miyazaki, Hayao 6, 9, 12, 13, 16–17, *16*, *18–19*, *18*, 26–31, **26**, 36, 46, 49, 60, 67, 76, 82, 86, 94, 106, 110, 116, 117, 137, 140, 143, 154–5, 160–1, 162–3, 167, 184, 185
Modest Heroes **158–63**
Momose, Yoshiyuki *158*
Momotaro: Sacred Sailors 12
Morimoto, Kōji 48, 49, 100, 102, 103, 111
Morita, Hiroyuki 49
Morricone, Ennio 22
Movie Critics Awards 149
Murai, Sadayuki 86
Murayama, Masao 87
Muruyama, Masao 155
Mushi Production 22
music videos 98
My Neighbours the Yamadas 106

N
Nakadai, Tatsuya 22
Nakamura, Kazuko 12
Nakashima, Kazuki 172
Naruto 9
Neo Tokyo 81
Neon Genesis Evangelion 36, 42, 102, 116, 117, 172
Netflix 92, 161
Night on the Galactic Railroad 12, **32–7**, 128, *128*, 130, 131, 149, 167
Nihon Falcom 140
Nihon SF Taikai 40, 46
Ninja Scroll **58–63**, 81, 102, 122
Nishikubo, Mizuho 35, **126**
Nishimura, Yoshiaki 158, 160–1, *160*, *163*, 191
Nobumoto, Keiko 48, 92, 94

O
Oga, Kazuo 35
Ōhashi, Hiroyuki 178
Ōhashi, Tsutomu 51
Okada, Mari 150
Okada, Toshio 40
Okiura, Hiroyuki 69, **72**, 81, 143
Okuyama, Reiko 12
Oldfield, Mike *179*, 180
One Piece 9, 12, 185
original video animation (OVA) 69
Oshii Jyuku 74
Oshii, Mamoru 54, 56, **64**, 74, 76, 86, 87, 94, 130

Ota, Akemi 12
Otaku no Video 42
Otomo, Katsuhiro **44**, 48, 86
Ōtsuka, Yasuo 12, 16, 28, 30, *154*

P
Panda and the Magic Serpent **10–13**, 16, 28, 34
Pink Floyd *179*, 180
Pixar 30, *30*, 31
Plaid 111
Ponoc Short Films Theatre 158–63
Production I.G. 74, 122, 128, 135
Promare **170–5**
propaganda 12, 43, 175

R
Ray, Satyajit 22
Redline 61, 102, **120–5**, 150, *172*
Reiko Okuyama 12
Rintaro 12, 60, **78**, 184
rotoscoping 178
Roujin Z 48, **52–7**, 74, 86
Royal Space Force: The Wings of Honnêamise **38–43**, 116, 130

S
Sadamoto, Yoshiyuki 40
Sailor Moon 12, 98, 185
Saito, Yuichiro 185
Samurai 31, 94, 103, 122, 150
Satoh, Masahiko 22
Science Saru 106
Shimizu, Shinji 98
Shimoji, James 124
Shinkai, Makoto **138**, 143, 191
Silver, Joel 69
Simonetti, Claudio 22
Snow White and the Seven Dwarfs 12, 13
Space Battleship Yamato 40, 86, 106
Spielberg, Steven 22, 29, 69, 82, 130
Spirited Away 6
Star Trek 40
Star Wars 40, 49, 86, 102, 116, 125, *154*, 172
storyboarding 28, 61, 67, 86, 106, 125, 143, 150
streaming services 46, 92, *92*, 161
Studio 4°C 102, 106, 111, 154, 166
Studio Pierrot 67
Studio Ponoc 158–63
Studio Trigger 102
StudioCanal 9, 191
Sugii, Gisaburō 12, **32**, 130, 131, 167
Sugita, Shigemichi 98
Suzuki, Toshio 17

T
Takahata, Isao 9, **14**, 16, 28–30, 31, 35, 67–9, 86, 106, 116, 130, 154, 155, 160–1, *163*

Takenouchi, Kazuhisa **96**
Tanaka, Eiko 102, 106, 111, 154, 166
Tatsunoko Productions 67
Team Oshii 74
Tekkonkinkreet **108–13**, 154, 166, 178
3DCG processing 69
time travel 67, 142, 187
TMS 30
Toei 12–13, 16, 28, 30, 34, 80, 98, 154, 184, 185
Toho and Kodansha 49
Tokyo Movie Shinsha 49
toymakers 40, 49, 92
Tubular Bells 180

U
Ultraman 118
U2 69

V
video games 29, 49, 63, 67, 102, 110, 111, 140, 155, 161

W
Wachowski siblings 61, 69, 69, 70, 92, 102, 103, 111
Wakabayashi, Hiromi *172*
Warner Bros. 102
Watanabe, Ayumu **164**
Watanabe, Shinichirō **90**, 100, 102, 103
West, Kanye 98
The White Snake Enchantress, see Panda and the Magic Serpent
The Who 179
The Wings of Honnêamise, see Royal Space Force: The Wings of Honnêamise
World Masterpiece Theatre 17

Y
Yabushita, Taiji **10**
Yamada, Futaro 60
Yamada, Naoko 5, **146**, 178
Yamaga, Hiroyuki **38**
Yamamoto, Eiichi **20**, 60
Yamamoto, Sayo 150
Yamashita, Akihiko **158**
Yasuda, Michiyo 16
Yellow Magic Orchestra 35
Yellow Submarine 22, 24, 98, 106, *107*
Yonebayashi, Hiromasa **158**, 191
Yoshida, Reiko 98, 149, 150
Young Magazine 48
Your Name 9, **138–45**, 149
Ys 140
Yuasa, Masaaki 30, **104**, 112, 167, 178
Yuri on Ice 150

FURTHER READING

Clements, Jonathan. *Anime: A History* (Bloomsbury Publishing)

Clements, Jonathan and McCarthy, Helen. *The Anime Encyclopedia: A Guide To Japanese Animation Since 1917* (Stone Bridge Press)

Denison, Rayna. *Anime: A Critical Introduction* (Bloomsbury Publishing,)

Greenberg, Raz. *Hayao Miyazaki: Exploring the Early Works of Japan's Greatest Animator* (Bloomsbury Academic)

Le Blanc, Michelle and Odell, Colin. *BFI Film Classics: Akira* (Palgrave Macmillan)

McCarthy, Helen. *500 Essential Anime Movies* (Collins Design).

Napier, Susan. *Anime from Akira to Howl's Moving Castle: Experiencing Contemporary Japanese Animation* (Palgrave Macmillan)

Napier, Susan. *Miyazakiworld: A Life in Art* (Yale University Press)

Osmond, Andrew. *Satoshi Kon: The Illusionist* (Stone Bridge Press)

Osmond, Andrew. *100 Animated Feature Films* (Bloomsbury Publishing,)

Ruh, Brian. *Stray Dog of Anime: The Films of Mamoru Oshii*, 2nd edition. (Palgrave Macmillan,).

ACKNOWLEDGEMENTS

Thanks, first and foremost, to our podcast partners Steph Watts and Harold McShiel, who have stuck with us through every twist and turn of the multimedia adventure that is Ghibliotheque. This book wouldn't exist without the support of our colleagues at Little Dot Studios, namely Dan Jones, Tom Hemsley, Hal Arnold, Jay Tallon, Alice Hyde and Kirsty Joyce. Similarly, we're grateful to the team at Welbeck, led by Ross Hamilton and Conor Kilgallon, for putting these words onto the printed page. As film fans and critics, we're indebted to distributors who specialize in anime, because how would we even see these films otherwise? Thank you to Andrew Partridge and Kerry Kasim at Anime Limited, Dave Jestaet and Lucy Rubin at GKids, and the great Carys Gaskin, stalwart custodian of all things Studio Ghibli in the UK at StudioCanal. We're in awe of your energy, expertise and passion for animation. Thank you to Hiromasa Yonebayashi, Yoshiaki Nishimura, Mamoru Hosoda, Makoto Shinkai and everyone we've had the honour to interview over the years, informing many chapters in this book. And, for their help, encouragement and inspiration, thank you to Helen McCarthy, Alex Dudok de Wit, Kambole Campbell, Andrew Osmond, Jonathan Clements, Rayna Denison, Sam Clements, Edward Szekely, James Hunt, Rowan Woods, David Jenkins and Pamela Hutchinson. Above all, thank you to Mim, Ivo and Louisa for letting us continue to monopolize the big TV and the sofa to watch yet more cartoons. It's for work, honest.

CREDITS

The publishers would like to thank the following sources for their kind permission to reproduce the pictures in this book.
Key: t = top, b = bottom, c = centre, l = left and r = right

Alamy Stock Photo: 48, 50, 67, 69, 70, 81, 93b, 94, 121, 136, 137; /Aflo Co. Ltd: 64, 132, 152; /Album: 4, 66, 68, 142, 148-149, 150t, 150b, 154; /BFA: 30, 45, 49, 47, 65, 71, 139; /Collection Christophel: 110-111, 113, 116, 151; /Entertainment Pictures 80, 83r; /Everett Collection: 8, 24t, 24b, 25, 74, 92t, 92b, 147, 159, 160, 161t, 162, 163, 173b, 174t, 178, 179t, 180, 181t, 181b; /Famouspeople :26; /Moviestore Collection Ltd: 7, 157. 161b; /Photo12: 12-13, 15, 16, 17, 18, 19, 21, 22, 23t, 23b, 46, 51, 69c, 79, 82, 83l, 93t, 95, 97, 98t, 98b, 99, 101, 102l, 102bl, 102r, 117, 118, 128, 129t, 129b, 131, 133, 134-135, 135, 136b, 140, 141, 144l, 144r, 145, 156, 190; /Reuters: 78, 138, 182; /Sipa US: 14; /TCD/Prod.DB: 165, 166-167, 168, 169t, 169b, 171, 172, 173t, 174b, 175, 177, 179b, 183, 184-185, 186l, 186tr; /Zuma Press, Inc: 164

Elvis/Commons Wikipedia licenced under the Creative Commons Attribution-Share Alike: 38

Getty Images: Alberto Pizzoli/AFP: 84; /Vittorio Zunino Celotto: 120

Private Collection: 10, 11, 20, 27, 30t, 32, 33, 34-35, 36, 37, 39, 40, 41, 42, 43, 44, 52, 53, 54, 55, 56, 57 ,61, 62, 63, 72, 73, 75t, 75b, 76, 77, 85, 87, 88, 89, 90, 91, 96, 104, 105, 106, 107, 109, 112, 114, 115, 120, 122, 123, 124, 125, 126, 127, 146, 152, 153, 170, 176

Tekkonkinkreet/Commons Wikipedia licenced under the Creative Commons Attribution-Share Alike: 108

Special thanks to BAC Films, CoMix Wave Films, Daft Life, Entertainment Japan, Gainax, Kyoto Animation, Madhouse, MAPPA, Monkey Punch, Mushi Production, NPV Entertainment, Paramount Pictures, Production I.G./ING, Rock'n Roll Mountain, Sunrise, Toei Doga, Toho, Tokyo Movie Shinsha, Studio 4°C Co., Ltd, Studio Chizu, Studio Ponoc, Studio Khara, TMS, Tokyo Theaters Co., Village Roadshow Pictures, Wild Bunch

Every effort has been made to acknowledge correctly and contact the source and/or copyright holder of each picture and Welbeck Publishing Group apologizes for any unintentional errors or omissions, which will be corrected in future editions of this book.